THE SPRAWL

THE SPRAWL

Reconsidering the Weird American Suburbs

JASON DIAMOND

COFFEE HOUSE PRESS
Minneapolis
2020

Coffee House Press books are available to the trade through our primary distributor, Consortium Book Sales & Distribution, cbsd.com or (800) 283-3572. For personal orders, catalogs, or other information, write to info@coffeehouse press.org.

Coffee House Press is a nonprofit literary publishing house. Support from private foundations, corporate giving programs, government programs, and generous individuals helps make the publication of our books possible. We gratefully acknowledge their support in detail in the back of this book.

LIBRARY OF CONGRESS CATALOGING-IN-PUBLICATION DATA

Names: Diamond, Jason, author.
Title: The sprawl : reconsidering the weird American suburbs / Jason Diamond.
Description: Minneapolis : Coffee House Press, 2020. | Includes
 bibliographical references.
Identifiers: LCCN 2020015243 (print) | LCCN 2020015244 (ebook) | ISBN
 9781566895828 (paperback) | ISBN 9781566895903 (ebook)
Subjects: LCSH: Suburban life—United States. | Suburbs—United States.
Classification: LCC HT352.U6 D52 2020 (print) | LCC HT352.U6 (ebook) |
 DDC 307.740973—dc23
LC record available at https://lccn.loc.gov/2020015243
LC ebook record available at https://lccn.loc.gov/2020015244

PRINTED IN THE UNITED STATES OF AMERICA
27 26 25 24 23 22 21 20 1 2 3 4 5 6 7 8

To Emily. You're my home no matter where I am.

Though you have done nothing shameful,
they will want you to be ashamed.

—Wendell Berry

Contents

Preface

I'm suburban; I'm *of* the suburbs. I've spent my entire adulthood in cities, but I still get nostalgic when I smell freshly cut grass. It brings me back to the malls of my youth, to the food court at Town Center at Boca Raton, the mall we used to go to whenever I visited my grandparents in South Florida, or the old tobacco store in some forgotten shopping center in the middle of the country. I love grilling meat on a Weber grill I spent an hour trying to light, and by God, I miss not having a never-ending stream of cars honking outside my window.

It took me a long time to admit any of that. I was, at best, ambivalent about where I come from, but filled with pure hate is more like it. Whenever somebody asked, I always told them I was from Chicago. That's the way most people do it, right? If you're from Round Rock, Texas, you'll say you're from Austin. If you grew up in Fountain in a house with four bedrooms, a two-car garage, and a big backyard, you just tell people "Colorado," because they won't know your hometown. If you're from Long Island, ran on the cross-country team, and lived in a quiet little subdivision but moved away to college and never looked back, you'll tell anyone who asks you're from New York—which isn't wrong. You just hope they assume you mean Manhattan and not Hicksville, which is over an hour away.

Yet getting to a place where I could clearly and honestly tell people yes, I grew up in suburbia, in neighborhoods up and down Lake Michigan, took a long time. I left as a teenager and immediately started telling people I was from Chicago. I never looked back—until I did.

After an adulthood spent mostly in two of America's biggest cities (Chicago and New York City), the suburbs came back into my life in my midthirties. It started slowly: weekend trips to my in-laws' house outside Hartford, Connecticut, in a whimsical little town called Avon in the shadow of Talcott Mountain. From their backyard, you can look up and see Heublein Tower, the "castle" A.1. sauce and Smirnoff vodka manufacturer Gilbert Heublein built his wife in the early twentieth century. You can walk barefoot around my father-in-law's immaculately green grass and gaze at the hawks as they circle or watch the woodchucks scatter about. It's country quaint, but it's suburbia, no doubt. Drive five minutes and there's a Chili's, an antiques dealer/coffee shop, a hotel bar I sometimes sneak away to for a quiet drink, a few car dealerships, some elite private schools, a couple of local farms that sell pumpkins and cider, and a golf course—then another golf course, and another. It's *Gilmore Girls* cozy with a deliberate small-town feel baked into the city plans, even though the population reaches over 18,000, and the bulk of the housing is from the twentieth and twenty-first centuries. It's all thanks to that postwar boom; the place jumped from 1,738 residents in 1930 to 11,201 fifty years later, in 1980.

I hear a lot of debate over what is and isn't a suburb. My general rule of thumb for including somewhere in the "is" category tends to be when the population of a place has increased since World War II, but industry hasn't been added to lure people there. So when houses and grocery stores and coffee chains and places of that nature pop up in locations where things were traditionally made or grown, that generally is a sign that a place is suburban. It's not always the case, but people moved to the little town of Avon, for example, to work in nearby cities, such as Hartford, a fifteen-minute drive away. Avon became a suburb out of necessity.

There isn't all that much to do in this small suburban town, and frankly, that's nice to me. It's still and quiet. I don't have to worry about getting on the subway and dealing with people coughing on me or some guy clipping his fingernails between taking bites of a burrito (yes, I've actually seen this). There aren't sirens and jackhammers and people

yelling outside my window. When I go to my in-laws, butterflies flutter around in the summertime and there's a fireplace to sit by in the winter. In the city, there's the dirt-and-god-knows-whatever-else-covered snow, and rats, lots of rats. That all said, I think I'll spend the rest of my life in cities. The suburbs are nice to visit, but at this point, more of my life has been lived as an urbanite than not; everything else feels like a vacation. I'm part of that group of younger Generation Xers and older millennials[1] who moved back to cities after our parents and grandparents left to build a better life, with backyards and places to park their station wagons. And I'm pretty sure I'm staying put.

But who knows?

The American suburbs were the great promise to the baby boomers. If you were white and middle class, a little piece of the postwar pie was yours for the taking in the years after World War II. Suburbia was the idea of the good life, something humans had been looking to attain for centuries but only the wealthy could afford: a place outside the city. After the war ended, that dream became more attainable, especially— and this needs to be repeated—if you were white. The Federal Housing Administration, starting in 1934 and all the way until 1968, graded neighborhoods from A to D. Areas with large black populations usually received the lowest grade, and those same black people who wanted to make a change were shut out of attaining loans to help them afford housing in newer, nicer, safer areas.[2] This is enough to make any sane person want to rebel against the idea of the suburbs, a place that actively kept groups of people out. But as I'll show, there's more that has colored our view of what the suburbs are and aren't. We have so many ideas of what we think suburbia is, yet we don't realize how suburban we've become, whether we live in a suburb or not.

The suburban way is taking over our lives. Walk down Bedford Avenue in Brooklyn's Williamsburg neighborhood, and you no longer find mom-and-pop stores or Spanish and Yiddish speakers outnumbering English speakers; you find an Apple Store, a Whole Foods, and banks where independent businesses used to be.

Cities may be our media hubs, but suburbia makes the news. It's where horrible violence happens, like the shootings of unarmed black teenagers Trayvon Martin and Michael Brown (Martin in a gated Florida community by George Zimmerman, a neighborhood watch member once described as being "obsessed with suburban law-and-order minutiae,"[3] and Brown by a police officer in the St. Louis suburb of Ferguson). School massacres, from Littleton, Colorado, to Newtown, Connecticut, and Parkland, Florida, seem to almost always happen in places where people tell the news some variation of "this isn't supposed to happen here." The suburbs, we're also told, are the battleground where each and every election will be decided.

Today, over half of all Americans, 55 percent according to one Pew study, live in the suburbs.[4] If we want to live well together in this country, we must gain a better understanding of the suburbs as a concept. Suburbs are places that are made up of white people, African Americans, Mexicans, Chinese, Russian, and Indian people, and just about every other nationality or group you can think of. LGBTQ people live in suburbia. There are churches, mosques, synagogues, and all other places of worship in the suburbs. The suburbs aren't only Democratic or only Republican. There's poverty, violence, and drug abuse in the suburbs, and there's also creativity, passion, and genuine character in these places. The suburbs aren't one thing or another; we try to pigeonhole suburbia, act like it's a great big boring monolith of conformity and tract housing, but there's so much more to it than that, and we need to understand it better. Otherwise, I believe the things we consider to be true about the suburbs, the fears and misconceptions we have about these places, will overtake us.

The title of this book was borrowed in part from speculative fiction writer William Gibson. In his work, notably the Sprawl Trilogy (*Neuromancer* [1984], *Count Zero* [1986], and *Mona Lisa Overdrive* [1988]), Gibson gives us the near-future Boston–Atlanta Metropolitan Axis (BAMA) megacity. I sometimes see traces of that fictional dystopia as I drive down endless roads lined with strip malls and car dealerships. I've seen

this sprawl not only in America but also all over the world, from Canada to China. The sprawl, to me, is soulless. It's bad planning, it's corporate, it's bland, and it's spreading. It's everything becoming one, and not in some utopian hippie love-in way. The sprawl is building more stuff on top of stuff; it's design without thinking; it's building without caring. It's putting up another golf course or a third home goods store or adding another chain restaurant instead of propping up local independent business. It's this car culture Americans are still so obsessed with. We get into these things, drive up our wide streets to get on the highway, and our feelings and compassion seem to go out the window the longer we sit in traffic. The sprawl, not the suburbs, is what I don't like. I want to separate the two to better understand and appreciate these places that are everywhere.

Since I'm from the suburbs, and the suburbs have given us some of our greatest creators of science fiction (from Ray Bradbury to Gibson to George Lucas and Steven Spielberg), I'll use another analogy: the suburbs are Anakin Skywalker.

Yes, I'm making a *Star Wars* comparison. But it's apt not only because the franchise's creator, George Lucas, grew up in what is often referred to as the "sleepy" California suburb of Modesto, but also because Anakin is a flawed, imperfect, but ultimately good person. He's seduced by the Dark Side and eventually turned into a masked cyborg version of himself. My aim is to show how the suburbs are Anakin and the sprawl is Darth Vader. We want to find our good side, however flawed and deeply buried it may be, and fight off the evil guy in the cool black uniform.

I can say with certainty that suburbia is an outsider. I'm putting all the designations of the suburbs—the exurbs, edge cities, and commuter towns—under this umbrella to avoid confusion. Schaumburg, Illinois, for instance, is a large, sprawling area with nearly 75,000 residents (74,184 at the time of this writing), malls, and lots of tall glass buildings. It's home to the North American branch of Zurich, a Swiss insurance company. The Motorola Solutions headquarters was also there for years. Schaumburg sounds like a city, yet it's a suburb. On the other

side, there are parts of Queens, New York, that look like Grosse Pointe, Michigan, or Simsbury, Connecticut, but it's still a city. Queens, just like its fellow borough of Brooklyn, which could qualify as one of the first true American suburbs, is within, not outside, the city. What makes something a suburb is where it is in relation to a city. The *Merriam-Webster* definition of *suburb* is "an outlying part of a city or town."[5] An outlier, something *other* than the city. It's sub-urban; it's beneath a city.

Outsiders are odd; you look down on things that are below you. The suburbs, too, have taken on the status of cultural oddity, something Rod Serling picked up on in some of the most iconic episodes of *The Twilight Zone* and Shirley Jackson and John Cheever channeled in their very different types of fiction. Matt Groening drew it as the Springfield of *The Simpsons;* David Lynch and Stephen King placed monsters, human and otherwise, in the suburbs; and even today, acclaimed indie rock bands like Arcade Fire write albums like 2010's *The Suburbs,* and filmmakers from Jordan Peele to Greta Gerwig mine suburbia for inspiration.

I look around my Brooklyn apartment, and I see so much influenced by cities: books by New Yorkers Edith Wharton and James Baldwin, records produced in Los Angeles and old Motown LPs from Detroit, hats representing sports teams from Chicago and Boston. We know what was built in the cities (industry, commerce, media, political power); what we ignore is just how much the suburbs have influenced our culture. America's early days were rural, then the urban century sprang up during the Industrial Revolution. Today, we're still very much in the middle of the suburban century. America has fashioned itself from the suburbs since the end of World War II; so many people are suburbanites, and we're constantly reminded of how much influence the suburbs yield over the rest of the world. Learning to better understand anything of such importance is vital.

Suburbia's influence will only grow, not only in America but also throughout the world. On nearly every continent there are places that could be considered suburbs that have populations of over one million. And

in the u.s., while there's been a lot of talk about the boom some of our once-forgotten cities have experienced over the last decade, the fact is, the suburbs are still growing. According to the Brookings Institute, the fifty-three major metropolitan areas across the country outpaced suburbia in growth in 2010–11 and 2014–15; but in 2015–16, city growth declined to 0.82 percent.[6] While the suburban growth rate also dipped from the previous year, it was still above its urban counterpart with a rate of 0.89 percent growth.

Cities are great. I live in one, and I wrote the bulk of this book from my apartment in Brooklyn and the library on Forty-Second in the heart of Manhattan. Yet the suburbs are legion, and people argue they're more livable than the cities. They offer so many of the things I hear my other friends in cities complaining they miss—from more space to less noise—all the time. Yet we keep staying in the city for whatever reason: because our jobs are here, we can walk to the subway or the little restaurant that serves the best fried chicken or the bar that makes the best bloody mary; *stuff is happening* in cities. As one person told Al Jazeera in 2017, it's "the culture, the food, the shopping," that keeps them living in a city and not a suburb. Another said, "There's just something kind of cool about a big city with skyscrapers and glass windows and, um, kind of the hustle and bustle of downtown living," adding, "It's pretty cool."[7]

I've never heard anybody say that about the suburbs.

While every suburb is different in some way, what links them from coast to coast is that undercurrent of strangeness, of bottled-up energy, rage, passion, and creativity—the great suburban exports. As a structured and structuring way of being, suburban sprawl foments a kind of imaginativeness in people that's both unique to the boring suburban imagination and reflective of an alienating longing for the archetypal urban lifestyle. These emotions engendered by living in the suburbs are consistent over time: anxiety, boredom, and alienation. Understanding how and why the suburbs are this way can help us better understand the present and the future, whether we live in suburbs or not. Because America,

by moving farther out of the cities and building new subdivisions filled with single-family households bordered by malls and office parks, created modern suburban sprawl. But in the end, that sprawl reshaped America, became our modern condition, a state of mind: more stuff—more cars, more houses, more stores—and less of what we need.

The suburbs were a smart, practical idea that was put into practice in all the wrong ways, and they deserve to be scrutinized. This book isn't a celebration of the suburbs as an idea or a way of life. Rather, it examines how the suburbs came to be what they are today, how much they've influenced our world, and what we can learn going forward, since the suburbs aren't going anywhere anytime soon.

THE SPRAWL

We Were Promised Hoverboards

The future isn't what it used to be—at least our interest in what the future might look like has changed, as has our enthusiasm. Every generation has to listen to the previous ones talk about the "way it used to be," but people don't want to speculate on what *will* be as much as they used to.

Imagining how the future will look in ten, twenty, fifty years was, especially after World War II, an American obsession. There was the *Leave It to Beaver* and station wagon life portrayed in photographs by Maynard L. Parker on the covers of *House Beautiful* and *Better Homes and Gardens* magazines. There was also *The Jetsons* with their flying cars and robot maid. People dreamed of not only having man walk on the moon but also someday living on other planets, and that vision often looked suburban. In 1957, when Walt Disney Imagineering and the Massachusetts Institute of Technology (with thanks to their sponsor, Monsanto) showed us the House of the Future, where microwaves ensured "everything is done just right at amazing speed" and furniture made of "practical but comfortable . . . serviceable yet beautiful" plastic, it was suburban.[1] There was a lot of enthusiasm about how things would look someday, and the future could often be found in the suburbs. The stereotypical midcentury picture of the white, middle-class family and their perfect normal lives was the past, present, and future model of the country that companies and advertisers wanted to portray.

After the chaos and bleakness of the sixties and seventies, there was an understandable desire for a time when Americans were intrigued by what could be. A cursory look at the politics and pop culture landscape of the decade shows that in the eighties, people yearned for a past that was enamored with the future, from the former movie star running the country to one of the highest-grossing films of the decade, *Back to the Future,* taking viewers back to the Eisenhower administration. And while the "greed is good" decade had more than its fair share of films set during the formative years of the baby boomers,[2] *Back to the Future* offers a cool teenager going back thirty years from 1985 to 1955, getting his parents together, saving the life of his friend, Dr. Emmett Brown, altering the future, and possibly inventing skateboarding. Michael J. Fox's Marty McFly is one of the great film characters of the eighties, and the movie is the type of classic that's almost certainly playing somewhere in the world every minute of every day. But *Back to the Future* also provides a perfect encapsulation of the rise and fall of the American suburbs throughout the first half of the trilogy's opening film, something that gets lost in discussions of the best lines and the DeLorean time machine and debates over what the movies got right and wrong about the 2000s.

It's dusk when Marty rolls home on his skateboard. The camera pulls back to show us the entrance to Lyon Estates, a subdivision in the fictional California town of Hill Valley. A lone streetlamp illuminates the wide stretch of pavement. The houses are pushed back from the curb, there are massive power lines in the distance, and there're a couple of trees on the block—hardly anything natural about it; it's unremarkable in every way. The shot is painted in a bluish gray because of the time of day, but it's fair to assume the streetscape always looks like that. It's lonely; something you realize after you've watched enough movies and TV shows about the suburbs is that they're often shot that way. At the front of the development's entrance, a pair of lion statues keep watch. It's hard to tell, but they're pretty weathered from the California sun, and nobody cares enough to fix them up. Lyon Estates has seen better days. There's an Edward Hopper quality to the whole shot, a lot more to unpack if you're willing. But, of course, there's not

much reason to do that if you're just watching the film to see Marty cruising the space-time continuum and looking cool—which is totally reasonable since that *is* what the movie's about.

Marty is bored. His family is at the lower end of the middle, and his life in Hill Valley is unfulfilling. His brother works at Burger King, his sister doesn't seem to do anything, his dad is a nebbish with some low-level number-crunching job, and his mom is a burned-out housewife who likes to start cocktail hour a few hours earlier than she should. It's a middling existence, one Marty desperately wants to escape, the little one-floor ranch home with transmission towers in the backyard that are probably frying his brain. It isn't so much that there's much wrong with the house itself (which is a real home on a street in the San Fernando Valley lined with pickup trucks owned by the mostly working-class neighbors). Rather, it's what the house and neighborhood have become in the film and what they've come to represent: deterioration, the American Dream stripped of all its sheen. This is the future that Marty will try to get back to.

When Marty goes back thirty years to 1955, we see a different version of his hometown. His Lyon Estates subdivision is still an empty chunk of land that will soon be filled with houses and concrete, with a bucolic background filled in by trees and hills. There is a sign with an illustration of a perky white nuclear family and the slogan, "Live in the home of tomorrow . . . Today!" That, and the lion statues at the main entrance, which look like they're standing watch. The 1955 version is vibrant and more alive than the stale and forgotten 1985 version. When Marty walks the two miles into town, the little Eisenhower-era Hill Valley downtown is Main Street U.S.A., the type of place where young men in spotless uniforms run out to service any car that visits the gas station, and people are out walking around enjoying their town. Hill Valley in 1985 is mostly desolate and falling apart, with trash blowing everywhere and the movie theater showing porn on a big screen that, in 1955, is playing *Cattle Queen of Montana*, starring Barbara Stanwyck and Ronald Reagan, for fifty cents.

Yes, this is largely baby boomer nostalgia for a time when the owner of Lou's Cafe could crack, "A colored mayor. That'll be the day," when

the African American busboy says he'd like to be mayor of the town someday (the character, Goldie Wilson, is, in fact, the mayor of Hill Valley in Marty's 1985). But the juxtaposition of the two Hill Valleys paints an adequate picture of suburbia's boom and bust in the decades after the Second World War. Coming just a few years after the end of the Vietnam War, the gas shortages, and the Iran hostage crisis, and in the final years of the Cold War, the 1985 version of Hill Valley also represents the disillusionment Americans everywhere felt, from farmers in rural areas dealing with one financial heartache after another as exports fall and interest rates and farm equipment prices rise, to urbanites struggling with crumbling buildings and skyrocketing crime rates. The breakdown of the suburbs encapsulates all that. Baked into the selling of suburbs in the middle of the twentieth century was that they were a change, an escape from the problems of small towns and big urban centers. At a time when the suburbs—the American Dream— were showing signs of decline, *Back to the Future* summed up the suburban zeitgeist better than most people might've realized.

Three years after *Back to the Future* came out, in 1988, Studs Terkel introduced us to Ray and Sandy Scholl in his book *The Great Divide*.[3] The Scholls live in a Chicagoland suburb they describe as a "gray-collar area," where the people who make up the community range from "welfare Section 8 to some rather affluent people." Terkel notes that where they live is "your classic bedroom community," and that it is "more an enclave of subcommunities, one being wholly alien to another. Though they are all within the radius of a couple of square miles, they are planets apart." He goes on to mention the shopping malls, the chains like K-Mart and McDonald's, and the streets that have names connected to the Native Americans who once lived and thrived in the same place. You've maybe never been to the area he's talking about, but if you've been to any suburb, you can easily imagine it. Ray is a Vietnam War vet who works as an independent insurance broker ("I'm not at a point where I can be your typical insurance agent and spend three days at a golf course," he says with a laugh); Sandy owns a small commercial cleaning service.

There's one exchange early in the interview, right after Ray describes the kind of people who live in the suburb, where Sandy notes that the middle class is disappearing from the area. She says, "No matter how well you do, you're never quite able to stay ahead. It's harder and harder for the average person to attain the average American dream."

Sandy's right. Twenty years later, in 2008, even if you had attained that suburban American Dream, the ease with which it could be taken from you, almost overnight as banks foreclosed on homes across the country, was something out of the dystopian, alternative 1985 timeline from the second *Back to the Future* movie.

"After serving in Vietnam and working all my life, this just seems like a failure of justice," said Mitchell Versher, an Army vet and security guard who was in his late sixties when he talked with the *Chicago Tribune* in 2016.[4] The nine-hundred-square-foot Cape Cod–style home twenty miles south of Chicago's Loop he and his wife, Loria, had purchased in the suburb of Markham for $137,000 was their dream home. Less than fifty years earlier, in 1960, not long before Versher would have been old enough to fight for his country, that dream would have been just that, since the bulk of Markham's population was predominantly white (78.4 percent or 9,180 of its citizens).[5] Versher, an African American, would have found all kinds of hurdles that would have made it virtually impossible for him to buy a home. But as the largely white population of European immigrants and their children moved away from the city, the numbers changed, and by 1990, they had reversed almost completely: 10,048 of the citizens of Markham were black (76.5 percent), while 2,936 (22.4 percent) were white. In 2016, the Versher house was foreclosed on, listed for sale for $29,500, with court filings showing that the couple owed Nationstar Mortgage $180,000.

As Mitchell Versher put it, "We thought we were getting the American Dream and a measure of stability at this stage in our lives."

There is something to the plight of the Vershers and others like them who felt the weight of the economic crisis of 2008 that is a very American sort of tragedy. That isn't to say it's their fault for losing their homes; rather, the system failed to put protections and safety nets in

place for those who moved to the suburbs. While I can't speak to particular families' finances, evidence shows that there wasn't much of a plan for the suburbs' future. The 1955 Hill Valley and the 1985 version Marty is from show this. A subdivision was built, the homes were sold, and voilà—you could call it a community or a neighborhood without it really being one. A community wasn't developed, and a robust city government and structures weren't put in place to make sure Hill Valley was livable for decades to come, so everybody would have opportunity there. That's why the two versions are so different from each other. Marty has to go a long way to get to the center of culture in his town, the Twin Pines Mall; nothing seems to work; there are abandoned storefronts and, most notably, homeless people. This is worth pointing out not only because there weren't many fictional portrayals of homeless people in the suburbs before *Back to the Future,* but also because in the real-life War on Poverty that President Lyndon B. Johnson would wage in the early to midsixties, the belief was that poverty didn't exist in the suburbs, so there was no need to study it—a trend that would continue well into the next century. As Scott W. Allard points out in his book *Places in Need: The Changing Geography of Poverty,* Johnson's administration found very little poverty in the suburbs—which makes sense because back then, going to the suburbs was a sign of moving up in society. Poverty was mostly a rural issue, while "central-city residents—both white and black—were at greater risk of being poor than suburban residents." This, of course, was just as what we today call "white flight" was beginning to gain steam, with people and businesses leaving cities. While the term has its share of critics, the truth is that it *was* mostly white people leaving, because at the time, it was mostly white people who *could* afford to leave the cities as they decayed. At the time, the American suburbs, then relatively young and new, were a work in progress, so, as Allard points out, "With the race and poverty crises in cities demanding scholarly attention, the seemingly homogenous pastoral suburban locations were less interesting."[6]

Eventually the suburbs grew to such a point that attention had to be paid to who lived there and where they fit on the economic ladder. As the

suburban population swelled, it became more interesting to the scholars Allard mentions. The 2005 American Community Survey replaced the decennial census with yearly sets of demographics. Three years later, in 2008, suburban poverty trends data was shared alongside data on cities and rural areas. The Brookings Institute also started the Metropolitan Policy Program in 1996, uncovering that "the number of suburban poor exceeded the central-city poor by 1.5 million in 2008."[7]

Suburban poverty is real but hardly discussed. As Allard points out later in his book, "Poverty has been present in suburban areas, even many newer suburbs, for several decades," and "funding of social services in most suburban places lags behind urban centers by almost an order of magnitude."[8]

Even with the new studies, we still don't pay attention to who lives in the suburbs or what they don't have because we've always assumed they're fine, that the suburbs represent safety and security. But that isn't really the case. Instead, today's suburbia, in the era that was the future for Marty McFly, has in many cases deteriorated further since 1985. Drive through some suburban places, like Markham, Illinois, or even overbuilt areas outside places like Orlando or Phoenix, some one-time Neighborhoods of Tomorrow, and you'll see what I'm talking about. The cracked paint and unkempt lawns are there, sure, but it's more about what isn't there and what we don't talk about. It's things ignored and things disappearing.

"You see a lot of homes in our neighborhood that are empty, and have been for ages, upscale homes with weeds growing in the yard," one resident of Franklin Reserve, a development fifteen miles south of Sacramento, California, told the *Guardian* in 2008. "I've noticed very nice houses being built, but 10–15-year-old cars in the driveway. Then the cars disappear, and they're replaced by empty driveways."[9]

For me, it all goes back to lions. In 2015 I found myself on the side of the road on Illinois 120, staring up at a pair that looked very similar to the two that guard Marty's subdivision. Behind them was an abandoned car dealership. It was a hot July day, the type you learn to hate

growing up in the large area known as Chicagoland, which extends into southern Wisconsin and western Indiana. There's no breeze to cool you, and in a part of the country where the Windy City serves as the center, you sort of expect some respite to blow past.

But no such luck as I got out of my car and stood gazing at these two brown lions, which had seen better days. Everything was chipped and weathered in the empty lot and on the building that was Extreme Jeep until 2012. I just stared. The whole scene looked, frankly, apocalyptic, save for the sunny sky, with the puffs of clouds, that felt like it went on forever over the flatlands of northern Illinois.

I know McHenry well. It was a place I visited in the summers as a child, sometimes going up there to ride in a friend's father's boat that was docked on the Fox River, other times fishing for muskies and small-mouth bass with my grandpa. I lived there for a few years, although I can't say I ever got completely comfortable with it. Growing up on Lake Michigan, in Chicagoland suburbs that were undeniably suburban, with all the subdivisions, chain stores, malls, and other signifiers you look for, McHenry the city and the bulk of McHenry County seemed strange to me. I could never tell if it was a rural area that wanted to be suburban, a suburban area that wanted to retain some of its rustic charm to entice people to move there, or both.

"During the last few years, the population of McHenry County has skyrocketed faster than that of any other county in the state of Illinois," one editorial in the *McHenry Plaindealer* from August 1967 claimed. "Towns that were once considered rural areas are now thought of as 'Suburbia.'"[10]

No place starts out as anything; it could have been hills that were leveled to make room for a smattering of townhouses; a stream covered where the center of a bustling downtown is; or a Taco Bell sitting on land where native people used to live. It *becomes* farmland, a city, or a suburb when people work to make it so, and the division between the three is sometimes hard to tell. For many years McHenry was a small rural town a little over fifty miles north of Chicago. It didn't give birth to any senators or businesspeople who changed the course of the

country; TaylorMade, the golf club manufacturer, was founded there in 1979, and John Brzenk, a world champion arm wrestler, was born there in 1964, but that's about it. McHenry doesn't have any famous songs written about it, besides a mention in a Tom Waits tune where he sings about how his wife, Kathleen Brennan, grew up in neighboring Johnsburg, Illinois. Matt Skiba of the pop punk band Alkaline Trio grew up there, but as far as I can tell, he never mentions the town in his songs. There's one building on the National Register of Historic Places,[11] compared to two in the neighboring, much smaller towns of Marengo (population of 7,648 as of the 2010 census) and Richmond (population of 1,874 in the same census). McHenry has never been known as a hub of arts or activism the way Woodstock, Illinois, was when it played host to the anarchist Emma Goldman and director Orson Welles, or when it served as the filming location for the 1993 film *Groundhog Day*. It's just a place. You spend enough time there, and you catch on that that's all its residents want it to be, just a place.

What you do get is a lot of water and trees. It was a prairie once, a place where the calls of purple finches and eastern meadowlarks still echo through the Volo Bog, a little sliver of nature that can date its creation back to a large glacier melting away toward the end of the Wisconsin glaciation about ten thousand years ago. McHenry was never quite rich in any one thing or another, nor was it ever a headquarters for a big company. It was just a nice, quaint place to live—it just took a little longer for people to get up there.

The population broke a thousand at the start of the twentieth century and didn't go above 1,500 until 1940. When the next headcount was taken in 1950, 2,080 people lived there. In 1960 it was 3,336, In 1970, the population reached 6,772, and by 1980, it was 10,000. While many across the country seemingly sprang up overnight, McHenry and other towns in the county transformed into suburbs. Sure, you could still drive to nearby Johnsburg and see miles of corn rows, and Harvard, Illinois, calls itself the Milk Center of the World. But McHenry and fellow county members Crystal Lake and Woodstock were considered suburbs starting in the early sixties. It's difficult to get to Chicago since

only a couple Metra trains depart from McHenry station each day, but when I lived there in the middle of the 1990s, there was business in and around the area—at least enough for the town to grow and attract more.

McHenry had the typical turn-of-the-century main drag down Green Street, with stores to buy sports equipment and gym shirts for the local high school, restaurants, and a little movie theater where, when I was fourteen, I saw Adam Sandler in *Billy Madison* four times in one week. And just like main streets across the country, the heart of the town slowly died when bigger businesses like Wal-Mart, Target, Sears, and McDonald's started popping up a mile away, sprawling outward, gobbling up farmland and wooded areas. But twenty years later, in 2014, they all closed too. Sears went bankrupt, Target cited the store as underperforming and included it in series of closings, and Wal-Mart found a bigger, better deal in Johnsburg. The *Northwest Herald* reported on the opening festivities in 2011, noting the "singing of the National Anthem by the Johnsburg Madrigals . . . perked up by the Wal-Mart cheer being led by the employees who had been at the McHenry store since it opened in 1989."[12] Many of the places that housed these businesses, as well as the smaller ones they put out of business, remained vacant for years.

After decades of growth, it felt like the air had been let out. When I visited that same year, the little theater, which had been operating since 1919 before burning down and being rebuilt in the fifties, the same place where I'd seen Adam Sandler on the screen too many times, had gone out of business.[13] It had opened and closed and changed hands many times since the eighties, but considering it along with everything else that had emptied out, the chain stores and mom-and-pop businesses alike, I couldn't help feeling the little town that held so much promise seemed stuck. I stood beneath the empty marquee looking at posters from films that had finished their runs two years earlier, and I thought about Peter Bogdanovich's iconic *The Last Picture Show*, about how the 1971 film set in a small Texas town in the early fifties was a coming-of-age movie, but it was also about the death of the American small town.

The closed theater served as a reminder of McHenry's embrace of big box stores instead of the small, independent businesses on its main street. The sad statues of the lions that looked so much like the ones in *Back to the Future,* a fifteen-minute walk from the heart of the city, serve as relics from the time in the not-too-distant past when McHenry tried to stretch out and grow into the future, when it became suburban.

Some suburbs were designed and built from the ground up to look the way they do, the Levittown idea of preplanned everything: every inch mapped out, houses and trees and yards spaced to specific measurements so buyers feel like they have their own little island just far enough away from the sidewalk and their neighbors. Others, like McHenry, just made the turn: they suburbanized. They weren't planned and built to resemble what we know today as the suburbs, and they feel uneven; sections feel like they're from another time because, well, they are. You'll notice a definite turn—buildings from the nineteenth century and early part of the twentieth century give way to more modern structures, to aluminum siding, nonnative hand-planted trees, subdivisions, cul-de-sacs. In contrast, cities like Arcadia, Arizona, were flattened and built back up to get rid of any sign of the past before the Second World War. In Arcadia, a suburb of both Phoenix and Scottsdale built on former citrus groves, you'll find mostly contemporary homes pushed way back from the curb with stunning views of mountains behind them. You'll see a mix of everything in terms of architecture, from midcentury ranch homes from the early days of the neighborhood to modern takes on Spanish revival architecture that don't always hit the mark. We're told that variety is the spice of life, but in suburbs like Arcadia, the mix is often disorienting. There's not much of a sense of place when everything looks all jumbled. Still, the Arizona real estate website phxre.com compares Arcadia to Beverly Hills and points out that living in the neighborhood "holds a lot of weight if you live within the respected boundaries."[14] Meanwhile the satirical architecture criticism website McMansion Hell's description of Phoenix architecture in general could also sum up the mishmash. Kate Wagner, the writer and

critic behind the site, writes that the state's architecture "is mostly what we in the industry like to call 'hella tacky,'" and she's isn't wrong.[15] Development in the southwestern state is largely a product of the twentieth century, with big influxes of easterners moving to the warmer desert towns with their ideas of what they want their homes to look like as opposed to what's native to the area.

There's no one single way a suburb *should be,* and there's no catchall to describe what a suburb *is.* Despite that fact, we've built suburbia and the suburban lifestyle up to be a monolith in the American mind. The ideas of what the suburbs are and the stereotypes of who lives in them, however, have drifted mostly out of the minds of people living in cities. One of suburbia's harshest critics in the middle of the twentieth century was historian, writer, and *New Yorker* critic Lewis Mumford, who, in his 1961 National Book Award–winning *The City in History,* called the suburbs "a multitude of uniform, unidentifiable houses, lined up inflexibly, at uniform distances, on uniform roads, in a treeless communal waste, inhabited by people of the same class, the same income, the same age group, witnessing the same television performances, eating the same tasteless pre-fabricated foods, from the same freezers, conforming in every outward and inward respect to a common mold, manufactured in the central metropolis."[16]

Culturally speaking, cities were supposed to be the opposite of the suburbs. I was part of that big wave of suburbanites in the 1990s and early 2000s that moved back to the cities my family had moved away from, looking for something different. Yet in 2014, over fifty years after Mumford's book, a *Brooklyn Magazine* article shows just how blurred the lines may have always been, or at least how blurred they've become. The headline asks, "Is Brooklyn Just Another Suburb?" and writer Kristin Iversen points out that technically, yes, Brooklyn started out suburban, with the posh Brooklyn Heights neighborhood being considered the first American suburb. It's the trend of the more recent "mall-ification" of Brooklyn and other cities that Iversen finds disturbing. Even though the borough started out as suburban, it's not a specific place that represents suburbia. Rather, she writes that "in the greater

cultural consciousness, 'the suburbs' are a place from which you escape; they represent conformity, repression, and banality." Iversen cites things like lower population density, chain stores, ubiquitous cars, as well as a dearth of cultural and economic diversity. Echoing Mumford, Iversen writes that the suburban way of life is "conformity to the banal." She goes on to say that it's the fragmenting of "the collective attitude that we are part of something larger"; that it's about anonymity; that you're invisible in places like Brooklyn unless you can afford it. "This is what we talk about when we talk about the suburbs, and this is more than just about where we live: it's about how we live, and how that way of life is disappearing. Maybe for good." [17]

The concept of getting out of the city is hardly a new one, and it isn't an American idea: America just did what America does and eventually mass-produced suburbia and made it available to more people. Wealthy Babylonians had rural places to escape to outside the congestion of the urban center, while the upper crust of Roman society built vacation villas around the city walls. The poet Martial retired to one such villa to write some of his *Epigrams,* mentioning "all the cool suburban haunts of Rome."[18] The Russians had dachas in the country, and French nobles built hamlets on the outskirts of cities before the Reign of Terror. It could be said that the British pioneered the modern suburban way of life we know today: again, it was the wealthy citizens of congested, smoke-and-soot-filled Industrial Revolution–era cities like London, Birmingham, and Manchester who could leave behind the sordid conditions and cast of Charles Dickens characters for country life.

Americans would soon catch on. By the middle of the nineteenth century, residents who could afford it started escaping New York City, Philadelphia, Baltimore, and other big cities. Affluent Americans, inspired by the lush country homes outside London, the garden city movement founded by Ebenezer Howard, and the British arts and crafts movement, also looked to build something beautiful outside cities. The irony here is if you study the work of people like Howard, or of writers and designers associated with the arts and crafts movement, you'll often find not only

a search for balance and harmony between human and nature but also between humans. While William Morris may be best known today for his wallpaper designs, read his *News from Nowhere* and you'll find a picturesque place in this work of socialist utopian fiction that feels a million miles away from the city. It's a place that isn't quite rural, but where humans have learned to find balance between the modern world and the natural one. It wasn't what the suburbs would become, but it gave designers who came after Morris and Howard a template to work with.

While there were always limitations on who could live in these sorts of places—often depending on their financial situation, the color of their skin, their religion, or other factors—the oddest thing about the suburbs is how steeped in utopian ideas they are, a fact that's become harder to see and understand in this modern era. Ideas that were once revolutionary were sanitized and packaged, becoming commonplace today. People long for peace and serenity in suburbia, but they often end up disappointed. And that disappointment manifests in various ways.

The sale of the American suburb—whether it be Brooklyn Heights before the Civil War, a rural place like McHenry that saw its future as a suburb, or Arcadia, which flattened out its past to build something new—has always been future thinking, focusing on the possibility of what could be, of a better life. Yet it feels as if we're still waiting for that promise of the suburb to come to fruition.

Instead of the better tomorrow suburbia promised, we're told that the suburbs are "uniform" and "banal," a middling wasteland for the blissfully apathetic. We got mundane; we got disillusionment and darkness; we got weirdness. It's easy to say these are all just abstract ideas, but the way they've manifested in our collective consciousness refutes that: these ideas have also materialized into great art. It's Shirley Jackson writing about "people starting to come apart" in the suburbs in her short story "Pillar of Salt." It's the horror that lurks beneath the streets in Stephen King's *It* or in the bad part of towns imagined by David Lynch. It's Régine Chassagne of the band Arcade Fire singing

about how "living in the sprawl . . . dead shopping malls rise like mountains beyond mountains" on an album titled, simply, *The Suburbs*. It's the teenage protagonist in Greta Gerwig's *Lady Bird* looking to turn her back on the Sacramento suburbs where she grew up and on her family struggling to make ends meet so she can go to college somewhere "with culture." It's African Americans fearing they'll fall into their own "sunken place" in the white suburbs of Jordan Peele's *Get Out*. It's that shot of Marty McFly going home to his sad little subdivision in *Back to the Future*.

How did we get here, and how can we do better?

If You Build It, He Will Come

"Man plans and God laughs" is one of the most famous Yiddish phrases to make it into English, and Zion, Illinois, has always been a city of big plans.

On the surface, Zion looks like any other suburb, one that's nearly tripled its population since 1950, that touts its "Historic Past . . . Dynamic Future" on the sign that welcomes you to town. Yet growing up driving through Zion on trips into Wisconsin, I could never shake the feeling there was something off about the place. Yes, I'd grown accustomed to the feeling of space, the idea of suburbs being spread out, but I couldn't put my finger on why Zion felt so different from preceding Illinois cities that brush against Lake Michigan. The line of places that make up the more affluent North Shore terminates once you cross from Lake Bluff into North Chicago, where the Naval Station Great Lakes is located. Between the sailors, the eastern European immigrants who settled there, and later the African Americans who made the area their home during the Great Migration, wealthy white people were fine ignoring everything from North Chicago all the way up to the tip of Wisconsin, where Zion is the last city of over ten thousand people before you cross the border. North Chicago, Waukegan, and Zion are just as much part of the northern shoreline as nearby places like Lake Forest and Highland Park, but they're not North Shore.

Zion, to its credit, has had a few eventful moments, attempts to do something big. From 1973 to the day it was decommissioned in February 1998, it was home to the Zion Nuclear Power Station. Opened as part of nuclear energy's glowing, postwar promise of peace and prosperity, it spawned several local legends I heard growing up: accident cover-ups or how terrorists wanted to blow it up, and how, since I lived about thirty miles away, that I'd inevitably die in the blast.

Before the power plant was shut down, Zion also had two brushes with rock stardom. The first came on August 1, 1981, when a new thing called MTV made its debut. The twenty-third video the network ever aired, wedged between Robert Palmer's "Looking for Clues" and the Stevie Nicks and Tom Petty duet "Stop Draggin' My Heart Around" was "Too Late," a track by local power pop band Shoes.[1] Fifteen years later, another local band would gain national exposure when the song "Bound for the Floor" by the Zion band Local H made it to the fifth spot on the Billboard Modern Rock Tracks chart. It didn't exactly earn the town the moniker of Zion Rock City, but that's not a bad track record for a suburb.

I'd say Local H's big hit was one of the best songs you could hear on the local alternative radio station around 1996, with its crunchy guitar and lyrics railing against a person who just accepts everything, trying to keep it "copacetic," the best instance I can recall of that word appearing in a hit song. All that, and it's just two guys making all the noise. The song has always sounded familiar to me. It's the angsty and angry feeling brought on by a kind of disillusionment people sometimes feel in the suburbs. And coming from a place like Zion, where hopes and promises seem to go to die, that attitude makes sense.

The band is still around today, still playing and putting out records. Yet they had only that one hit. I wonder how much coming from a small Illinois suburb one rock magazine called "unassuming" held them back. The two-piece had plenty of great songs and could play alongside any band of the day operating under the grunge label, like Alice in Chains or Screaming Trees. But unlike those bands, which all hailed from the then–rock capital of Seattle, Local H really felt like they came out of

nowhere, because on the United States of Rock map, Zion *is* nowhere. Listening to them today, that's what sets them apart—their suburbanness. I'm not sure they could've come from anywhere else, and that's why I think they stand out among those midnineties bands.

After the nuclear power plant closed in 1998, taking with it jobs and half of the property-tax base, Zion felt like a dying town in the shadow of the two tallest structures in Lake County, those sleeping nuclear towers. It was the kind of place Bruce Springsteen would've written a song about if he were from Illinois and not New Jersey.

"We are," the town's mayor at the time, Al Hill, said, "a nuclear waste dump."

There were plans for a comeback, though. Zion's next big moment would come on May 28, 2009, when a small announcement in the "Also . . ." part of the *Chicago Tribune* sports section mentioned that "the Northern League team owned by a group led by actor Kevin Costner announced it will be known as the Lake County Fielders," and that the team would make its home in Zion.[2] Team president Rich Ehrenreich said the name was picked because it conjured up the "nostalgic, Midwestern image we're trying to capture." That, and there was the not-so-subtle nod to one of Costner's most famous films, *Field of Dreams*. The promise of the team came with $750,000 in added annual revenue for the city, three hundred new jobs, and, best of all, the state-of-the-art, $15 million, five-thousand-seat Fielders Stadium, the future jewel of Zion. This was going to change everything. "Sometimes God just smiles," Delaine Rogers, a native of the city and Zion's economic development director, told the *New York Times*.[3]

Unfortunately for the team and the town, a smile often precedes a laugh. Before the inaugural season in 2010, the Fielders announced they were downsizing their plans for a stadium. By 2011, Grand Slam Sports and Entertainment, the team's parent company, filed a lawsuit against the City of Zion asking for over $10 million in damages, claiming that the city lied to the investors about its intent to actually build a field, that they went as far as putting up a construction fence to make it look like there was building happening.[4] The lawsuit was dropped

in 2015; the company got $55,000 three years after the team ceased operations in 2012.[5] In 2017, what was left of the dream of the Fielders was selling for scraps: the city council approved plans to sell millions of dollars in lights and eighteen acres of the unfinished sports complex to the right developer.[6]

The whole Fielders debacle was sad and embarrassing on a local level. The literal field of dreams wasn't going to make Zion some big player in the world of professional sports, but it would have given a city that was rattled by the closing of its nuclear power plant and the 2008 financial collapse something to cheer for. In the grand scheme of things, Zion was built on big promises that never came to fruition. The Fielders stadium was three miles away from where John Alexander Dowie, founder of the evangelical Christian Catholic Apostolic Church, built Shiloh House, the twenty-five-room, Swiss chalet–style mansion that served as his headquarters in the middle of Zion, the town that Dowie, a Scottish-born faith healer, founded in 1901 for his followers to worship and work in. The controversial Dowie claimed to have cured everything from diphtheria to cancer, and he built a following of thousands. With his long white beard and proclamation that he was Elijah the Restorer, people truly believed Dowie could be the one to bring the second coming of Christ. A forebearer to Pentecostal preachers like Oral Roberts and Jimmy Swaggart, he asked his followers to give him their faith as well as their dollars, and he used that money to support a luxurious lifestyle. One newspaper account points to his stable of horses "worth a fortune themselves," and notes that when he traveled, "hemmed round with a little army of liveried servants, the prophet of humility and self-denial has a special train chartered, and whenever spiritual burdens become too great a tax there is a delightful country residence belonging to him in which to retreat from the clamor and importunate appeals of the faithful."[7]

After becoming a celebrity in Chicago, making his name staging public healings at the 1893 World's Columbian Exposition, he founded the Christian Catholic Apostolic Church in Zion in 1896. With everything from a printing business to a college connected to the church and

a growing number of followers, the only thing left to do was move them out of the city to a place where they could work and worship. Every donation went straight into Dowie's pockets. In 1900, he bought up land about forty miles north of Chicago and told his followers to put all their money into Zion Bank, pack up their things, give up their old lives, and live a more holy life in Zion.

Zion wasn't all that different from the company towns built and owned by Andrew Carnegie, Henry Ford, and George Pullman. Everybody who lived there worked for and gave their money to Dowie. He ran the schools and owned everything from the bank to the lace factory he imported from the u.k.[8] Dowie also wrote the city's laws according to his own interpretation of biblical scriptures: No smoking, drinking, swearing, or gambling was allowed in Zion. Neither was eating pork or practicing modern medicine. Oh, and you had to believe that the earth was flat, a law that stayed in effect until the forties.[9] The drinking ban stuck around until locals voted to lift it in 2004, making it one of the only dry towns in the region. Yet Zion's association with the idea that the world was flat really picked up in 1923 when Dowie's predecessor, Wilbur Glenn Voliva, started wcbd, making him the first preacher to own his own radio station.[10] He believed that Zion was just the start: "I shall eventually evangelize the rest of the United States and Europe," he claimed. Since Voliva was an early pioneer of radio, he was also one of the first—if not *the* first—people to use the young medium as a way to spread the idea that the planet was really the shape of a pancake, a belief that remained in the town charter until the forties. Still, other preachers followed his lead and took to the airwaves, most notably Father Charles Coughlin, who would broadcast from his Shrine of the Little Flower in the affluent Detroit suburb of Royal Oak, where he'd spew his anti-Semitic conspiracies to countless listeners throughout the thirties.

But times changed. While Dowie's flock reportedly reached into the tens of thousands, just a century after his death his church was renamed and the number of followers in North America hovered around three thousand. The town he founded, which traded religion for the

hopeful glow of nuclear energy, was left dark and searching for a resurrection of another kind.

Man plans, and you know the rest.

The story of the birth and early growth of America is an assortment of tales of our heroic founding fathers. You grow up hearing them not realizing many of them are embellished and omit the sad truth that America wouldn't be the country it is today if people hadn't been uprooted from their homes, enslaved, killed, or forced to assimilate into what the young country believed to be its culture.

The stories of the founding of early American suburbs, which started popping up in the early nineteenth century, on the other hand, aren't usually as eventful or traumatic. Some suburbs just evolved. Take King of Prussia, Pennsylvania, which started out as an inn founded by Quakers in 1719, eventually turning into a popular tavern that George Washington visited. Today it's a census-designated place with its own zip code that is mostly made up of a mall that takes up 2.9 million square feet. The earliest suburbs, like the "middle-class paradise" of Brooklyn Heights, which started developing in the 1820s, were places where residents could work in the city by day, then jump on the ferry and be home to their peaceful, clean neighborhood in an hour.[11] The suburbs were often a creation of convenience, especially as steamboat and railroad travel replaced commutes that otherwise would have been made by horseback or carriage. By the end of the Civil War, new areas opened outside major cities. John D. Rockefeller and Jay Gould built their grand mansions outside New York City, in Westchester County; the Country Club was founded in 1882 outside Boston, in Brookline, as a social club and place to ride horses. A decade later, they'd introduce golf, one of the activities that would become synonymous with suburban life.[12]

Religious groups, too, were moving farther away from the cities to establish new places where they could worship, work, and learn. In 1851, a group of Methodist businessmen founded Northwestern University; Evanston, Illinois, would be built around it. As a sort of response,

Presbyterians built Lake Forest College a few miles north in 1857, and the city of Lake Forest was planned around it with the help of landscape architect Jed Hotchkiss, who had been suggested by none other than Frederick Law Olmsted and Calvert Vaux, who had their hands full trying to win the rights to design Central Park in New York.[13] Tranquil and secluded with ravines and grand bluffs overlooking the waterfront (the kind you associate more with New England or the Scottish Highlands than the middle of America), the land was given up by the Potawatomi tribe when they were forced to sign over everything at the end of the Black Hawk War. Hotchkiss sculpted and manicured a place that struck a balance between humans and nature. Natural trees stayed in place, as did the bluffs and so much of the forested areas that helped name the town. It was paradise, a Romantic painting come to life, a place where harmony could be achieved and God could hear you better without all the noises that come with living in the city. But by the end of the Civil War, with some investors backing out, Lake Forest started letting outsiders into the quiet little world, and by the end of the nineteenth century, the small city had gone from a cozy place for Presbyterians to live and worship to one of the most desired areas in the entire region.

Even though Zion is about an hour north of Evanston and fifteen miles from Lake Forest, and even though all three were built by religious leaders along Lake Michigan, the two cities feel worlds apart from Zion. The originally self-sufficient Zion, for one, was, at best, what McDonald, Ohio, was to the Carnegie Steel Co., or like George Pullman's company neighborhood in Chicago: a place one person lorded over, controlling nearly every facet of its residents' daily life and finances. A more honest way to put it was that it was a scam. The initial goal of Evanston and Lake Forest, on the other hand, was to educate and elevate the spiritual lives of their residents.

In much of art and literature throughout the nineteenth century, the search for the connection between humans, nature, and the divine in the middle of the Industrial Revolution is a typical subject. In America, rapid expansion and the Civil War sent people looking for answers.

Some practiced art or literature, others practiced old religions, while some found new, different ways to worship. However they were coping with the times, people were leaving cities, moving to the borderlands and beyond, looking for salvation.

Members of the Hudson River school, for example, painted landscapes that looked the way they might have imagined heaven. Thomas Cole's most famous work, *The Course of Empire,* depicts the building of a civilization over five paintings, with the second, *The Arcadian or Pastoral State,* the most tranquil of the group. By the fourth and fifth (*Destruction* and *Desolation*), the empire falls because it betrayed its bond with the natural world—a warning for America as it tried to get through its first full century. Henry David Thoreau noted, "My profession is always to be on the alert to find God in Nature, to know his lurking-places, to attend all the oratorios, the operas, of nature,"[14] and Emily Dickinson wrote in her poem "Some keep the Sabbath going to Church":

> Some keep the Sabbath going to Church—
> I keep it, staying at Home—
> With a Bobolink for a Chorister—
> And an Orchard, for a Dome—
>
> Some keep the Sabbath in Surplice—
> I, just wear my Wings—
> And instead of tolling the Bell, for Church,
> Our little Sexton—sings.
>
> God preaches, a noted Clergyman—
> And the sermon is never long,
> So instead of getting to Heaven, at last—
> I'm going, all along.[15]

People were looking for heaven on earth. The populations of New York City, Boston, Philadelphia, and Chicago swelled to once-unimaginable

numbers. Cleveland, for instance, started the 1800s with under a thousand residents, but saw a 464.7 percent boom between 1830 and 1840 after the completion of the Ohio and Erie Canal. By the turn of the century, 381,768 people lived there. Getting out of the city was a trendy luxury, but for some, it was also an attempt at living a spiritually fulfilling life on earth.

As the new country grew, it also saw many small communistic societies setting up far away from the hustle and bustle. German Pietists who fled their home country and the dogma of the Lutheran church and called themselves Wahre Inspirations-Gemeindeds (Community of True Inspiration) set up a community outside Davenport, Iowa; the Harmony Society built little towns in Pennsylvania and Indiana; and, most notably, Mormons founded Salt Lake City in 1847. John Humphrey Noyes's Perfectionist group built a small community in the middle of New York where they shared everything, including spouses. The group, known as the Oneida community, also instituted a eugenics program known as stirpiculture, with members going before a committee where they'd be matched with a mate in an attempt to give birth to "more perfect" children. In a country that was founded by people looking for the liberty to practice their religion, these people felt they had to go even farther to freely practice their beliefs.

Some practitioners of Spiritualism also believed communicating with spirits could be accomplished more easily outside cities; ghosts hate all the loud noises just as much as the living do, one would assume. Throughout the century, small communities started popping up far away from urban areas, most notably Lily Dale in New York, an hour south of Buffalo, and Cassadaga in northeastern Florida.

Get out of the city and not only will you be healthier and happier, but you'll also be closer to the heavens. The people who founded Evanston and Lake Forest felt that, and the people who followed Dowie to Zion believed it. Llewellyn Solomon Haskell also believed that. And his belief that building a perfect place for people to live harmoniously with nature on earth—in New Jersey—would help bring about the Messianic Age and shape the American suburbs as we know them.

Today, Llewellyn Park is still a painting come to life—at least that's what I'm told by the people I've talked to who have been there. I've never actually been in the gated suburb. Lord knows I have tried, but it was designed to keep people out. Approaching the entrance from Main Street in West Orange, New Jersey, you can't help thinking there's something they're trying to hide from the rest of the world, everything shaded and obscured by acres of trees. That's probably why Thomas Edison, members of the Merck, Stetson, and Colgate families, politicians, and Whoopi Goldberg have been among the neighborhood's residents, and why there are, according to one person across the street at Edison's laboratory, "lots of people that don't want you knowing they live there."

I don't think there's anything that ominous about Llewellyn Park, but I can understand why, in the twenty-first century, when you can pretty much find out anything about anybody, there's something off-putting about a community that goes out of its way to stay hidden. According to the locals I talked to in West Orange, the people who live in Llewellyn Park do their own thing. Nobody I spoke with knew much about the residents or the community, save for a park ranger who told me all about Glenmont, the Llewellyn Park Queen Anne mansion Edison bought from its original owner, Henry Pedder, after Pedder was convicted of embezzling money from his company and went to prison. Edison purchased the twenty-nine-room home fully furnished in 1886, six years after it was built, for $125,000. But besides that, I have to go by the pictures I find online to know that, yes, Llewellyn Park is still green and picturesque. Gas lamps designed to look like they're from the 1800s still line the streets. The homes are all magnificent. Judging by what you can find online, it's quiet, and neighbors are friendly toward each other. There's still a Ladies Association that gets together to plan the yearly Easter egg hunt and Victorian picnic. It's "a country Utopia" that is "surrounded by development, yet remains a sanctuary from the city," according to the website. It's very beautiful, peaceful, and expensive, but maybe not quite the "dream" its founder had in mind.

Haskell, a New York City businessman and owner of a firm that imported and manufactured pharmaceuticals, suffered from rheumatism,

so his health played into his stealing away to Orange on the Morris & Essex railroad line from Manhattan to the nearby farming community. Haskell's upbringing could've also played a part in his Jersey getaways. Born in New Gloucester, Maine, a bucolic New England town thirty miles north of Portland, he preferred to live on the outskirts of Philadelphia and New York when work necessitated he be there. But there was also something beyond the cities that Haskell thought he could find, something more than just clean air and quiet: God.

The tower in what today is known as the town of Kearny isn't there anymore. It was said that when it stood, you could see the Brooklyn Bridge and Statue of Liberty from the top of it. When an article on the tower appeared in the September 1, 1887, issue of Patterson, New Jersey's *Morning Call,* it noted that the curious structure "is of brick, over ninety feet high, and is built in a tubular form. Its breadth at the base is sixteen feet, but towards its top the tower is tapered." One resident told the paper that construction on the building began in 1843; over forty years later, as the newspaper noted, it sat vacant, "and the elements have since made sad havoc of the place."[16] By the turn of the century, what was left of the building was torn down.

While the *Morning Call* article noted that Haskell was considered "much esteemed," a man who had "fine taste and ample means," the townspeople couldn't get over how he was "odd and fanatical in religion," and that he'd built the tower "to reach heaven." Haskell, a Millerite, followed the teachings of the Baptist lay preacher William Miller, who told his followers that through his studies of the prophet Daniel, he could pinpoint the Second Coming of Jesus Christ to October 22, 1844. The day came and went with no resurrection of the dead, no rapturing of all the saints, and no Jesus coming down from the heavens. What followed is known as the Great Disappointment: Some of Miller's followers carried on his beliefs, becoming what we know today as Adventists. Others turned their backs on their former spiritual leader. A few, like Haskell, continued to hold out for Christ's return in their lifetime, believing the original date was a simple misprinting or miscalculation. On one of the

newly revised dates of the resurrection, in 1845, Haskell and his family climbed to the top of the tower in spotless white garments, the wind howling as they waited until midnight for Gabriel's trumpet to blow, but they got nothing but the wind whipping across the trees. As the story goes, two of Haskell's children died soon after they came down from the tower, having caught severe colds. As the townspeople told it, every evening after that, his wife, Mary, would climb to the top of the tower to communicate with the souls of her dead children. Not long after, the Haskells also turned their backs on Miller, looking instead to the burgeoning practice of Spiritualism and holding regular séances in the mansion on the grounds where the tower stood.

Whether or not the Haskells were still holding séances a few years later isn't easy to figure out, since Spiritualism was an informal movement that many kept quiet about. And the exact time Haskell began associating with the religious group known as the Perfectionists isn't easy to figure out either. But it makes sense that a person who was obviously looking for guidance believed that perfect living could help bring about a perfect existence on earth as well as the Second Coming Haskell was obviously very invested in helping make happen. Perfect living, Haskell thought, meant living your mortal life in a perfect house surrounded by the perfect setting. This belief would lead Haskell to purchase woodland on the eastern slope along the first ridge of the Watchung Mountains in the early 1850s. It was there, among the running streams and lush natural foliage, that Haskell set out to build his utopia, one of America's first planned suburbs, Llewellyn Park. While there were places like Brooklyn Heights and the horse-and-streetcar suburbs that dotted the North American map from Massachusetts to Ohio, Haskell's idea was something different, with something bigger in mind than earthly comforts.

Today, the suburb still has winding roads, ponds, and lots of trees— many of the things you'd find in today's upscale suburbs, the kind that are direct descendants of Llewellyn Park.[17]

Humans have tried to find ways to show where the divine and nature meet for as long as we've been explaining things to each other. Prophets wander in nature to connect with God; you can read it in the

philosophy or poetry of any era and see it when you walk through the Louvre in Paris, the Met in Manhattan, or nearly any museum throughout the world. It's a Ming Dynasty painting of a poet atop a high cliff or, similarly, Caspar David Friedrich's *Wanderer above the Sea of Fog* from the Romantic era, each depicting a person in a similar setting searching for something nearly impossible to touch, but they know it's out there. The naturalist John Muir wrote, "God's love is manifest in the landscape as in a face."[18] Llewellyn Park, where Haskell saw the natural world as a heaven on earth, was designed with similar intentions. With its impressive fifty-acre common space known as "the Ramble," roads canopied by trees, and Victorian-era splendor juxtaposed with nature, it's easy to look at things from his point of view. It was built to connect humans to the heavens.

Maybe the most famous structure in the neighborhood is one Haskell himself lived in. Castlewood is exactly as the name implies: an American castle. It's maybe not as big as what you find in England, but it's imposing.

Yet Llewellyn Park was more than just a church in the wild for Haskell, a person who was obsessed with the Second Coming. That's the idea of any follower of any messianic religion, right? You *want* to see the savior come during your lifetime. The difference here is that not everybody has the means or the ego to think they can make it happen by building a small community themselves.

But it was also an investment. People had to buy property for it to work, and the sort of people who did end up moving to Llewellyn Park were an assortment of folks described as odd. Artists and people with long hair are described in some reports from the era. The neighborhood helped give way to the modern creation of the planned suburb, but it was also an early "hip" area. Nearly two hundred years before cool young people with the means to do so started seeking out places like Brooklyn, Los Angeles, or Austin as a destination, their nineteenth-century counterparts moved to the suburbs.

Haskell, however, didn't get to live out his last years in his creation. Instead, he made his way out west, to California, supposedly depleted

of funds after sinking it all into his dream neighborhood—although some kinder accounts say he simply retired.

But Llewellyn Park lives on. Its legacy as the picturesque type of place so many developers would replicate, as well as its gates that kept the rest of the world out, remains to this day. And fittingly, Castlewood, Davis's spooky castle, turned into a legend straight out of a ghost story, the sort of place that would make the perfect setting for an Edgar Allan Poe poem. By the middle of the twentieth century, it had fallen into disrepair and was abandoned, boarded up, the yard gone to seed. Of course, a forgotten castle in suburbia inevitably gets the haunted house tag applied to it. The belief that ghosts roamed the cobweb-covered halls lasted well into the seventies, when businessman and president of the New Jersey Senate, Frank J. Dodd, restored the home and started throwing lavish parties that spilled out onto Castlewood's enormous lawn.

Today, Castlewood and the exclusive neighborhood it resides in are both in the news for being a little *too* exclusive. Trying to sell a home in the neighborhood is often a chore. Castlewood itself was the subject of a 2008 *New York Times* article on the "Ins and Outs of Castle Selling." Of course, this was 2008, the height of the subprime mortgage crisis and the beginning of the recession, so the climate to sell just about any property was terrible, and trying to unload a castle was pretty much impossible. It was made even more difficult because the Castlewood open houses in the notoriously private neighborhood were actually open only to brokers, not to potential buyers. "We live on sort of a fantasy island here," the castle's owner, Anthony J. Ferrara, a retired oral surgeon, said of the property he was trying to unload for $2.5 million. "It's incredible—the woods, the gardens, the architecture, the history—but not that many people know it's here."[19]

Today, Zion and Llewellyn Park are polar opposites. When I ask a friend who lives in Illinois about Zion, he says, "That's just a town you go through on your way to Wisconsin." In many ways, Zion resembles the fictional town of Springfield from *The Simpsons*—if it had kept the

power plant and minor league baseball team. It's a place with a weird past that always seems to have potential it never fulfills, where over 10 percent of the more than twenty-four thousand residents live under the poverty line. Homes in Llewellyn Park, meanwhile, tend to go up for sale and sit for a bit, the asking prices for homes usually starting at a million. As one broker said in a 2005 article looking at the community's crisis of wondering if it's "too private" to grow, "Everybody loves the fact that Llewellyn Park is the world's best-kept secret—until it comes time to market a house."[20]

There are worse problems to have, of course, than not being able to unload expensive property. And the founders of the two suburbs, Dowie and Llewellyn Solomon Haskell, seemed to have different motives for founding their communities. Dowie was a huckster, a cult leader who profited off his followers, while Haskell seemed lost, just a rich man looking for spiritual fulfillment. But their fates seem similar. Both men died in relative obscurity, with Haskell supposedly blowing his fortune on his grand idea and Dowie usurped by his second-in-command, Wilbur Glenn Voliva, after suffering a stroke in 1905. He'd spend the next two years trying to take back his power, but the church fell back on the claim that over three million dollars was unaccounted for, and that Dowie, who lived like a king off the money his followers gave the church, was responsible. He'd die in 1907. In 1942, Voliva, dying of cancer, admitted to his followers that his own lavish lifestyle was indeed thanks to his misappropriating funds. By the end of the forties, the church's following was almost totally gone, but Zion, a religious company town propped up by businesses connected to the church, making everything from lace to chocolate, found itself searching not for God, but for a new identity.

There was something in these places, that promise of not just spiritual fulfillment but of playing a part in great big biblical things just by living and contributing. It's trying for literal Utopia, spiritual enlightenment through good landscaping. That was the goal of places like Llewellyn Park and Zion, and that hope of finding something—maybe not as big as seeing Jesus descend from heaven and walk across your

lawn—is what modern suburbia is still all about. It may not be religious, but the modern suburbs, the places that came after the Llewellyn Parks and Zions, are often sold as places where the chosen few can get a little closer to fulfillment.

Not Allowed

If you grow up in the Chicagoland area, you know the suburb of Highland Park for concerts and bar/bat mitzvahs. Concerts because, since 1904, everybody from Ella Fitzgerald to Janis Joplin, Cat Power, John Legend, and Frank Zappa has taken the stage at Ravinia, the oldest continuous music festival in the u.s., which runs from the start of June until September. And the ancient rite of passage for thirteen-year-old boys and twelve-year-old girls because the town has been home to a sizeable Jewish population since around the start of the twentieth century, when a prominent German-Jewish family built a summer retreat on a small stretch of land. When Jews were largely shut out from owning property or joining clubs along Lake Michigan, Highland Park was one of the few areas they could turn to, transforming it into a vacation destination and later a thriving Jewish town.

Highland Park is also known for beautiful buildings and homes that span different architectural styles of the twentieth and twenty-first centuries and mesh seamlessly. These include Frank Lloyd Wright's Willits House and Mary W. Adams House, the International Style Henry Dubin House, and the modernist Ben Rose House built by A. James Speyer in 1953, better known as the glass home the 1961 Ferrari 250 GT California Spyder crashes out of in the John Hughes classic, *Ferris Bueller's Day Off*.

Like its counterparts along the lake, Highland Park is a beautiful town where the median household income is high ($137,450),[1] the schools are good, and, as it goes in other affluent neighborhoods, nothing too exciting happens, because that's what people pay big money for. So when, in November 2013, one of the biggest names in hip-hop moved into a 5,600-square-foot home on a cul-de-sac off Ridge Road, it became the last thing neighbors wanted: national news.

When he moved into the neighborhood, Chief Keef, who was still a teenager at the time, was in the news almost daily. Just two years earlier the controversial rapper, born Keith Cozart, had graduated from underground sensation who got kicked off Instagram for posting a photo of himself getting oral sex, to the subject of a label bidding war that eventually saw him sign with Interscope for $6 million. After that, it was a guest spot on one of the best tracks off Kanye West's *Yeezus,* a place in *XXL* magazine's 2013 Freshman Class, more music, and jail time for the rapper born and bred on the city's South Side. Things weren't safe for him in the Englewood neighborhood where he'd grown up, so his management team rented the Highland Park home, and things escalated quickly.

Even before he moved in, the rapper was clocked doing 110 mph down Winnetka Road in a BMW X6 M.[2] After he moved, there were noise complaints almost immediately. Residents alleged Keef, who also goes by the name Sosa, rode dirt bikes and other ATVs up and down the streets with his crew by day and threw wild parties at night. Another big issue, as one resident put it, almost poetically, was that "when the wind comes from the west, one can smell the dope being smoked" in the home.[3] What was maybe just as bad was the attention it brought to the neighborhood. Fans and friends would routinely show up. *Vice* magazine sent a camera crew to film Keef and his friends hanging out at another nearby McMansion that a member of his crew was renting. A picture of the rapper sitting on an ATV with a group of young, mostly white girls popped up on social media. Locals were outraged.

There isn't much crime in Highland Park. Reports show that in 2014 there were no murders (continuing a trend going back to 2003,

when there was 1), 3 robberies, 11 assaults, and 277 thefts.[4] It's a relatively safe, quiet town, with bluffs overlooking the beach and breathtaking views of Lake Michigan. I counted three Starbucks last time I drove through. It's home to the North Shore Yacht Club and is made up of 91 percent white people.[5] Put all those things together, and you get a sense why Highland Park residents weren't exactly happy about a celebrity moving in. And not just any celebrity—a rapper from the South Side. Chief Keef was a black man in a very white town. From the start, you had the feeling things wouldn't end amicably.

The neighbors who lived near Keef's manager, Uncle Ro, in nearby Northfield, a neighborhood with demographics similar to Highland Park, were also unhappy, and they let the local authorities know it. In emails to the Village of Northfield, residents complained about the "public nuisance" and told the city to "get these thugs out." One resident suggested parking a police car outside Uncle Ro's house twenty-four hours a day "to deter the nuisance and drive them out."[6] Things only got worse after Keef posted a photo on Instagram showing him aiming a machine gun and another guy standing next to him holding an AK-47. Not long after, there was a nonfatal shooting incident in Uncle Ro's home. The rapper was questioned but not charged with any crime. Still, residents weren't pleased. "We all knew that something bad was going to happen at that house, but I still can't believe it is happening in my neighborhood," one said.[7]

By June of that same year, it was all over. Reports broke that Chief Keef owed $30,000 in back rent and had been evicted from his home. Officers from the sheriff's department ushered him out of the McMansion early one morning.[8] A month later, on July 14, he posted a picture on Instagram where he's looking out at a pool. The caption: "Fuck Highland Park I'm In Cali Wit It."

Drive along what's considered the true the North Shore—from Evanston to Lake Bluff—and you'll notice that each part has its defining features: Evanston is literally a college town. Winnetka has a winding, scenic stretch of Sheridan Road that locals call "the ravines." Lake Bluff

trades on small-town charm with its annual "It's a Wonderful Life . . . In Lake Bluff" celebration every December. Lake Forest is sort of the grande dame, with its old mansions and connections to American icons, from Frederick Law Olmsted designing some of the landscaping to F. Scott Fitzgerald, who based many of his characters after a girlfriend from there. Just the general look and atmosphere makes outsiders feel like they don't belong. It was what the founders set out to do when they selected the land, and the feeling of exclusiveness lives on. It's also what defines its neighboring cities.

While it's often difficult to separate fact from fiction—what Chief Keef did in the Chicago suburbs and what neighbors *thought* was going on—the undeniable fact is that Chief Keef is a black man, and there aren't a lot of black men in Highland Park. The same goes for Glencoe, Wilmette, and just about every part of the area (save for Evanston, which has a relatively more diverse makeup than other parts of the North Shore).

The area's very white, which for Lake Forest and other neighborhoods that followed was part of the plan. For nearly a century, "gentlemen's agreements" kept not only black people from living or owning land in Lake Forest but Jews and immigrants as well.[9] While places like the nearby village of Kenilworth were explicitly founded on ideals of "large lots, high standards of construction, no alleys, and sales to Caucasians only," it was more of an unspoken rule in Lake Forest.[10] But those who weren't allowed there, for the most part, knew. One 1898 *Chicago Tribune* article, with the headline "Dinner in Dixie Style," makes it all too clear what kinds of people lived in Lake Forest. The article describes a party held at the Onwentsia Country Club just a few years after the end of the Civil War, a "plantation dinner" the newspaper describes as being "as novel as it was interesting." The menu included fried chicken, roast suckling pig, hominy cakes, and watermelon, all served by "little negro girls." After the meal, guests were treated to "a program of 'coon' songs and acts."[11] Incidents like this gave Lake Forest a reputation of sorts. It became known as a sundown town, a place where minorities couldn't buy a house, join some of the country

clubs, or even set foot outside after dark. A glance at the 1984 edition of *The Forester,* the Lake Forest College yearbook, shows a photo of two white students dressed in blackface at a school dance.[12] According to the 2000 census, Lake County, home to the bulk of North Shore communities, was the richest county out of 102 per capita in the entire state of Illinois. It also recorded 44,741 African American people: 37 percent in Waukegan, 29 percent in North Chicago, 14 percent in Zion, and the rest, 20 percent, falling under "All Under."[13] That's a small number, even less than the Hispanic population, which fell under the same category at 34 percent. Lake County is a large place, counting 703,520 people living there as of 2017. Most minorities live in three places, and the rest are scattered about. Even today, very few live in Lake Forest.

So it was probably as much of a shock, or maybe a bigger one, when, in September 1986, a little under thirty years before Chief Keef moved into the area, another famous black man who grew up on Chicago's South Side purchased a sixteen-room, English country–style Lake Forest mansion. When Mr. T moved to Lake Forest, one resident noted, "This is a very conservative area. But I'm sure people would live and let live."[14]

And they did, for about nine months, until the *A-Team* actor, known for his big muscles, gold chains, and mohawk haircut, started doing some unwelcome landscaping.

"The Massacre of Mr. T's Trees," as the local *Lake Forest News/Voice* headline put it, was the opening shot in a war between star of *The A-Team* and his neighbors over the cutting down of a handful of trees he claimed triggered his allergies.[15] More than a hundred oak trees fell in what the *New York Times* (which ran a picture of the actor and the story on the front page of its May 30, 1987, paper) said locals had dubbed the "Lake Forest Chain Saw Massacre."[16]

A big TV action star with bulging muscles and flashy jewelry moving into a posh neighborhood and getting into landscaping disputes with the neighbors might sound like something out of a sitcom.[17] Stuck-up rich locals and a guy who made it good and wants to do things his way is a recipe for rags-to-riches comedic gold like *The Beverly Hillbillies* or *Caddyshack.* It could've been funny, except when you considered who

Mr. T was and where he came from (famous, African American, new money from the South Side), where he was living, and who he was offending (old-money white people living in the area's poshest neighborhood). As with Chief Keef, whether Mr. T was right or wrong isn't the point; they were both outsiders who made it into neighborhoods where the people didn't necessarily think they belonged. While the trope of the outsider—the misfit, geek, weirdo, or whatever other name you can think of—would come to define so many twentieth-century stories of people overcoming the odds and proving everybody wrong, the fact is, suburban outcasts, the original templates for which people did and didn't belong, are much more complicated.

The eighties into the nineties were the golden era for films about suburban outcasts: the punks at T.R. House, an abandoned tract home off the Los Angeles freeway in Penelope Spheeris's 1984 film *Suburbia;* Winona Ryder's Veronica Sawyer in *Heathers* realizing there's more to life than being rich and popular; Johnny Depp as Edward Scissorhands trying to fit into the bright and colorful suburban neighborhood he's adopted into even though he's pale, dressed all in black, and, well, has scissors for hands; Dawn Wiener in Todd Solondz's *Welcome to the Dollhouse;* John Cusack as Martin Blank, who doesn't quite fit into the posh suburban Detroit ecosystem but goes on to great success . . . as a contract killer in *Grosse Pointe Blank*; and so on.

Yet it was the North Shore of Chicago that came to define the suburbs, starting with *Ordinary People,* the 1980 film that would nab Robert Redford the Oscar for Best Director and Timothy Hutton the Academy Award for Best Supporting Actor, as well as the Oscar for Best Picture. Based on the 1976 Judith Guest novel of the same name, it depicts an upper-middle-class Lake Forest family dealing with the aftermath of the favorite son, Buck, dying in a boating accident on Lake Michigan: just ordinary, albeit rich, people in the suburbs whom we watch come apart. It's hard to believe anybody seeing the film would imagine the same Chicagoland area would be fertile ground for some of the most iconic films of the decade, starting with the lesser-known

1983 prep school romp, *Class.* Using Lake Forest and Evanston as locations, and starring Rob Lowe, Andrew McCarthy, and John Cusack, *Class* could be viewed as one of the earliest films of the Hollywood "Brat Pack" of young movie stars who'd rise to fame throughout the decade. A month later, in August 1983, Tom Cruise turned his parents' Highland Park house into a brothel in *Risky Business,* at an address only fifteen minutes away from Chief Keef's eventual home.

But starting with 1984's *Sixteen Candles,* which utilized Winnetka, Glencoe, Evanston, and nearby suburbs Northbrook and Skokie as locations, John Hughes would turn the northern Chicago suburbs into the place people worldwide pictured when they thought of the American suburbs. *The Breakfast Club; Weird Science; Pretty in Pink; Ferris Bueller's Day Off; Planes, Trains and Automobiles;* and *Home Alone* were just a few of the films Hughes wrote, produced, and/or directed throughout the eighties and early nineties, and all were either filmed around the North Shore or set in his fictional suburban Chicago city of Shermer.

While Hughes (who died in 2009) has long been lauded for his ability to portray teenage characters in a more realistic, sympathetic light, his view of the suburbs was also a change, something in line with Norman Rockwell or Frank Capra's vision of Anywhere, u.s.a., where teens cause trouble but never anything *too* bad, and everything works out in the end. That, and Hughes's suburbs are almost entirely white, something his critics still bring up along with other problematic scenes and characters from some of his films, including racist caricatures and date rape jokes. Whether Hughes didn't give much thought to diversifying his portrayal of suburbia or he was just a stickler for details I can't tell you. But as we've seen, he nailed the whiteness of the North Shore.

For years after his last few films trickled out, portrayals of both teenagers and suburbs in American cinema smacked of Hughes. Films like 1995's *Clueless* and 1999's *10 Things I Hate About You* were both set in the suburbs and also featured mostly white casts (although both films had people of color in supporting roles). The same goes for the 2004 film *Mean Girls,* written by Tina Fey and what could be called

a John Hughes tribute. Films about black people in the suburbs didn't really exist, since so much of what we know about the suburbs was based on these fictional versions that truly were made up of mostly white people. It wasn't until 2017 that a film starred a black person in the suburbs and changed the way many viewers saw suburbia: the horror film *Get Out*.

In the movie, which won writer and director Jordan Peele an Oscar for Best Original Screenplay, we meet Chris Washington (played by Daniel Kaluuya), a black photographer dating a white woman named Rose Armitage (played by Allison Williams). Rose comes from a wealthy family who looks to live somewhere on the East Coast, possibly Westchester or some suburb in Connecticut (the film was mostly shot in Fairhope, Alabama, a popular small suburban town), when she and Chris go for a visit. Her family is liberal but say off-putting things about black people; there's obviously something strange about the Armitages and the few black people who work for them. As the film goes on, we find that something very sinister is indeed taking place: the parents run an operation that transplants the brains of wealthy white people into black people to exploit their talents and bodies. The black people, meanwhile, are relegated to a lifetime of mental purgatory known as the "sunken place."

I won't spoil more of the plot for those who haven't seen *Get Out*, but critics saw it as a film that uncovered liberal racism in America; Twitter user @kyalbr drew parallels to Sigmund Freud's 1919 essay "The Uncanny"; Damon Young of Slate saw a parallel between the film and white America's lack of caring when a black person goes missing.[18] Some people called it satire; others compared it to Alfred Hitchcock. "The real thing at hand here is slavery," was what Peele himself said when discussing the movie's underlying theme.[19]

For Nicolas B. Aziz, a writer, performance artist, and New Orleans native, *Get Out* was all too familiar. In my need to read just about everything I can about a movie I like, I found his *Huffington Post* article, "I Went to High School in the Suburb from 'Get Out'—But I Got Out."[20] Aziz writes about attending an all-male private school in the New Orleans suburbs he puts at "90–95 percent white" that produced the top

three National Merit finalists in the state the year before he attended. Aziz points out that, despite test scores showing he was gifted and skipping a grade before he started, he struggled to maintain a 2.0 grade point average at the school and constantly found himself in detention for minor things like unshined shoes or a crooked name tag.

"These struggles severely impacted my identity and confidence as I would frequently come home to my parents and tell them that I was 'inferior' and that they 'had to accept that I was stupid and mediocre,'" he writes.

Thankfully, things turned around for Aziz. He calls Hurricane Katrina "the camera flash that my soul needed to set me on a new path out of 'the sunken place.'" He ended up having to relocate with his family and started at a more multicultural high school, where he flourished both academically and socially.

"I was also able to recognize my true potential and the limitations that certain social constructs such as race can attempt to place on people. This is the type of awakening that many members of the Black community in America need as we work to correct the effects of destructive false narratives born from hundreds of years of systemic transgressions," he writes.

Aziz's essay popped into my mind as I spent an afternoon at the Starbucks Reserve Store that serves shoppers in Lake Forest's Market Square, quite possibly the nicest Starbucks location I've ever visited. It's spacious, with leather seats, fireplaces, exposed brick, and made-to-order pour-over coffee. I looked around the buzzing corporate coffee shop and thought about how I was in the heart of what most people consider your typical American suburban scene, with high school boys in letterman jackets, girls in Ugg boots getting mochas, and moms rocking expensive baby strollers with one hand while they talk about whatever. And every customer was white.

Up until I clicked on the *Huffington Post* article, I never really thought of *Get Out* as a suburban film. I'll admit I have my own biases toward what I will and won't say makes up for the cinematic suburban canon, since I come from the area around Lake Forest, where I grew up

the only Jewish kid in my summer camp for two years, aware of my differences but still believing my little region of the world was an idyllic, wonderful place. And that's not to say it isn't: Lake Forest has one of my favorite public libraries in America, and I love the pot pie at the Deer Path Inn. Walking in the woods by the beach in Highland Park on an autumn day is a must; driving the ravines in Winnetka takes my breath away every time; and I hope everyone can see the Bahá'í House of Worship in Wilmette just once in their lifetime. When I made it out of the suburbs and told people about where I grew up, they would say, "Sounds like a place out of a John Hughes movie."

What makes *Get Out* so unique and important as a suburban movie is that it isn't about setting; there are no townhouses or shots in a mall or anything like that. What the film does is show the experience and the feelings many people of color, immigrants, and non-Christians often connect with suburbia. Some of us could pass just enough to make it through, when the accents and traditions from the old country our parents or grandparents came from finally faded away. Others, like the fictional Chris Washington and the very real Nicolas B. Aziz, didn't have it that way. While the John Hughes image of suburbia is just as ingrained in the American imagination as Frank Capra's enduring portrayals of small towns or as certain shots of New York City as an urban wasteland in the seventies and eighties, Peele hits on the very real fears people the suburbs weren't made for feel when they go there. It's about the outsider needing to not just get out, but also to not go near.

Are the suburbs white? Without getting into a college freshman philosophy argument over *is anything really anything anyway,* I'll spare you and just say there are many dueling philosophies that went into the building of the American suburbs. Some places—like Llewellyn Solomon Haskell's Llewellyn Park, or even Columbia, Maryland, a twentieth-century master-planned suburb with its "balanced community" philosophy of people from all races, religious backgrounds, and economic situations living on equal footing—were built on the idea of creating a utopia. But one person's idea of utopia can leave other people out,

unfortunately. That's the case with Lake Forest, for instance: the rich Presbyterians who founded it were carving out their own little perfect place. But the thing about utopia is that it's opposite is dystopia, and what one person considers good and pure can be scary and evil to another. Some people were allowed in Lake Forest, and others were not. This is the story of so many early suburbs. There were insiders and outsiders, and that legacy can be felt to this very day, whether it's stated or not. *Get Out* showed that through the lens of a horror movie.

To figure out how far exclusion in the suburbs goes back, I drove to the Baltimore suburb of Roland Park. Like Lake Forest, there's nothing scary or strange about it; Roland Park is downright beautiful. My first time driving through it on a Sunday morning in the winter, a few hours after the snow had fallen, couldn't have been more picturesque. I kept thinking how badly I wanted to live in the neighborhood with its century-old Victorian homes next to younger colonials built in the twenties and thirties. I saw an old Mercedes 300TD station wagon, my dream car, and kids sledding down a little hill while a dad looked on with a mug of coffee or hot cocoa in his hand. The smell of bacon drifted from somewhere in the distance. There are hints of the protosuburbs everywhere: I spotted an arts and crafts–style cottage on Elmwood Road; the layout and landscape of the neighborhood makes it look less like some modern version of suburbia and more like something Ebenezer Howard would've approved of. As I walked around, I thought to myself that, yes, John Waters, the "Pope of Trash" known for shocking and campy films like *Pink Flamingos* and *Hairspray,* may be a product of other nearby Baltimore suburbs, but Roland Park is straight out of Frank Capra or John Hughes.

There's also something very Jordan Peele about it, I notice, namely that you don't see many black people there. I didn't see one, save for a Starbucks employee, in the four hours I spent driving and walking around. As a friend of a friend who lives in the neighborhood assures me, there are lots of Jewish residents in Roland Park, but I don't see any black residents. I guess you could say any Jewish population in Roland Park is a small sign of progress, while the lack of black residents is, unfortunately, business as usual for one of America's first suburbs.

While Roland Park is one of the earliest American suburbs, the neighborhood's legacy should always be part of its story. How it was built, and whom it kept out, namely blacks and Jews, will always be part of its origin story.

The building of Roland Park, as noted by the historian Paige Glotzer, wouldn't have been possible without financing from some pretty unsavory sources. "Suburbs may seem uniquely American," Glotzer writes in "Building Suburban Power: The Business of Exclusionary Housing Markets, 1890–1960." "Caribbean slavery, British industrialization, imperialism, and even the battles for women's rights all directly affected who invested in them and where the capital came from."[21] That, and Roland Park and its British investors opened a new way of profiting off racial segregation that would remain well into the twentieth century. Using deed restrictions to keep "undesirable" people out, it was sold as safe and upscale because only white people could live there. The Baltimore Country Club, which was founded in 1898 and has a location in Roland Park as well as one in Lutherville, Maryland, famously used to have signs up that read No Dogs, No Coloreds, No Jews.[22] It's a beautiful place with a dark past.

Roland Park couldn't legally continue keeping people out based on their skin color or religion, but sadly, it still does in many ways. There are no signs or deeds anymore, but "that's just the way things have always been," one African American resident of Baltimore tells me with a hearty laugh when I ask him about the small black population in the neighborhood. When you consider that Baltimore, as of the 2010 census, is 63 percent black or African American, and that "the way things have always been" continues in Roland Park, you get a sense of just how ingrained the idea of keeping people out is in our culture.

Things, I believe, are changing. Maybe not everywhere, but the old idea of who lives in the suburbs is being chipped away. Just go to your local library or bookstore to see.

I know that sounds incredibly precious, but I really think books have a special way of telling us where culture is and where it's heading. And

who writes about the suburbs tells us not only about the places but also the people who are living there now.

The canon of our great American books has largely been made up of white men—Herman Melville, Henry David Thoreau, Mark Twain, Ernest Hemingway, F. Scott Fitzgerald, and so on. There have been some, but very few, diversions from that pattern, be they Edith Wharton, James Baldwin, or Zora Neale Hurston, but the nineteenth and twentieth centuries didn't offer much in terms of publishing diversity.

Personally, I've always been fascinated with the postwar boom of Jewish writers, from J. D. Salinger to Saul Bellow, Grace Paley, and Philip Roth, because, at the time, it represented something different in terms of who got to tell our American stories; Jewish authors became part of the norm. But in the fifties and sixties, not long after the Holocaust ravaged most of Europe's Jewish population, voices like Salinger and Roth getting pushed to the forefront of American culture was a much bigger deal than we give it credit for today.

I feel a similar way about contemporary literature, specifically fiction, where there's a push to see more writers from different ethnic backgrounds, more women, more LGBTQ writers, and just more of the people who've been ignored in the past.

In 2017, I came upon two novels I loved and felt I had something of a connection to. The first was *Little Fires Everywhere* by Pittsburgh-born author Celeste Ng, the child of parents who moved from Hong Kong in the late sixties. The other—*No One Can Pronounce My Name* by Ohio-born writer Rakesh Satyal—focused on Indian immigrants in the suburbs outside Cleveland, presumably not too far from the Shaker Heights neighborhood where Ng set her novel. Using the all-American Richardsons as the focal point, Ng effortlessly updates the type of story writers like John Cheever and John Updike hinted at. Stories of "everything going wrong in suburbia" will always be a solid bet for writers to explore, but few do it as masterfully as Ng, and few balance grace and humor like Satyal.

Growing up in the suburbs outside Cincinnati "was especially difficult for a young queer Indian-American like me because I was a double minority," Satyal says. He notes the city's complicated history,

how there were race riots just twenty years before he was born. "I felt mainly ostracized because of my flamboyance, as I witnessed more overt homophobia on a daily basis and, frankly, was too young at the time to discern how subtle racism could be (homophobia seemed to thrive on more conspicuous, over-the-top gestures, and again, since I was quite effeminate, I was bullied about this constantly)." But he still looks back with some fondness on growing up outside the city. "I benefited from a really amazing public school education, and even though I went on to attend an Ivy League school and work in a rather high-profile media job in New York, I still maintain that my high school friends were among the brightest and most hardworking people I've ever met."[23]

After reading dozens of stories and novels about the suburbs from the fifties all the way into the early aughts, I noticed that, by the 2010s, writing books about people in the suburbs had gone out of vogue. There were a few examples, like Jenny Han, whose parents emigrated from Korea and who gave a modern update on the all-American suburban teen romance with *To All the Boys I've Loved Before* in 2014. A year later, Karolina Waclawiak looked at a posh Connecticut suburb in *The Invaders* and gave it a spin that was equal parts Cheever, Alfred Hitchcock, and David Lynch. Waclawiak, who was born in Poland in 1979 and moved to the United States in 1981, took the tried-and-tested trope of the cracks starting to show in the American suburban facade and freshened it up. Similarly, Mira Jacob, the daughter of East Indian immigrant parents, looked to the suburbs outside Albuquerque for part of her *Sleepwalker's Guide to Dancing,* which came out that same year. Fantasy and sci-fi writer Nnedi Okorafor's biography routinely mentions her Nigerian parents as well as her upbringing in the suburbs outside Chicago and how these things influenced her work. These are the writers who are steering part of the literary conversation today.

When I read Satyal's and Ng's novels, I realized the bulk of the newer books I'd read about suburbia or set in the suburbs were by immigrant or first-generation writers, many of whom were also writers of color.

"I think that this does have something to do with the fact that the children of the first and second wave of immigrants are now aging into the seriousness of their work and that this leads to a general uptick in immigrant suburban fiction," Satyal says. "After all, very few people like me grew up under circumstances like mine prior to my doing so, just because of the timing in terms of when South Asian immigrants came en masse to this country. But I also think that there is something to be said about the opposite of what we're seeing now: there seemed to be a period of time in which immigrant families were welcomed into this country, and telling their stories was encouraged, because it strengthened the altruistic idea of America as a beacon of hope, as a place where dreams could be realized regardless of your ethnic background. I think the confluence of those generations aging into their work, as I noted, and this overall sense of cordiality and support led to an ideal of the immigrant suburban novel and the promise of its stories and characters."[24]

Writers who didn't grow up with parents who benefitted from the American postwar boom are giving the suburban story new meaning. Prior to that, the white suburban novel of the late nineties and early aughts often felt like a look back, like the suburbs were passé and we as a culture had moved on because our leading intellectuals had. Dave Eggers, with his memoir *A Heartbreaking Work of Staggering Genius,* shows the writer and his family early on in the Chicagoland suburbs; Tom Perrotta's 1998 dark comedy, *Election,* is in some ways a twisted update on the eighties high school ecosystem of John Hughes films; Jeffrey Eugenides based *The Virgin Suicides* and *Middlesex* in the suburbs of Detroit; and Rick Moody's 1994 novel *The Ice Storm* took place in early-seventies suburban Connecticut. Similarly, Jonathan Franzen, Michael Chabon, and David Foster Wallace, some of the biggest names in American literature as the 2000s rolled around, were either products of the American suburbs or wrote about them in some way.

Writers like Han, Ng, and Satyal are changing things. They aren't celebrating the suburbs, per se; they're showing us who lives there today, that the American suburbs are still slow to embrace change, but they are

indeed changing. The people living there and the ones writing today's suburban novels are proving that. And I think that speaks for something. It's important that the suburbs, which have long been connected to whiteness and to keeping certain people out, are shown as places where anybody can and does live. It's not just the typical bored white kids and their parents representing these places that make up so much of our country. It's Satyal and Ng and other children of immigrants. It's Eddie Huang in his 2013 memoir, *Fresh Off the Boat,* showing what it was like growing up the child of Taiwanese immigrants in the Florida suburbs, and how his obsession with American culture clashes with the culture at home. It's the black poet Morgan Parker telling one magazine that she grew up in a "super white suburban area" and that all the while she kept thinking, "[I] can't wait to get out of the suburbs."[25] It's about everybody being able to have a say in the American suburban experience. The experience doesn't have to be a loving one (for example, Parker just wanted to get the heck out), but everybody can have the experience now, and anybody can write about it.

"I had a rather creative and content childhood," Satayl says. "Living in the suburbs granted me the joy of access to the natural world—we literally lived next to a big public park—and there seems to be a kind of in-the-trenches sensibility to high school kids in the suburbs who band together and celebrate their idiosyncrasies. And one thing that growing up in rural America has shown me is that there are so, so many good people who are more complex and giving and generous than frequent depictions of Middle America-with-a-capital-M-and-A can show them to be, and that is one thing that gives me hope for the future. Being able to bear witness to that has demonstrated to me the importance of showing complexity in the suburban characters I write—and to have them work out these discussions within my work as a proxy for a way forward."[26]

Life on Mars

I was feeling a little somber as my friend Isaac and I ate hot dogs while sitting outside Hiram's in Fort Lee, New Jersey, on a sliver of land that fits over thirty-five thousand citizens into less than three square miles atop the Palisades. I was thinking about the soul and if, when I pass on, I'll find out if there truly is such a thing, and where mine might go. Yes, food has moved me to get all kinds of emotional in the past, but this was something else. A hot dog had never made me undertake some deep theological examination.

I've heard dozens of people from New Jersey tell me that while living in the state, whether they were from Princeton, Hoboken, Asbury Park, Trenton, Cherry Hill, or somewhere else, New York City felt like their backyard. That's the term they often use, one that always strikes me as funny since I pretty much gave up on having an actual backyard once I moved to Brooklyn, along with things like fireplaces, a garage, and a front lawn I could mow myself.

The "backyard" wording is meant to signify that getting to the East Village was just a PATH train or car ride away; but the idea of Manhattan as the thing you see when you look out your back window is totally plausible if you live in Fort Lee. The big city is visible; it feels right there. One website said that the borough "appears urban, but it feels suburban."[1]

It was a nice summer day, not too hot. The second week of June was coming to an end, and the sun was starting to make its slow descent. Isaac went to order us deep-fried franks, and I got us a spot at one of the picnic tables. As I sat waiting for him to come back, I pulled out my phone and did what I always do to kill time: I read up on the place I was visiting. Some of the stuff I knew, like how Fort Lee was the motion picture capital of America at the start of the twentieth century. There was Fox Film, Metro Pictures, as well as Goldwyn Pictures before they merged with Louis B. Mayer to form Metro-Goldwyn-Mayer, and many others called Fort Lee home at one point. In a few seconds, I also learned that market researcher James Vicary flashed quick, almost unnoticeable messages like "Drink Coca-Cola" and "Hungry? Eat Popcorn" across a local movie theater screen in 1957. The result was an 18.1 percent increase in Coca-Cola sales, a 57.8 percent hike in popcorn sales, and the start of Fort Lee being the home of subliminal advertising.[2] What I didn't know (and might've learned if I'd paid attention during freshman history in high school) was that Thomas Paine wrote, or was at least inspired to write, *The American Crisis* as he participated in General George Washington's retreat after the Battle of Fort Washington. Paine was talking about the retreat, which made its way up what's now Fort Lee's Main Street, when he wrote, "These are the times that try men's souls."[3]

Nearly 240 years later, on the fifth episode of the fifth season of his CNN television show, *Parts Unknown,* famous chef, writer, and television personality Anthony Bourdain, who grew up ten minutes away by car, talked about how he went to Hiram's "to feed my soul." It was a holdover from his childhood that still made the guy who had eaten pretty much everything the world over happy.

The reason Isaac and I had journeyed across the river to order two burgers, two chili dogs, two fries, and two bottles of Miller Lite from this place that meant so much to somebody we both respected a great deal was because Bourdain had committed suicide a week earlier in France. We were in mourning. The old eating-when-you-feel-sad trick. I think both of us, trying to make sense of it all, wanted to go somewhere

a piece of Bourdain might still be felt, hoping maybe his soul was hanging around this little restaurant.

The hot dogs and burgers were, unsurprisingly, great. The fries were crispy, and the beer was cold. It was a somber meal, but I do believe eating as a form of communication is a very real and very deep thing. As my friend and I sat there quietly feeding ourselves with the sun going away, the mosquitos coming out, and the buzz of the daytime activities retreating into nearby homes only to be replaced by chirping crickets, I did feel a connection to Bourdain. I went to the suburbs and I fed my sad soul.

I can't say I knew Anthony Bourdain; I was lucky enough to talk to him only a few times. I also can't really say I uncovered much about him that wasn't already public knowledge. He told me during an interview he liked to write in the morning; that he grew up a comic book nerd, a fan of *Mad* magazine and R. Crumb, stuff that was "really disturbed, something really dark and filled with anxiety and sex and violence"; that he grew up in the New Jersey suburbs with New York City just outside his window.

Bourdain talked a lot about his suburban upbringing. He grew up in the town next door to Fort Lee, Leonia, New Jersey. In a 2013 interview, he said, "We were a pretty typical suburban family in most ways. I was a reader. I lived in a house filled with good books. Both parents loved good movies—this was important."[4] He wrote about his obsession with the John Cheever short story, and its film adaptation, *The Swimmer,* recalling that the place he grew up was "a leafy, green world, filled with mysterious backyards, tree-lined streets, the sound of distant lawn mowers in the summer."[5] Bourdain didn't ignore the suburbs on his travels or in his writing; he was very open about how much suburbia shaped him, and his belief that the suburbs were just like many other parts of the world. Still, that didn't prevent him from leaving for New York City. Almost all big-name chefs have to do that if they want to make it in the business: Julia Child, David Chang, Danny Meyer, Thomas Keller, and the list of food icons with suburban upbringings goes on and on.

Bourdain has always interested me, because while he became famous after writing a memoir about working in kitchens, he was never really known or lauded for his cooking skills. His James Beard awards came for his television shows, and he never owned a big-name restaurant of his own. Still, Bourdain drifted away from the suburbs, lured to the grit and energy of New York City in the seventies, and he never looked back. He may have traveled the world twice (three times?), but Manhattan was his home. The New Jersey suburb he grew up in had become the place he could maybe see from his window on a clear day.

People in the food industry tend to be nomadic, moving where the work is, something Bourdain pointed out with pride. Child started in Pasadena, one of the many suburban areas around Los Angeles, and ended up bringing French cooking to Americans. Keller started out washing pots and pans in a West Palm Beach yacht club before becoming possibly the most acclaimed chef in American history. Meyer grew up in the St. Louis suburb of Ladue, Missouri, before founding a food empire that includes the Manhattan staples Union Square Cafe and Gramercy Tavern, as well as the burger chain Shake Shack. Chang, the child of Korean immigrants, grew up in the Virginia suburbs before starting his Momofuku empire in New York. Chef Samin Nosrat, author and host of the book and Netflix series *Salt, Fat, Acid, Heat,* wrote, "I grew up in southern California, which is suburban, sterile and super-polished" to Iranian immigrant parents.[6] The point is, there's plenty of great food to be had in the American suburbs, but the cuisine that gets noticed is usually the stuff being prepared in cities.

Suburbs exist that are destinations for just about anything, be it cuisine, art, music, architecture, media, museums, universities, or other cultural attractions. But they're a rarity. Instead, these things are concentrated in cities, so more often than not, people need to either leave the suburbs or commute if they want to see an exhibition of Rodin's sculptures, be an editor at a publishing house, or try the hot new restaurant every influencer is talking about.

Of course, that was sort of the whole point of what Bourdain did with his television shows. Sure, many of the episodes were titled using

the name of a country or city, but he went beyond the city limits to small towns, to little remote villages, and, yes, to the suburbs from time to time. But there's something else about Bourdain that goes beyond food, something I picked up from him early on, which I think is why I felt such a deep personal connection to him. For me, Bourdain was a suburban weirdo, somebody who was born or raised in the suburbs but didn't quite fit in. He had a sort of boundless curiosity I feel is the product of a childhood in the suburbs, of wanting to see beyond the horizon and to unearth things. He was the epitome of someone who just didn't fit in his normal home on his normal street in his normal town—the existential outsider.

There are some people who end up in the city because it's where school or work is. But for others, it's something deeper than that: getting *out* of the suburbs is simply of necessity. But what makes an outsider that way? And how do you define somebody who doesn't fit in? Usually you think it's someone who behaves or looks differently than the crowd. The black sheep or the misfit. The nonconformist.

Medically speaking, some doctors say the feeling of not belonging starts in childhood and can last throughout a person's lifetime, that people who are abandoned or otherwise marked as different early on carry that feeling as they grow up.[7] Google "I feel like an outsider," and you'll find countless blog posts and articles, from "On Being the Outsider" by Ditta M. Oliker, PhD, on psychologytoday.com to "6 Signs You're an Outsider (and How to Make It Work For You)" on healthista.com to Biblical scriptures for finding comfort when you feel like you just don't fit in.

On the one hand, we're fascinated with the outsider: preachers will tell you Jesus was one; some of our most famous literary figures, from Jane Eyre to Holden Caulfield and Harry Potter, are outsiders in their own way; we're taught to "think outside the box" and to "be ourselves." On the other hand, feeling like you don't belong is a very real and deep experience, one that isn't always pleasant. Is it something people are born with, or does the world shape them? It's a very chicken-or-the-egg deal, especially when you throw a suburban

upbringing into the mix—a question that pits place and nature against each other.

Suburbs in the postwar era were built with homogeneity in mind, and nothing develops a sense of not belonging like telling somebody they have to fit into a mold. While it's impossible to figure out the roots of each and every case of suburban alienation, stepping back and seeing that there's something downright strange about the actual concept of the modern suburb—how it's built and the psychological impact it can have on people—isn't nearly as hard.

As I drove through Fort Lee, I couldn't shake a familiar feeling. I'd never been to the suburb before, but I'd been to so many places like it. It was the area that shaped a young Bourdain, and it called to mind the work of one of the most visionary writers of the last four decades. But it also reminded me of something I couldn't quite place.

"The property they [developers] built on had been farmland, overlooked by a big rickety-looking wood frame house," the science fiction writer William Gibson tells me of his time living in a Charlotte, North Carolina, suburb ("on Blackberry Circle, where all the homes seem to have been built in 1954") that today is called Collingwood. "I once referred to it [the farmer's home] as a poor people's house, and my father corrected me, saying that they [the farmer who owned the land] had lots more money than we did, because they'd sold the rest of their land to the company Gibson's father worked for, which had built the development," Gibson recalls of the property the homes were built on.[8]

Gibson once described living in that suburb as "like living on Mars," with no grass and orange clay all around.[9] I remember reading that and thinking about how much his suburban experience sounded like an old sci-fi story.

In the eighties, Gibson introduced readers to a bourgeoning strain of science fiction dubbed "cyberpunk," a noirish, computer-and-technology-choked futurescape. Nearly forty years after his groundbreaking 1984 novel, *Neuromancer,* some would describe Gibson as a modern-day

prophet. Set largely in the Boston-Atlanta Metropolitan Axis (basically the bulk of the eastern seaboard), *Neuromancer* depicts a near future affected by war, environmental catastrophe, huge wealth gaps, dependence on the internet, and people looking for any way to dull the pain, from drugs to entertainment. The nickname for this area is "the Sprawl," and it always struck me as a sad, lonely place.

Gibson's vision influenced Bourdain. He describes the "amazing sprawl" of Tokyo in his book *Kitchen Confidential* as "something out of William Gibson"; planned to build a food court influenced by cyberpunk literature and movies; and told the *New York Times* that while he typically avoided most science fiction, he read Gibson.[10] I related to that because, even though I went through my own short-lived sci-fi phase as a kid, what really stuck with me and helped mold my views of the world from my teenage years to the present day was reading Gibson, as well as stories by J. G. Ballard or Philip K. Dick and watching movies like *Akira* and *Blade Runner*. I distinctly recall being around fifteen, sitting in the backseat of a car as we drove down some stretch of suburban road that never seemed to end, just miles of power lines, chain stores, and flashing lights everywhere, thinking of Gibson's books. The orange of Home Depot gave way to the gray and blue of the Ford dealership, which gave way to a Toyota dealership, a used-auto lot, the honking of car horns mixed with whatever was playing on the radio as the soundtrack.

I can tell you exactly where I was, but really I could've been nearly anywhere in America, and as I got older I realized it could've been on almost any continent as well. In my young, early-nineties mind—after I first read *Neuromancer* and right before I had internet access and other opportunities to read about Gibson and his work—I concluded that what I was passing was indeed the sprawl Gibson wrote about.

I was a teen; I'd already started turning into the angsty, angry kid who liked punk and skateboarding. But that was one of those "aha!" moments where I started thinking about things—namely, the suburbs—in a different way. And that wasn't the only place where Gibson's vision influenced me and others. Around the time I first read *Neuromancer*, I

also picked up the album *Daydream Nation* by the band Sonic Youth, and found myself particularly fascinated by the song called, yes, "The Sprawl." It was only years later that the song's writer, Kim Gordon, confirmed in her memoir that the song was indeed influenced by Gibson. She wrote, "The whole time I was writing ['The Sprawl'], I was thinking back on what it felt like being a teenager in Southern California, paralyzed by the still, unending sprawl of l.a., feeling all alone on the sidewalk, the pavement's plainness so dull and ugly it almost made me nauseous, the sun and good weather so assembly-line unchanging it made my whole body tense."[11]

I related to all these things because I'm a product of the sprawl. My childhood was, for all intents and purposes, an unhappy one. My parents divorced when I was young, and I experienced mental and physical abuse from them growing up. Around the time Gibson and Sonic Youth came into my life, I was a bored, anxious, alienated teenager going from one medication to another to try to "fix" (as doctors and my parents put it) my adhd and depression. I didn't have a lot of friends who went to my high school, but around age thirteen, when I went home, I found some semblance of community with the screen names in aol chat rooms. *Cyberspace,* a term Gibson coined in the 1982 short story "Burning Chrome," became my salvation. It made me realize I wasn't alone on my little street in the suburbs, and that suburbia wasn't for me. My story really isn't that different from the stories of countless other Generation X and millennial kids, and all these years later, I can perfectly picture that drive through the sprawl, and it serves as a symbol of when I decided I needed to get away. Every person who wants to get out of or starts to despise the suburbs has their reasons. Bourdain's suburban childhood seemed, in his own words, pretty calm; his memoir points to the childhood family trips he took to Europe as opening him up to the larger world. Gibson wasn't as much a product of modern suburbia as Bourdain, but he experienced it enough in its early stages, enough to leave an impression. "I imagine we were living in what had been the 'model home,' for selling other, unbuilt lots," he tells me over Twitter dms. "At the very start of our stay, most of the land

around us was still raw NC orange clay. My first experience of home air-conditioning."[12]

As a child, Gibson's father worked middle management for a construction company that went from building structures for the government during World War II to developing subdivisions after it. Gibson's childhood was during the boom times, the future-thinking times of cars that looked like rocket ships, of toy metal robots, of *The Day the Earth Stood Still* and *Invasion of the Body Snatchers* playing on the big screen, and of pulp magazines at drugstores offering stories of alien invasions and explorations of other worlds. The wide-open future was the great promise to Gibson and his generation, and he got to see the beginning of it pretty much firsthand. The house he talked about, the one without grass, was a show home the family lived in for a time in North Carolina. They moved around a lot, and Gibson's father was often away on business, scouting new locations for new suburbs. It was on one of those business trips, when Gibson was six years old, that his father choked to death, prompting his heartbroken mother to move her son back to the small Virginia town she was from, which Gibson once described as "a place where modernity had arrived to some extent but was deeply distrusted."[13] He was pulled from the suburbs and the future back into a rural part of America that was stuck in the past.

His mother would eventually ship her only child off to a private boys' school in Arizona when he was fifteen. Three years later, she, too, would pass away. In 1967, after a few years of traveling and immersing himself in the counterculture, Gibson moved to Canada to avoid the draft. He eventually went to college in Vancouver and in the late seventies started writing science fiction. The time in the developing neighborhood in North Carolina, he tells me, "was my only personal experience of suburban living, as it happened."[14]

While Gibson says the Sprawl was "a vision of a big, bad metropolis," his fictional idea of the future and the progression of the real suburbs are eerily similar.[15] And driving through the Long Island hamlet considered the first modern suburb (and the model for the subdivisions

his father's company built, Gibson notes), I can't help thinking the Sprawl had a different starting point, and it was Levittown.

Gibson didn't coin the term *sprawl;* it started popping up around the time he was born. One of the earliest known uses of the phrase *urban sprawl* was in a 1947 article in *Geographical Journal* entitled "The Industrialization of Oxford." So when we talk about sprawl, we're thinking of an almost entirely postwar concept.

Sprawl is rows and rows of nearly identical houses with a little space between. It's driving away from the houses (and you usually have to drive) and finding large commercial and industrial areas, box stores, and business parks. Sprawl goes on for miles, stretching into cities and suburbs in every direction. It feels claustrophobic, like it's all pushed together. This is exactly how I'd describe Levittown to somebody who hasn't been there.

One of the first things you see driving into Levittown on the Hempstead Turnpike is the OTB. Off-track betting parlors went extinct in New York City in 2010, but there it is, three letters bigger than the wooden Welcome to Levittown sign a few feet away. The crowd of patrons, mostly older men, sit and bet on horses on a two-lane street that's still technically the turnpike. It's one long row of businesses, then there's a curve and you can either turn onto the continuing turnpike (NY-24) or drive straight onto Wolcott Road.

If you happen to be at the OTB and want a coffee at the Starbucks across the street, or maybe some snacks from the gas station next to it, you have to cross nearly ten lanes of traffic. But chances are you wouldn't because the stretch of road is one of the most dangerous in Long Island. This is the heart of Levittown: a long road of businesses—many of them of the big box store variety—lined up to watch a parade of congestion inch past.

It's suburban sprawl, yes, but Levittown also calls to mind what the architect Rem Koolhaas dubs "junkspace"—ugly, bland, utilitarian buildings and a lot of things that serve very little purpose. "Junkspace is the sum total of our current achievement," Koolhaas writes. "We have

built more than all previous generations put together."[16] The buildings I see in Levittown and many other suburbs are often just that, buildings. They serve little purpose other than to house things, with little thought put into the design. It's all function over form.

To Koolhaas, the traffic is junkspace, the little stores are junkspace, and, in a very Gibson-esqe way, he believes that someday soon, "junkspace will assume responsibility for pleasure and religion, exposure and intimacy, public life and privacy." I'm just looking for something, anything, a little interesting in Levittown, whatever it takes to break up the monotony. As somebody who grew up in suburbs that came after William Levitt's vision was complete, I'm used to suburban humdrum and the ennui it can conjure. But seeing the starting point of this modern condition puts it into a unique perspective.

Driving into Levittown the first few times is a suffocating experience. The roads are long. Unidentified wires (telephone? electrical?) hang low at certain points as you drive down the turnpike ("low" as in a few feet above my car, like they fell from a higher perch and nobody hung them back up). Smaller abandoned storefronts sit in the shadow of larger chains like Petco and Staples. Many of the buildings along the road look worn down. But when you turn into the residential areas—down Shelter Lane, Pond Lane, Grove Lane, Penny Lane, Beaver Lane, and many other streets dubbed "something" Lane—you still see a lot of the white picket fences that were part of the package in October 1947, when Theodore and Patricia Bladykas and their twin toddlers, Patricia Ann and Betty Ann, entered their new home in the planned community that would be called Levittown six months later. The fence came with the new washer and dryer, stove, refrigerator, and stainless steel cabinets shown off in the August 23, 1948, issue of *Life* magazine in a profile on developer William J. Levitt, president of Levitt & Sons and, according to the magazine, "the Nation's Biggest Housebuilder."[17] At the time, the Levitts had built four thousand houses in a year on a thousand acres of land that was once a potato farm. It was the first of what we consider the modern suburbs.

Using assembly-line tactics out of Henry Ford's playbook (not to mention "unskilled" and nonunion labor), Levitt sold the four-room

Cape Cod cottages for $7,900 each (adjusted for inflation, that's under $85,000 today, an affordable price to *some* returning soldiers thanks to the G.I. Bill).[18] The houses came as they were, you couldn't build an addition to your property, and you were tasked with the upkeep, from mowing your lawn to making sure the fence stayed white. Around the same time as the glowing reports of William Levitt's vision, the real legacy of Levittown started to take shape, the one that, like the fence maintenance, was meant to keep it as white as possible: clause 25 of the houses' leases, which banned occupancy "by any person other than members of the Caucasian race" save for "domestic servants." It was taken out after a group called the Committee to End Discrimination fought to have it removed. Even though they were successful in having the clause taken out, Levitt didn't change his policies regarding who he'd sell or lease to, saying, "The plain fact is that most whites prefer not to live in mixed communities."[19]

The Levittown color barrier wasn't broken until 1957, when residents in the second Levittown outside Philadelphia arranged a private sale of a home to Daisy and Bill Myers, an African American couple with their children. In a picture from the family's move-in day, August 13, 1957, you see the remnants of a mob that tried to protest their arrival on Deepgreen Lane—about twenty-five white people surround the house, which a couple of police officers guarded as the family tried to settle in. Some would argue that Levitt was just bound by his times, that federally sponsored acts like "redlining," which began with the National Housing Act of 1934 and kept African Americans from living in mostly white areas, were in place before the first white fence. Levitt himself would defend his decision, writing once, "The Negroes in America are trying to do in 400 years what the Jews in the world have not wholly accomplished in 600 years," going on to say, "As a Jew, I have no room in my mind or heart for racial prejudice. But I have come to know that if we sell one house to a Negro family, then 90 or 95 percent of our white customers will not buy into the community. This is their attitude, not ours."[20] Of course, what Levitt left out was that he and his family had built an even more exclusive—and exclusionary— community in the Long Island town of Manhasset.

Strathmore Vanderbilt stood on a hundred acres of land sold to the Levitts by the Vanderbilts. When Levitt purchased the land from the Vanderbilts at the start of the thirties, his vision was to offer something not too far off from picturesque neighborhoods like Llewellyn Park in New Jersey and Lake Forest outside Chicago, with the old French chateau turned into a county club at the heart of it. To name the town, Levitt kept Vanderbilt (since few things signify success in America like the Vanderbilt name) and attached Strathmore, the WASPY name of the upscale Tudor-style homes the family sold for $14,000 each during the Great Depression (around $200,000 today). He probably didn't call it Vanderbilt Levitt because, well, Levitt sounds too Jewish, and William Levitt didn't sell Strathmore Vanderbilt property to Jews, African Americans, or other nonwhite groups.

As much as Levitt and others have tried to clear his name in the years since, the fact is, whether it was personal or truly a business decision, William Levitt kept people out, and that practice has endured to this day not just in the towns he created but in suburbia as a whole. Of course, as we've seen, the suburbs' history of keeping certain people out is as old as the places themselves. Levitt just happened to be the first to bring the suburban dream to the masses, which means he was also the first to deny people that dream as well.

So, yes, Levittown kept people out like the earlier, even more exclusive suburbs that came before, like Roland Park and Lake Forest. But it's the way Levittown was laid out—a design nearly every modern suburb would come to adopt—that helped foster a sense of not belonging in generations of people. Whereas God was in the details for places like Llewellyn Park, it's the lack of those details, the uninspiring layout of our suburbs, that creates the sense of displacement when you move around Levittown or any number of the places it influenced.

I finally get out of the traffic, turn off the turnpike, and arrive at the Levittown Public Library, a midcentury library that looks like nearly any library in any other town. Its design—gray brick with white columns—isn't exactly an architectural wonder, but it sticks out among

the Cape Cods, one of the area's many shopping plazas a few feet away, and a plot of green grass with brown patches that isn't used for anything except what looks like a generator with a chain-link fence around it. There's nobody else outside on this sunny autumn afternoon. It's the weekend, so kids aren't in school, yet there are none outside playing.

In their 2000 book *Suburban Nation,* Andres Duany, Elizabeth Plater-Zyberk, and Jeff Speck talk about "useless and useful open space," noting that "in today's conventional suburbs, man's relationship to nature is represented by engineered drainage pits surrounded by chain-link fences, exaggerated building setbacks at road frontages, useless buffers of green between compatible land uses, and a tree requirement for parking lots."[21] I saw all those things from where I stood in the plot next to the Levittown Library. And it wasn't just in Levittown that I noticed useless space. These sometimes very large plots of land that don't seem to serve any purpose except for the occasional dog to pee on.

I decide to keep walking around Levittown, first into the library, which is a very nice place, I must say. Still, it isn't easy to access. Nothing in Levittown is easy to get to unless you get in a car—and even then, it feels like a journey.

"As a child you're disabled by not being able to walk anywhere. Nothing is nearby," Dr. Jose Szapocznik, then a professor of psychiatry and behavioral sciences and director of the Center for Family Studies at the University of Miami, told the *New York Times* in 1999 in an article titled, "How Suburban Design Is Failing Teen-Agers." The article, which appeared in the paper's Home and Garden section, was written in the wake of the Columbine High School massacre, where students Eric Harris and Dylan Klebold murdered twelve of their classmates and one teacher in their suburban Colorado school with semi-automatic weapons and explosives. It looked at how "the troubling vision of a nation re-pioneered in vast tracts of disconnected communities has produced uneasy discussion about the psychological disorientation they might house," and how "the isolations of larger lots and a car-based culture may lead to disassociation from the reality of contact with other people."[22]

Criticism of the design of suburbs is nothing new, but studies of its impact on young people is still in relatively early stages. In his 2004 TED talk, "The Ghastly Tragedy of the Suburbs," James Howard Kunstler talks of "entropy made visible," and of how the places, specifically the suburbs, we've built since the Second World War have "deprived us of the ability to live in a hopeful present." Even worse, the way the suburbs have been built is "inducing immense amounts of anxiety and depression in children."[23] Hearing that really struck a chord with me. It made me think about how I can go back to my younger years in suburbia and conjure that feeling of hopelessness for reasons I could never quite put my finger on.

Driving around Levittown, or any suburb, really, it's easily to feel isolated. As an adult it's one thing; you can get in your car and drive away. You have a little more freedom. As a kid, you're basically stuck. Stuck and isolated with your anger, sadness, rage, and boredom. That's a toxic combination.

Despite what today's Levittown residents, who have property values in mind, might say, it's difficult not to think about the town's history and the fact that as of the 2010 census, it's still overwhelmingly white (90.1 percent). Of course, you shouldn't go *anywhere* in America without taking into consideration the founding and building of a place and the pain it's caused. You can't escape America's ghosts. Streets, towns, and states are named after the tribes and words of indigenous people who once lived there. Areas all across the country were built on the backs of people who were taken from their homeland and bought and sold like livestock because of the color of their skin. Other areas relied on exploiting people seeking a better life—Jews from Eastern Europe; Irish, Chinese, and Mexican immigrants; and many others—by paying next-to-nothing and forcing laborers to work under horrible, sometimes deadly conditions. But the fact remains that Levittown's creation is more recent. It's still there, and not only is it still there, but it grew, multiplied; it turned into the sprawl.

Even disregarding all that weighty history, there's this creeping feeling as I get back in my car and drive away that there's a metaphor to

be drawn about decay from Levittown, about the big ideas we once had all squashed together in one small place, that we keep building over things instead of fixing and nurturing them. Very little feels natural in Levittown; it's a gloomy place. But most of all, it's hard to shake that feeling of loneliness. Not so much like being stuck alone on some distant planet, as Gibson described the small suburb he lived in. More like another planet we colonized and built up, then sort of gave up on. There are stores and wide roads, power lines and big fences, but you rarely see people walking in Levittown unless they're getting out of their car to go somewhere. There's so much in Levittown, but there also isn't much of anything. It isn't the noirish cyberpunk future Gibson envisioned, but since it's real life, it almost seems more depressing.

In her book *The Lonely City,* Olivia Laing writes, "You can be lonely anywhere, but there is a particular flavor to the loneliness that comes from living in a city, surrounded by millions of people."[24] Laing is right, of course. The suburban version is that it's difficult to be sure of how many people you're surrounded by because, whether it's Levittown on Long Island, Bourdain's little New Jersey town, or the Charlotte subdivision Gibson used to live in, people are mostly inside—in their cars, in stores, or in their homes. You don't see a lot of folks walking around in the suburbs, interacting with strangers. Some people, like Gibson and Bourdain, need more than that. They want a better version of the world, and they grow up trying to figure out how to attain it. The suburbs don't offer it, so they leave.

I can relate to that.

A few weeks after my memorial hot dog, I found myself back in a place that could've been my home: Buffalo Grove, Illinois. It's a suburban village I tend to avoid when I go back to Chicago, because it's almost guaranteed I'll start wondering what could've been: What could've been had my parents stayed together longer? What could've been if I'd grown up in one home instead of bouncing around? How would things have been different if this one place was *my* place? That's a lonely feeling.

The buffalo that used to roam the land before it was plowed under were long gone when the first houses started going up, as were the Potawatomi that lived there and then the German farmers who would replace the native people, when Buffalo Grove was incorporated in 1958.

Twenty-three years later, after Buffalo Grove had bloomed from 12,333 residents in 1970 to over 22,000 in 1981—a number I assume includes me since I was born a year earlier—my family moved into a home on a cul-de-sac. It was a white-and-brown split-level with a front yard that sat on a bit of a slope, so in a neighborhood that was once all prairie, it felt like it was the highest house, like an upper-middle-class mansion on the hill.

My parents put a down payment on that house, which was being built the year I was born. Well, they paid people to build it. My first year was spent in a rented apartment until finally, the house was completed. We moved in and my earliest memories were made there: parties, the sky-blue wallpaper with clouds and rainbows on it in my bedroom, my dog, and my parents fighting. Within a year and a half of moving into the home that was supposed to be my family's future—or at least the start of it—my father moved out. Not long after that, my mother did as well. The future they'd dreamed of was dead.

Buffalo Grove would continue to torment me, however. Every month we'd visit my aunt, uncle, and cousins, who had purchased a home a block from our old one in hopes of living close to family. As I got a little older, I'd sometimes sneak away from the backyard barbeques and birthday parties and walk down the street by myself. I'd walk the two minutes and stand on the sidewalk to look into my old bedroom at the wallpaper, or to stare at the swing set that was rusting away in the backyard.

Eventually somebody bought the house. They ripped the wallpaper off the wall and tore the swings down, so I stopped haunting the property I once called home. Instead, I'd stick to my cousins' backyard, climb to the top of the very similar swing set my uncle put together for them, and look out over the tall wooden fence. In front of me was this other world, this part of Buffalo Grove I wasn't familiar with. It frightened me,

how everything looked from my vantage point. It was the unknown, the great beyond. A bunch of houses all laid out across acres of Midwestern flatland. When I stood at the top of the slide, all I could see were rooftops all the way to the horizon, and it stirred in me this combination of excitement and unease. I had no idea what that place was; I knew it wasn't far away, but it felt like another world. Not quite like what Gibson had described, but a more advanced planet in the same solar system.

I ended up driving through Buffalo Grove on a visit during early October 2018. The sky was bright blue with puffs of white clouds scattered throughout. It feels silly to say it was the same sky I'd grown up with, but since I'd long moved on from the middle of the country, I'd grown used to more crowded views of the heavens, so there's always something instantly familiar about a northern Illinois sky. I popped on the first album by American Football, an indie band started by Mike Kinsella, one of the few people I can name who came out of Buffalo Grove. It's this ritual I have whenever I find myself there; the music is perfectly suited for driving around a quaint suburb you have a connection to but feel conflicted about. I did the weird thing where I drove past my old house, then had a mediocre sandwich at a mediocre restaurant. As I was paying the check, a thought popped into my head: I'm an adult. I've got a car. I need to see that place beyond the fence.

So I did. I drove back to the street I lived on as a small child, then followed the road until I found myself in the middle of it. That place that had been in my memory for decades, the one I knew only from a distance, was finally right there in front of me. It took all of seven minutes of driving. According to Google Maps, it would've taken forty minutes to walk there.

Driving down Knollwood Drive and Kingsbridge Way wasn't anything out of the ordinary. But there was a familiar feeling, like I'd seen these streets before. And maybe I had. Maybe I'd driven through those parts of town as a kid in the backseat and just didn't realize where I was. But there I was now, looking at all these colonials, that familiar sight of homes pushed way back off the curb, aluminum siding and green lawns chopped nearly to nubs. I'd seen a town like this subdivision recently.

But it wasn't like the place outside Charlotte where William Gibson lived, and it wasn't Anthony Bourdain's New Jersey suburb. I racked my brain as I drove until I had to stop at a Starbucks, pull out my laptop, and look it up.

I googled "Buffalo Grove Levittown" on a hunch, thinking maybe the subdivision was one of the many William Levitt–influenced places I'd seen all over the country. Of course, I've learned that the histories of most subdivisions have been obscured over time; they're out there, but not on the internet. If you really want to find out who built a row of townhouses or a development from the sixties or seventies in most suburbs, you'll have to do some digging. Not many people care about the developer who built a place that carries little or no historical significance.

Fortunately for me, there's something historically significant about the part of Buffalo Grove known as Strathmore: it was developed by Levitt and Sons in the late sixties.

I grew up looking out at one of William Levitt's creations.

Monsters, Mad Men, and the Mundane

Part 1: Today's New Haven Line . . .

It isn't hard to picture the scene on the New Haven Line tavern car headed home at seven on an evening in May 1953. The air is thick with smoke; men (because it's almost surely entirely men) in their Brooks Brothers and J. Press suits; Harvard alumni standing shoulder to shoulder with City College grads; blue bloods standing next to Jews and Catholics originally from poor families in Brooklyn or the Bronx; speculation that the Brooklyn Dodgers will probably make it to the World Series again, but so will Mickey Mantle and the Yankees—and the Yankees will probably beat Brooklyn to capture yet another title—talk of mistresses and business; vets from both world wars sharing stories; people drinking blended Scotch or lager. Characters out of television shows from *Mad Men* to *The Marvelous Mrs. Maisel* and from books by John Updike, Mary McCarthy, Richard Yates, Philip Roth, Sylvia Plath, and J. D. Salinger as well as Sloan Wilson's *The Man in the Gray Flannel Suit* all come to mind, but especially the works of John Cheever. Everybody is drinking, and everybody is having a grand old time; it's a soft spot between the workday and the drudgery of going back home to that stack of bills that's piling up, screaming kids, and a marriage that isn't exactly what it used to be. The tavern car that's open

to the general public is a few months old, but it's quickly turned into quite the social scene every night as commuters go home to their quiet suburbs up the Long Island Sound. A club on wheels, it's the best part of the day for some of the people riding it.

And then, just as it's about to pull out of the station, there's screaming. It's the Women's Christian Temperance Union. They're protesting the addition of the new bar cars. Mrs. Charles Archibald, president of her chapter of the WCTU, tells a reporter the new cars will be more trouble than they're worth, "with bleary-eyed males and females annoying the paying customers." And what will happen when things turn violent? Alcohol always leads to that kind of trouble. "What will happen when a 250-pound drunk with a grudge against the world starts pulling his gun?"[1]

Things get quiet for a second, then start right back up again as the protesters are ushered back onto the platform. For the next few decades and into the new millennium, a million conversations are had on these bar cars, and nearly all are lost to time.

The train bar car, especially the ones leaving New York City for the suburbs of Long Island, Westchester, and Connecticut, have achieved a small but mythical place in American culture. There was nothing exclusive about them—nothing fancy, no membership was required. When the *New York Times* reported in 2010 that the Metro-North Railroad line was considering retiring the remaining saloons on wheels because the money wasn't there to build new ones, some people saw it as another sign of the times changing for the worse. "Times will always change, but it is a shame to allow this aspect of our regional culture die off [sic]," wrote one commenter. Others, somewhat ironically, saw trains not serving booze as another sign of the gentrification of city life. "My whole world is becoming 'mallified' and disinfected in one way or another." Some, like Bruce, took it personally. "This is the only time that I have ever been glad my dad died in 2001 so that he didn't need to read this article. Thirty years Grand Central to Westport in the bar car let him decompress before he got home. A true Mad Man. I miss you, Dad."[2]

When the cars were finally put out to pasture (or to the train yard, or to wherever trains go to die), it was national news. "They are great

relics of the sixties and seventies," said NBC anchor Brian Williams when the axe finally came down in 2014.[3] Since then, plans for new bar cars have been talked about, but nothing has happened.

Of course, the Metro-North is far more than a movable party. It's a connector between the city and suburbs, just as the Long Island Railroad, the Metrolink in Southern California, and Metra in the Chicagoland area are. The difference between those railroad lines and Metro-North is that the train out of New York has that connection to America's midcentury, post–Second World War literary boom that gave us the likes of Updike, McCarthy, Salinger, and Cheever. Not only did their characters probably take the Hudson and New Haven Lines out of Grand Central, but the writers probably did as well. It's a tradition that would continue long after many of those writers had passed on: the movie version of Rick Moody's *The Ice Storm,* where we see Tobey Maguire's Paul Hood stuck in the frozen train car on his way home for Thanksgiving in New Canaan, Connecticut, and *Mad Men's* Don Draper and Pete Campbell on their way home to Westchester after boozing or cheating on their wives in Manhattan are two of the more modern examples. And if there's anything I learned from watching *Mad Men* or reading postwar writers, especially Cheever, it's that the characters maybe spent time in the old bar car, but it was a totally different world from the places where they'd disembark. It may have been a good time getting there, but once they exited the train and snapped back into their suburban existence, it was another story.

"These Westchester Sunday nights," Cheever wrote in his journal in 1952. "There has usually been a party on Saturday night so you wake up with a faint hangover and a mouth burned by a green cigar."[4] He goes on to catalog a mundane day in the suburbs: showering, taking the family to church, raking leaves that are too wet to burn, exchanging pleasantries with neighbors, having a drink before lunch, raking more leaves. Reading through the journal entries, you get a sense of how much Cheever's real suburban experiences influenced his fiction. Susan Cheever writes in *Home Before Dark,* a Cheever family history,

that "the suburbs of New York City in the 1950s were a homogenous and extended community held together by common interests: children, sports, adultery, and lots of social drinking." Sounding like a character out of one of his stories, Susan describes her father's routine. "Twice a day the tidal flow of cars to and from the railroad station passed our house, and once or twice a week my father joined the commuters on the train, lunched with an editor or an old friend who was still sticking it out in Manhattan, drank too much, sweated it out in the steam room at the old Biltmore Hotel, and took the train home." By contrast life in Scarborough, through Susan's young eyes, often seemed idyllic. "In warm weather the Hudson Valley landscape seemed to soften and sweeten, to bloom and then to rot. Summer nights at Beechwood were heavy with the fragrance of honeysuckle and roses, the animal musks of the farm, and the sweetness of new-mown grass. We escaped the steamy air by diving into the icy water of the swimming pool."[5]

The trains in and out of the city, the drinking, the cheating—the Cheever suburbs shaped so many of our ideas of what the suburbs were like back then. When he or any of his contemporaries wrote about these places outside the cities, they were often portrayed as exactly what Susan wrote: homogenous and filled with drunks who cheated on their spouses. Sad people with secrets to hide lived in the beautiful suburbs just north of New York City.

There are also the swimming pools Susan mentions, rows and rows of them, enough to inspire what would become her father's most well-known story, "The Swimmer." It starts off on "one of those midsummer Sundays when everyone sits around saying, I *drank* too much last night," and finds the protagonist, Neddy Merrill, trying to pull off what seems like a quaint, albeit drunken idea of "taking a dog-leg to the southwest, [so] he could reach his home by water." He decides to travel the eight miles back to his home in Bullet Park by swimming in every one of his neighbors' pools. He goes "close to naked" through the Grahams', the Hammers', the Levys', and up Route 424, eventually ending up in the pool of his former mistress. It starts with a burst of energy, then evolves into a hazy, dreamlike journey that slowly turns gray and rotten the

farther he goes. When he finally reaches his destination, he finds his home locked up, empty, and falling apart, a modern ruin in the suburbs. Neddy's hubris and demons, we can only imagine, caused this downfall, which ends with him shouting and pounding on the door only to realize his family has left him behind.[6]

As Cheever biographer Blake Bailey put it, at the time Cheever was writing "The Swimmer," he, "age fifty-one . . . still flung himself into icy pools with vigorous abandon, got drunk whenever he felt like it, and was always poised to fall in love or escape."[7] It's hard not to read the story and get some sense of autobiography in there, the middle-aged man who drinks and cheats.

Cheever began conceiving the story "after a hung-over day at the pool," his biographer Bailey would write, in the summer of 1963. It started with him playing with the Greek myth of Narcissus, but he abandoned that idea. In his journals that summer he wrote, "Swimming is a pleasure, a gulping-in of the summer afternoon, high-spirits."[8]

"The Swimmer" was published in the *New Yorker* in 1964. Four years later, there was Burt Lancaster in glorious Technicolor playing Ned on the big screen, Westport, Connecticut, serving as the backdrop. Things often get lost in the translation of literature into a movie, but time can also help evolve the story into something more. It can reveal something we didn't catch or that maybe didn't show itself on the page. That's the case with Cheever's "The Swimmer" and the 1968 adaptation.

Cheever, through all his symbolism and the blend of realism and surrealist scenes throughout the story, showed that no matter what we do, no matter how much we make, how happy we pretend to be, or how far we're willing to journey, our demons catch up to us. The film, however, which came out to tepid reviews and poor box office returns, shows something a little more than Neddy's point of view. The movie came out the same year as the assassinations of Robert Kennedy and Martin Luther King Jr., heightened racial tensions, an escalating war in Vietnam, and the rise of a counterculture tempting a generation of young people to turn their backs on the comfortable lives their parents had built for them. As a result, Cheever's story took on more meaning

than he'd originally planned. The suburbs are presented as a fake place full of fake and sad people, a trend we see emerge in literature with books like Sloan Wilson's *The Man in the Gray Flannel Suit* in 1955; *Rabbit, Run* by John Updike in 1960; and Richard Yates's *Revolutionary Road* in 1961. By the end of the sixties, the dull suburbs start to show up in films, most notably *The Graduate* in 1967, *The Swimmer* the following year, and the 1975 adaptation of Ira Levin's novel *The Stepford Wives*.

The growing disillusionment with the suburbs lines up almost perfectly with the growing disillusionment with America in general; three years before the publication of "The Swimmer," Lewis Mumford, who contributed to the very magazine Cheever's story would debut in, wrote that the suburban existence is "an encapsulated life, spent more and more either in a motor car or within the cabin of darkness before a television set: soon, with a little more automation of traffic, mostly in a motor car, travelling even greater distances, under remote control, so that the one-time driver may occupy himself with a television set, having lost even the freedom of steering wheel." He went on to write, "Those who accept this existence might as well be encased in a rocket hurtling through space, so narrow are their choices, so limited and deficient their permitted responses. Here indeed we find 'The Lonely Crowd.'"[9] Similarly, in a 1962 interview with *Mademoiselle,* Jane Jacobs would call the suburbs "inherently parasitic, economically and socially, too, because they live off the answers found in cities."[10] Around that same time, right down the street from the Greenwich Village apartment where Jacobs wrote *The Death and Life of Great American Cities,* some burgeoning folk singer was undoubtedly strumming and singing a cover of Malvina Reynolds's song "Little Boxes," about the little houses and the people who live in them, the doctors, lawyers, and businessmen who are "all made out of ticky tacky" and "all look just the same," playing golf and drinking Martinis and raising kids to be just like them.

After the first full suburban decade of the fifties, intellectuals like Jacobs and fringe thinkers who were labeled everything from beatniks to communists argued that suburbia was a bad and unhealthy place to

live, and that the people who lived there all looked and acted the same. By the end of the sixties, however, finding inspiration in the mundane, sometimes tragic aspects of suburban life was common. But it also showed that the American Dream is often just that: a dream.

No matter how interesting the story might be, or how well written, there's often something a little grotesque in our portrayal of suburbanites.

And for fair reason: the suburbs are supposed to represent achievement, a better life, that you've made it. But what, exactly, have you made? Plus, when you spend years building up the suburbs as a wholesome, "better than" option almost exclusively for whites, it's understandable why many people would be inclined to pick apart these places as anything but that.

Say you pick up the *New York Post* or *Chicago Tribune* and you read about the discovery of an underground sex club in one of those cities. You might see it and think to yourself, "Par for the course in the big city." When it happens in the suburbs, however, it's a viral sensation. Just look at the $750,000 colonial built in 1997 on a quiet street in Maple Glen, just outside Philadelphia. The listing on realtor.com promised a "sexy twist" in the home, which had four bedrooms upstairs, 2.5 bathrooms, three fireplaces, new sump pumps, a private wooded yard, and another bedroom in the basement.

It was that fifth bedroom, a surprise "private sexual oasis" as the realtor called it, that offered the "sexy twist" and got the site its first listing to hit a million page views.[11] Equipped with whips, chains, a cage under the bed, and plenty of things to tie up multiple people at the same time, the room got people curious. A sex dungeon in a McMansion, of course, is an interesting story. You look at the outside of the home and you imagine the kind of neighborhood where the paperboy is named Timmy, you can always count on one of the kids to pop up a little lemonade stand in the summertime, and everybody smiles at each other. You don't imagine the Gimp character from *Pulp Fiction* running out onto the lawn totally naked with his hands bound and his leather mask zipped up tight so you can't hear what he's screaming.

There's a reason over a million people clicked that listing: the house was in the suburbs. If a similar listing showed up of an apartment or small home in San Francisco or Seattle, sure, there would be some snickers and jokes on Twitter. But somebody in the suburbs hosting BDSM night after the PTA meeting? That's just too much.

There's this obsession with the boring lives of suburbanites, especially when they aren't what they're pigeonholed to be. Because we've built up this image of the sameness of the suburbs—the Levittown white fences, the paperboy waving hello, the cul-de-sacs, the boredom—it's fascinating when something doesn't go according to script.

Maybe it doesn't seem like the same thing as a neighbor who bakes apple pies and uses that cat o' nine tails like nobody else in the tri-state area. But in the pre-internet days, the suburban soccer mom also went viral and became a symbol to be both pitied and feared: pitied because she's imagined to be a full-time mom who doesn't have much else to do with her life, and feared because she votes in districts that could swing an election.

In the nineties, the soccer mom—this stereotype of the mother who drove her SUV to drop off and pick up her kids and had only a little time between housework chores to gossip with other soccer moms—was really an idea as old as the modern suburbs. The soccer mom was the stay-at-home mom with a twist: her "hands that steered the minivan were also deciding whether to turn left or right in the Presidential election," wrote Neil MacFarquhar for the *New York Times* in 1996. "If Bob Dole did not find a way to appeal to such women, they might swing the election for Bill Clinton. In his closing statement during last week's Presidential debate in San Diego, Mr. Dole even addressed soccer moms directly, saying he understood their problems." The soccer mom—the type of person who, MacFarquhar wrote, "at her most flashy might be found in a television commercial, peddling an improved brand of tuna fish"—was a caricature, and a sexist one at that.[12] Yet the idea of the soccer mom drew both heavy interest and ridicule. This obsession with suburban women is something you tend to see over and over.

Before the soccer mom you had the image of the bored suburban homemaker, the type portrayed on the 2000s show *Mad Men,* who

suffered in silence while her husband and children did whatever they wanted. The housewives were the women taking valium to get through the day in songs like the Rolling Stones' "Mother's Little Helper"; Mrs. Robinson seducing young, naive Benjamin in *The Graduate;* or the Stepford wives. Later, the docile matriarch would eventually give way to a suburban caricature that was the exact opposite, like Annette Bening's Carolyn Burnham in *American Beauty,* who cares more about career than family, or Carmela Soprano in *The Sopranos,* who seems to have a pretty good idea what's going on when her mobster husband Tony leaves the house, but who for the sake of her kids and her comfort sticks around. Mary-Louise Parker's Nancy Botwin starts selling pot in her upper-middle-class suburb to make ends meet on *Weeds,* even though (when the show came out) it was illegal. Today cannabis is legal in California, but the show is premised on the idea that she's doing a bad thing, though it could be much worse because she's only selling it to help her family.

The point is that these lives, real or fictional, interest us. We keep going back to suburban stereotypes: men who bury their deep sadness with booze or machismo; the soccer mom; the person dealing drugs or running a sex dungeon out of their McMansion. And every generation gets its own film about bored suburban high schoolers, from 1982's *Fast Times at Ridgemont High* and 1993's *Dazed and Confused* to 2007's *Superbad* and 2019's *Booksmart.* We pry into the lives of suburbanites because they're more interesting than we give them credit for, sure. But there's also something satisfying that comes with a sneak peek into the stories of people whose perfect lives are really as from far from perfect as you can get.

Part 2: Tessie Hutchinson Will Have Her Revenge on the Village

I've been going to Boca Raton, Florida, for as long as I can recall, back to when there were strawberry fields behind my grandparents' then-new townhouse in the western side of the city. My nana would sit at her kitchen table sipping her coffee. I'd join her, staying quiet because I

could tell this was her time to herself. I'd find myself just staring out the window, transfixed by the rows of strawberry bushes resting in the sunshine. Those little moments play back in my memory from time to time: I was young, and I felt safe and warm. It was the epitome of the suburban dream, especially for my grandparents, who up until that point had always lived in northern cities that were bitterly cold for half the year.

Today, the fields are gone, replaced by rows of nearly identical white houses. If I were to direct a movie about my life, the destruction of those fields could be a metaphor for the loss of childhood innocence.

My grandparents, along with countless other northerners who went from being snowbirds to full-time Florida residents by the end of the eighties, settled in Boca. It was a wonderland to me, a place where there was a restaurant/arcade owned by NBA legend Wilt Chamberlain, a Miami Subs, swimming pools, and the decade-old Town Center Mall on Glades Road. So much of Southern Florida gets a bad rap for being a place for senior citizens, but to me, it was the ideal suburban setup.

More of my family eventually moved to Boca, so I found myself making trips there well into my early twenties to celebrate holidays and mourn deaths, often chugging enough cheap coffee from rest stops to fuel me for marathon solo drives from Chicago all the way down to the southern end of Florida. Boca's luster wore off for me over time, though. I'd go there and find myself engaging in the most suburban pastime of all: driving aimlessly, not necessarily looking for anything specific to do or anybody to talk with. There was always a particular feeling of loneliness driving up and down Clint Moore Road, past the closed office parks, the lights of a Publix supermarket, or the sprinklers feeding the hand-planted lawns that reminded me that, yes, I was traveling through a place inhabited by humans. I was almost instantly bored whenever I'd end up in Boca, but I found some comfort in the familiarity, the feeling of safety, and the boredom.

In the days and months after 9/11, those things all went away, as they did everywhere else in America. Nothing felt familiar, we all feared for our safety, and the era of overstimulation really kicked in. People

were glued to the news, to CNN or Fox, trying to learn more about who, what, and possibly where could be next.

But in Boca, it was maybe a little more so. In the days after the attacks, news started leaking about the suspected terrorists' connection to Palm Beach County, that a few had lived and even trained to be pilots in South Florida. The fear there could be more attacks was voiced on television almost by the minute; Boca Raton residents had very real reason to believe their homes could be next. People talked about it on the tennis courts and golf courses of the affluent city because a week after 9/11, Boca Raton *was* attacked. In the heat of the moment, and in the pre–social media days when news didn't move at the pace it does now, it was maybe hard to realize the letter containing anthrax sent to the Boca offices of American Media (the company that publishes the *National Inquirer*) was one of several believed to be sent to media companies and politicians across the country. (Only the letters to NBC News, the *New York Post*, and two Democratic senators had been opened or detected.)

Even after the news came out that the suspected perpetrator, a government scientist named Bruce E. Ivins, hadn't targeted just one person or place, the general feeling around Boca was that there was more to come. The big attack, some believed, was going to take place in the heart of the city, its Main Street: the Town Center Mall. My younger siblings, then junior high students living in Boca, told me various stories of terrorists supposedly planning to bomb or shoot up the mall during its annual Halloween night of activities. Some concerned parents tried to get the event and others like it canceled due to similar worries; nearby Broward Mall and Fashion Mall, both in Plantation, halted Halloween events, as did others around the country. "We will increase our security heavily for that day," Town Center general manager Darin Griggs told the *Sun Sentinel* in the days leading up to the holiday.[13]

Thankfully, nothing happened at Town Center or any other mall. But people in Boca were still living in fear. In the time I spent there toward the end 2001, I heard everything from more rumors the mall was a target to speculation that terrorists were looking to spike the local water supply. On the one hand, it was clear we were living in a scary new

world. On the other, the things people were whispering about, the fears they had about how and where attacks might come, sounded strangely like urban legends that had developed over the twentieth century, from the fear of some sort of attack on Halloween to people looking to poison the masses through drinking water. While some of the concerns voiced by locals may have started as just a whisper, as an unfounded rumor that worked its way through the community, for some people, namely Muslims, Arabs, and anybody who could be confused for either of those groups, there really was plenty to worry about.

On September 15, 2011, Balbir Singh Sodhi, a Sikh American owner of a Chevron gas station in the Arizona suburb of Mesa, was shot and killed by forty-two-year-old local aircraft mechanic Frank Silva Roque. Roque, whose shooting spree would go on to injure a Lebanese American clerk at another gas station as well as a family of Afghan descent he opened fire on, shouted, "I stand for America all the way" as he was arrested.[14] He believed the first man he shot, the one with the beard and the turban, was a Muslim, not a Sikh born in India, as was the case. It was horrible and tragic and, unfortunately, one of many reported hate crimes against Muslims, Sikhs, Hindus, and others perceived to be from the Middle East or followers of Islam in the wake of the September 11 attacks. Other incidents were reported in suburbs across the country. For many, the fear of being harassed, beaten, or worse was very real. The owner of the gas station not too far from my family's home in Boca Raton took to wearing a button that said, "I am Sikh American, not Muslim" with an American flag pin above it.

Panic led to violence; people do horrible things when they're afraid. It was a scary new time in America, but it somehow felt familiar. Like we'd heard these sorts of stories before, about sacrificing things and people, and about how fear leads us to turn on our neighbors.

Shirley Jackson's New England town sounds like Susan Cheever's description of her childhood home in the suburbs of Westchester: "clear and sunny, with the fresh warmth of a full-summer day; the flowers were blossoming profusely and the grass was richly green." The Martins show up

to the event, as do the Graves and Summers. There's an old man who has "time and energy to devote to civic *activities*," people trading local gossip, and a woman who gets stoned to death by the locals. That part never shows up in anything I know of that Cheever ever wrote, but it's the horrifying climax of another story published in the June 26, 1948, issue of the *New Yorker,* possibly the most famous in the magazine's history: Jackson's "The Lottery."[15]

In her biography on Jackson, Ruth Franklin writes that a decade after Orson Welles pranked the country into thinking an alien invasion was taking place, "some did take the story for a factual report," since the magazine didn't designate whether or not a story was fiction or nonfiction back then. "As a psychiatrist, I am fascinated by the psychodynamic possibilities suggested by this anachronistic ritual," one reader, who believed the story to be fact, wrote in. As Franklin points out, there are more than a few theories about what the story is supposed to be about, noting that Jackson herself gave various insights into it, including "an insistence on the uncontrolled, unobserved wickedness of human behavior."[16]

Although Franklin believes Jackson took some liberties with telling the origin of the story, that it bothered people so much that some readers canceled their *New Yorker* subscriptions doesn't seem to be a commentary on any group of people from any specific place (although, one of Jackson's friends said the story had to do with anti-Semitism, and Franklin points out the theme of the story is comparable to a book written by a Holocaust survivor). The magazine itself responded to the furor by saying, "It's just a fable," and that's what I go by.[17] It's not supposed to be about the suburbs, but it's difficult not to think they influenced Jackson, just as it's not hard to view the attacks on innocent Arab Americans, Sikhs, Muslims, and other brown people in the suburbs after 9/11 as similarly ignorant and pointless attempts at alleviating fear. Jackson's characters hoped stoning a community member to death would bring a good crop season; the people who would go on to commit hate crimes in real life were out for revenge and motivated by some misplaced idea that going on the attack might keep them safe.

You can read fiction and come away looking at the little nuances of modern life or peoples' motivations in a different light; it can change your perception and make you more empathetic, even if it's not the author's original intention. Great fiction tells us so much more than just a story. Jackson, through horror and suspense, often explained the suburban condition better than nearly any other writer before or after. Having grown up in the affluent San Francisco suburb of Burlingame, California, a place that today has a median home value of over $2 million, she was aware that people felt alienated when they lived outside the city in the supposed peace and quiet. "I suppose it starts to happen first in the suburbs," one character who has moved with her husband from the city to the suburbs says in "Pillar of Salt," a story from the collection *The Lottery and Other Stories*. When the character's husband asks what, exactly, happens in the suburbs, she replies hysterically, "People starting to come apart."[18] Franklin also notes the "Stepford-like vision of the future" in a piece Jackson wrote for *Vogue* in 1948 about plastic and other artificial things being brought into "our charmingly fabricated living rooms, our glittering kitchens," and how the modern innovations of the time would lead to the day when "we women will find ourselves completely useless."[19] And while "The Lottery" may be a fable or a commentary on how downright horrible humans can be, it would be easy to place the same story on any street in any modern suburb, with its neighbors blindly acting the same way, committing horrible acts against each other in front of some idyllic backdrop.

A little less than a year before "The Lottery" scandalized readers, the autumn 1947 issue of pulp magazine *Planet Stories* ran "Zero Hour." Wedged between "Crash Beam" and "Asteroid Justice," the story didn't cause much of a sensation; it wasn't even included in *Dark Carnival*, the writer's debut collection of stories that came out that same year. To this day, when you talk about the work of Ray Bradbury, you think of *The Martian Chronicles, Fahrenheit 451*, or Green Town, the fictional setting he based on Waukegan, Illinois, the Chicago suburb he lived in as a child. "Zero Hour" doesn't really come up right away. Included

in the collection *The Illustrated Man,* it's not exactly a minor work of his, but it isn't one of his most well-known either. Like "The Lottery," though, it foreshadowed much of the anxiety and discomfort we have with the suburbs. Set in an unspecified time in the future, "Zero Hour" imagines a little neighborhood where rockets stream across the sky and "beetle cars" whisper by on the streets, where kids are left to their own devices and the parents, who seem too busy to pay attention to what's going on, inevitably suffer when we find out the game the children have been playing is actually helping pave the way for an alien invasion.

Jackson (born in 1916) and Bradbury (born in 1920) were both products of the prewar American suburbs. Jackson not only gave us "The Lottery" but also the isolated estate the Blackwoods live on in *We Have Always Lived in the Castle* and the haunted Hill House, places where there's something far deeper behind the spirits that may occupy that home down the block. In Jackson's world, loneliness and isolation are just as frightening as a ghost.

Bradbury, who moved out west as a young boy, witnessed the building of the sprawl firsthand, and it played into his work. As Michael Ziser wrote for the online magazine *Boom California,* "No writer of the period takes as many pains as Bradbury in detailing the material and psychological consequences of the explosion of residential construction in California after World War II."[20] But it's his stories set in the fictional Green Town, Illinois, that connect him with Jackson and the early strains of suburban gothic that would go on to make up so much of speculative fiction. In Bradbury's Green Town, you're supposed to feel safe and comfortable, but you also sense there's something lurking, something evil, things you should be afraid of even though you can't always put your finger on them.

Over a decade after the publication of "Zero Hour" and "The Lottery," a narrator's voice came over television sets across the country, setting the stage for a story that starts during a day very similar to the one Jackson describes: "Late summer. A tree-lined little world of front porch gliders, hop scotch, the laughter of children, and the bell of an ice cream vendor."[21]

This was Maple Street, another idyllic place where seemingly normal people commit horrible crimes. Bradbury's suburb had its future alien invasion, and Jackson's small town had its twisted public sacrifice. Rod Serling, creator of *The Twilight Zone,* took a similar idea and gave it a sci-fi twist. The Maple Street residents' *fear* of a possible alien invasion causes them to point fingers and turn on each other. Death and destruction follow, and in the end we learn it was all caused by extraterrestrials who orchestrated the entire thing as an experiment to test their plan to take over the world.

The Twilight Zone tackled everything from racism to war by subtly (and sometimes not so subtly) using horror and sci-fi as a vehicle, a metaphor, much like the stories of Jackson and Bradbury. In "The Monsters Are Due on Maple Street," an episode *Time* magazine called one of the ten best in the show's history, the closing narration highlights "weapons that are simply thoughts, attitudes, prejudices—to be found only in the minds of men. For the record, prejudices can kill—and suspicion can destroy—and a thoughtless frightened search for a scapegoat has a fallout all of its own—for the children—and the children yet unborn."[22] This was a bold statement to beam out to millions of viewers in 1960. America was at the height of the Cold War, and five years earlier, fourteen-year-old African American Emmett Till had been brutally murdered by the husband of a white woman the boy simply talked to. Unlike the writers who came before, Serling made sure to explain what his story was about. It wasn't a fable set in some unnamed village or small town. To discuss America's ills, Serling used the modern version of suburbia, and just over forty years after its premiere, with the murder of Balbir Singh Sodhi and countless other hate crimes committed in the wake of a disaster, it seemed almost prophetic.

If somebody from the middle of the twentieth century could build a time machine and witness the realities of post-9/11 America, it would probably resemble a horror story or dystopian novel or something out of *The Twilight Zone* to them: wars abroad, violence at home, school shootings, surveillance, the rapid spread of technology, AI, reality television. Just a look at what was considered sci-fi fifty years ago reveals

the phrase *stranger than fiction* has taken on a new meaning. And in the years directly after the attacks, the fear of mass annihilation, of big cities or all of humanity being wiped out by some madman or monster, took over from the killer that stalks suburban streets murdering teenagers one by one. The abstract became literal; you see it in horror films like *Cloverfield* or at the end of *The Cabin in the Woods*. Even superhero movies saw entire buildings of glass crumble to the ground, countless lives lost. Jackson, Bradbury, and Serling had created stories that seemed farfetched or worst-case scenario in the middle of the previous century, but in the new millennium often felt all too real (save for Bradbury's aliens . . . for now). As mass urbanization spread like the Blob throughout the second half of the twentieth century, Americans needed stories to explain their often abstract troubles. In turn, we got some of the most iconic horror franchises in cinematic history. The suburbs of Pittsburgh gave us George A. Romero's zombies as a metaphor for the turmoil of the sixties and later consumerism in the eighties. Michael Myers, from John Carpenter's *Halloween* franchise, is from the fictional suburban town of Haddonfield, Illinois. He murders for no apparent reason and is locked away in a mental asylum at the age of six. Out of sight, out of mind. It's a very suburban approach to things. And while Jason Voorhees from the *Friday the Thirteenth* franchise is an eighties outlier, doing most of his killing in the woods, his competition at the box office throughout the decade, the blood-thirsty spirit of child killer Freddy Krueger from a *Nightmare on Elm Street,* is something from the Ohio suburb's horrible past that adults don't want to reveal to their kids. Those kinds of fears didn't impact us as much after 9/11. We were too afraid of real-life things to have time for monsters.

During the second half of the twentieth century, TV shows, movies, and writers from Ira Levin to Stephen King helped the suburbs appear absolutely terrifying. There seemed no end to stories of the weird and spooky suburbs, from the haunted house in the planned community in 1982's *Poltergeist* to the town where everything is askew in the early-nineties kids show *Eerie, Indiana*. By the end of the century, however, it was a trope that was ripe for parody and self-reference, like 1996's

Scream, directed by Wes Craven—who was behind the camera for *A Nightmare on Elm Street.*

As we inched closer to the year 2000, horror moved away from suburbia. The years leading up to the new millennium saw remakes of classics like Alfred Hitchcock's *Psycho* and an updated version of *House on Haunted Hill;* newer techniques, like the use of supposedly found footage in *The Blair Witch Project;* and films that generally highlighted a fear of the unknown and unseen. And while the suburban horror story didn't go away entirely after the 9/11 attacks a few years later, they didn't seem to matter as much. Films like the torture porn–leaning *Saw* franchise and *Hostel,* as well as lots and lots of zombies (*28 Days Later, Shaun of the Dead,* and so on), ruled the era that wasn't necessarily bad for scary movies. Yet some of the landmark films from the time before and after the attacks feel like they are from an entirely different era. And why not? Even technology from just a few years before 2001 felt dated a decade later, once everybody had access to a smartphone, and after the attacks, the real world was strange and terrifying enough. Freddy Krueger haunting the dreams of the high school quarterback and Michael Meyers butchering the babysitter didn't seem as important, at least to the people who make movies.

I often think back to the things that truly scared me growing up in the suburbs. Sure, the prospect of some twisted, undead killer chasing me around with a large, sharp object was terrifying, but deep down I knew that was probably (I hoped) never going to happen. And while my introduction to horror and fantasy came watching the classic 1931 version of *Dracula* starring Bela Lugosi (if we're getting technical, it was more likely Mel Brooks' *Young Frankenstein,* but it's not really as scary), I grew up in the middle of suburban horror's golden age. Stephen King adaptations, *Poltergeist;* and *Halloween,* which begat an entire generation of suburban slasher films from the *A Nightmare on Elm St.* franchise to 1980's *Prom Night.* There were some suburban horror films with a slightly more humorous bend (but still terrifying to a young kid like me), including 1985's *Fright Night* and 1986's *House.* But my favorite was

1989's *The 'Burbs,* starring Tom Hanks, Carrie Fisher, and Bruce Dern, among others. There's no real violence in the film about a group of bored suburbanites living on a cul-de-sac who get obsessed with their strange new neighbors. The film is smart because first it has this sort of "The Monsters Are Due on Maple Street" *Twilight Zone* feel to it throughout, leading you to believe that Ray (played by Hanks) and his gang are acting irrational, that they just don't understand their new, very Eastern European neighbors, the Klopeks. But in the end, their suspicions were totally justified, because the Klopeks turn out to be killers.

The thing I like the most about *The 'Burbs* all these years later is that it really highlights the sense of panic suburbanites in the eighties and nineties almost seemed to *want* to feel. Like the people in the little village in Shirley Jackson's "The Lottery," Ray and his neighbors didn't know what, exactly, they were afraid of. Hanks had no proof that his neighbors were up to no good, but he felt in his heart that if he didn't take action, bad things would happen, and that the preventive action would keep the neighborhood safe the way the people in "The Lottery" believed stoning one of their own to death would insure a good crop.

There was no shortage of things people in the suburbs panicked about during the eighties and nineties. Some were real and truly horrifying, like the abduction and murder of six-year-old Adam Walsh, who was taken from a department store in the mall he was visiting with his mother in Hollywood, Florida, in 1981. By 1983, a made-for-TV movie about the crime and aftermath was seen by thirty-eight million viewers, then broadcast again over the next two years and watched by large audiences. Richard Moran, a criminologist at Mount Holyoke College, told *Time* in 2016 that the kidnapping and murder "created a nation of petrified kids and paranoid parents" that still lingers.[23] Other things had some degree of credibility, but then blew up into hysteria, like the fear of "cults in the suburbs after a wave of cat mutilations had been discovered around Orange County in 1989.[24] Yes, there were dozens of cats murdered in the area, but as the county veterinarian pointed out, "None showed any evidence of satanic cults, human intervention or hacking." It's good to read beyond the headline.

Maybe the most famous is the Halloween candy scare, the tale that somebody slipped a razorblade into candy or laced it with poison. There are documented examples of people tampering with or handing out items kids probably shouldn't eat, but they weren't a common occurrence. In the hamlet of Greenlawn on Long Island in 1964, Helen Pfeil, a mother and charity worker, was committed to a state hospital after she handed out dog treats, metal mesh scrubbing pads, and ant traps.[25] That same Halloween, trick-or-treaters in Royal Oak, Michigan, were given bubblegum laced with lye. That turned into the various urban legends of kids being injured or killed by Halloween candy, and it only intensified after seven people in the Chicagoland suburbs were killed after taking Tylenol that had been laced with potassium cyanide by a killer who was never found. And then you have stories that are just sheer urban legends, stories of certain homes or buildings being haunted, hook-handed killers stalking teens sitting in parked cars, or stories that start at a sleepover or with a parent trying to frighten their kids. These stories grow and grow until they become part of the folklore.

Some of these sound like tales you hear at summer camp. But stories can and do lead to real-world impacts on people. The satanic ritual abuse of the eighties and nineties, for instance, leads right back to the suburbs. As the writer Margaret Talbot called it in 2001, "The myth that Devil-worshipers had set up shop in our day-care centers, where their clever adepts were raping and sodomizing children, practicing ritual sacrifice, shedding their clothes, drinking blood and eating feces, all unnoticed by parents, neighbors and the authorities," could trace its beginnings back to Manhattan Beach, California, to the McMartin preschool. Talbot, who was writing one of the *New York Times Magazine* annual "The Lives They Lived" stories on a person whose death may have not gotten much attention over the course of the year, was writing about Peggy McMartin Buckey, "the paradigmatic victim of ritual-child-abuse hysteria: a middle-aged woman who worked in a day-care center run by her family and who had, until the day she was indicted, led an uneventful and unobtrusive life." As Talbot pointed out, the parent who filed a

report that her son had been sodomized at the school was later found to be a paranoid schizophrenic who had made accusations "of teachers who took children on airplane rides to Palm Springs and lured them into a labyrinth of underground tunnels where the accused 'flew in the air' and others were 'all dressed up as witches,'" leading a small army of therapists, social workers, police, the FBI, and Interpol to show up at the school's door. The result was a seven-year trial of seven people, including Buckey, on a total of 135 counts that cost $15 million and did not net a single conviction. Still, "Buckey served two years in jail, and her son, Raymond, served five. They spent their life's savings on lawyers' fees and in the end went 'through hell' and 'lost everything,' as Buckey put it after her 1990 acquittal."[26]

Satanic ritual abuse, drug panics like the legend of the temporary tattoos laced with LSD, and the fear of the violent outsiders getting 'in' to the suburbs are all, for the most part, anxieties and prejudices coming to the surface. When I was growing up in the nineties, there was a fear among adults that "gangbangers" were going to drive an hour north from Chicago, give drugs to the teens, then drive past houses and spray them with bullets. It all probably sounds absurd, but these were things I actually heard adults talking about, and they went to great lengths to make sure our little neighborhoods didn't turn into the violent urban areas depicted in movies and on television. There was the time a teacher told me to be careful because the Chicago Bulls starter jacket I wore when I was thirteen was popular with the L.A.-based gang the Bloods (even though the gang never had a known presence in the Chicagoland area at the time). Two years later, parents tried to get Wu-Tang Clan shirts banned, believing the hip-hop group's logo signaled affiliation with a gang.[27] Since I was one of those kids in a Wu-Tang shirt, I had to have a talk with the single member of the school's "antigang taskforce," a retired cop from the suburban city to the north of where I lived. These were the things people feared in the pre-9/11 American suburbs. It almost seems quaint in retrospect. The modern fears of looming terrorist attacks and the real, documented gang violence that politicians and the media are always willing to use

to their advantage ("MS-13 Terrorizing American Small Towns and Suburbs Ill-Equipped to Fight Back" screamed one 2017 Fox News headline[28]), are enough to make any adult not envy today's young.

Still, I grew up afraid of nearly everything, because adults told me that strangers wanted to kidnap me and Bloods or Crips were going to take over my town. (This was literally something a police officer told us could happen, and *did* happen in some unnamed part of "Southern Illinois" when he visited our school in 1993. I've never found evidence to back this up, but the story was ludicrous enough that I still think about it nearly thirty years later). I sometimes ask people who grew up in the suburbs and were born anywhere from the late seventies all the way into the early nineties what their biggest fears were that, today, seem irrational. One told me he was afraid of a certain section of his local mall because he had heard three children had been abducted from the same spot (he found out later this was totally untrue). Another told me about the house he and his friends simply called "the gate," because it was almost impossible to see from the road, hidden as it was by trees and a fence with a huge wooden entrance that he never once saw open. The belief was that a group of Satanists lived and practiced there. The median home value in his neighborhood was over $400,000, so, as he points out, it would be a pretty expensive place to use just for worshiping the devil, "but to each their own." Others talked of neighbors, of various rumors about them, their supposedly sordid pasts and horrifying practices—witchcraft, murder, and even a Nazi who had escaped Germany (when in fact the man with the funny accent was a Jewish Holocaust survivor). Two mentioned rumors of places near their homes that were supposedly haunted because they were built on Native American burial grounds.

Everybody has heard that one before. And just like so much American legend and lore, as writer and haunted house expert Colin Dickey notes in his book *Ghostland,* there's more to the myth of a home plagued by spirits on supposedly sacred ground than a scary story. Dickey writes that that anybody who buys a home in America is buying a piece of the American Dream, that they expect safety, security, happiness, and

a lack of uninvited entities in the home. "The haunted house is a viola-tion of this comfort, the American dream gone horribly wrong. And in the last few decades, the most common cause for a house's haunting—a problem cited so frequently it's almost become a cliché—is the Indian burial ground."[29]

There's maybe no tale of the haunted house on an Indian burial ground more famous than *The Amityville Horror,* a supposedly true story that stems from a very real, very awful crime.

On November 13, 1974, fifteen minutes away from Levittown, on Long Island, a real mass killing took place in a quaint Dutch colonial at 112 Ocean Avenue in Amityville. Ronald J. DeFeo Jr. shot and killed the six other members of his family. Over a year later, the Lutz fam-ily, believing they were getting a bargain on the house with a swim-ming pool and boathouse for $80,000, moved in. What happened next sounds like something from a horror movie, because that's exactly what it turned into. The Lutz family's account of living in the house shocked audiences. They claimed that the home was haunted by an evil spirit that caused insects to swarm, slime and ooze to drip from walls, red eyes to stare out of the windows, and all sorts of other ter-rifying stuff—which helped turn the book into a huge success and spawned a series of films, including the original 1979 *The Amityville Horror; Amityville 3-D* in 1983; 1992's *Amityville: It's About Time;* then an entirely new reboot in the 2000s, including a remake of the original, 2015's *The Amityville Playhouse,* and *Amityville Prison* in 2017. The reason the Lutz family believed all these horrible things happened—the murders, the ooze, the awful remakes—was because the Shinnecock Indians used the land for their sick and dying, accord-ing to the local historical society. Of course, as a 1979 *Washington Post* article, "The Calamityville Horror," points out, that was just one of the many inaccuracies in the book.[30] The Shinnecock didn't live any-where near the house and almost certainly didn't use the land to keep their dying and dead. The idea put forth by the book *The Amityville Horror* was that not only was the alleged haunting because the home was placed on a burial ground, but also that the horrific murders committed

by Ronald J. DeFeo Jr. were also connected to where the home was situated.

This is problematic for many reasons, obviously. It's nearly impossible to go anywhere in North America and not see something that gets its name from Native American culture: Mishawaka, Indiana, is named after Shawnee Princess Mishawaka. The Waco people lived on the Great Plains before the founding of Waco, Texas. *Waukegan* was the word the Potawatomi used for a fortress, and the name of the state it's in, Illinois, comes from the French interpretation of an Algonquian word for somebody speaking normally. You can drive down suburban streets with Native American names or send your kid to a high school with a Native American mascot and a team name like the "Braves" or "Redskins" (although, as of 2019, states like Maine and Oregon have banned this practice).[31] The Mondawmin Mall in Baltimore is named after a deity believed to give people corn. Even the raccoons and skunks that rummage through garbage cans derive their names from words used by native peoples. As Dickey writes, this all plays into the suburban consciousness and comes out in stories like *The Amityville Horror* or Stephen King's *Pet Sematary*. "The narrative of the haunted Indian burial ground hides a certain anxiety about the land on which Americans— specifically white, middle-class Americans—live. Embedded deep in the idea of home ownership—the Holy Grail of American middle-class life—is the idea that we don't, in fact, own the land we've just bought."[32]

The truth is that, often, people from the suburbs create the things they're most afraid of from their anxiety and angst. Sometimes it's harmless and becomes part of the legend. There are rare occasions, like with the satanic panic scare, that it turns into something bigger, something from a *Twilight Zone* episode. But there are some who can take those suburban fears and anxieties and turn them into our new folklore and our new stories. Most recently, it's the online creepy pasta stories. Based on message boards and blogs, the most famous of these stories is the Slender Man, a very tall man who looks like something out of a story by H. P. Lovecraft with long tentacle-like arms. Somebody started the tale, and others built it up into a viral sensation, with new stories

and new motivations for him. In the spring of 2014, two twelve-year-old girls from the suburb of Waukesha, Wisconsin, who claimed they wanted to impress the Slender Man, took one of their friends into the woods and stabbed her nineteen times, leaving her to die. The girl made it to the side of the road and was found by a cyclist, taken to a hospital, and survived. Her friends were found later wandering by the side of the road. They were tried, convicted, and given prison sentences that will carry well into their adulthood. Soon came the inevitable moral panic: schools blocking creepy pasta sites, the fear there would be copycat attacks, and the inevitable *Law & Order: Special Victims Unit* episode based on the story.

While horrific, the Slender Man stabbing showed people would always find things to fear in the suburbs.

What's Reality, Anyway?

Part 1: Utopia, Revisited

For the children and grandchildren of people who were old enough to see the beginning of the modern suburbs—Generation X, the millennials, and Generation Z, born, according to most definitions, from the midsixties all the way to the present day—the great promise of suburbia had lost some of its luster by the time they arrived. This was due in large part to slow economic growth (otherwise known as "stagflation") in the seventies that put a halt to the forward momentum of the decades following World War II. Fuel shortages meant getting around wasn't as easy as it had been in previous decades; houses built in the forties and fifties were starting to show wear; and in the sixties and early seventies, white baby boomers who had been given the gift of a healthy economy and the bright, shiny future outside the cities where their elders had lived and toiled rejected many of the traditions, norms, and laws that in some cases had been in place for centuries. With the emerging generation gap came a rejection of what previous generations considered the American Dream. The narrative changed. The suburbs were bland and bourgeois, no longer the space-age neighborhoods of tomorrow that they once were. The shine had worn off, but developers kept building more homes and neighborhoods, and people kept moving to

them despite housing market crises popping up throughout every one of the last three decades of the twentieth century.[1] Fortune 500 companies moved *outside* cities, big box stores opened outside cities, and the suburbs kept getting bigger and bigger, often awkwardly. You could go nearly anywhere in America and find housing developments, rows of ranch homes covered in aluminum siding with green lawns that all looked very similar, situated next to big gaps of empty or wooded areas. You could drive a little ways and find nondescript business parks that went dark and silent at night, and of course you could find suburbia's Main Street, the mall (more on that later). This is a typical description of the suburbs as people who experienced suburbia from the seventies onward might recall them.

The houses grew bigger, and more space was taken for townhouses, apartments, and especially McMansions. These homes, as Kate Wagner of McMansion Hell points out, are guilty of many crimes, from a total lack of balance among the parts of the building to the bad craftsmanship all the way to the often horrible landscaping. "McMansions lack architectural rhythm," she writes in one post. "This is one of the easiest ways to determine between a McMansion and a, well, mansion."[2]

The often gaudy and sometimes straight-up grotesque McMansions grew in stature thanks in large part to developers like Toll Brothers, who, in William Levitt fashion, mass-produced the homes identified by, as Virginia Savage McAlester points out in *A Field Guide to American Houses,* "complex high-pitched roof[s]" that tend to be "favored for huge custom-designed homes of five thousand to ten thousand square feet and up."[3] The houses typically employ a mishmash of styles that doesn't make much architectural sense (columns on a colonial or craftsman revival home, for instance). As Leigh Gallagher writes in her book *The End of the Suburbs,* "Provenance and accuracy weren't as important—it was size and scale and how much it glittered that mattered."[4]

You also saw blossom this idea that no matter what critics said about the suburbs, an old-timey feel could be built in newer communities where everything was laid out according to plans that said how every

little thing was supposed to look. The look would create a certain feel, and the idea was that people would pay big money because these places *felt* like they came from a simpler time.

As we've seen when it comes to suburbia, nothing goes according to plan.

Long Grove, Illinois, is one of those places: it has its share of McMansions and a promise that the village would maintain a semirural atmosphere. It was once indeed a "long grove," before white settlers came along. There's still grass growing wild, and some of the hickory trees there were around long before the neighborhood. The Village Tavern on Old McHenry Road claims to be the oldest restaurant and tavern in Illinois, dating back to 1847. Private roads are encouraged to limit traffic. Despite the buildup over the years, it still feels like there's a lot of open space.

I know all of this not because I researched it, but because I lived there. My family had done well enough throughout the eighties that my father felt an upgrade right before the start of the nineties was in order.

Our progression is a very American story: my father was born in Europe right after the war to Jewish parents who barely survived the Nazis. When they came to America, his parents worked and worked and worked until they finally found a niche-enough business, a little hole that nobody else was filling (they manufactured wafer candy, produced inexpensively and sold at a low price; the boast I heard was they outsold American staples like Oreos in the eighties), and moved from the city to the suburbs. In the seventies they eventually ended up in the Chicagoland suburb of Morton Grove, where my family finally became homeowners in America, purchasing a cool-looking modern ranch home with a cross-hipped roof and some cool midcentury flourishes. After my parents separated, most of my childhood was spent living all around the Chicagoland area. I was shuttled between both parents' various homes, including the house in Morton Grove my grandparents had purchased a decade earlier that my father lived in for a brief time after my grandmother passed and my grandfather retired to Florida. Eventually he sold that house and settled in Long Grove. In a McMansion.

Of course, back then I didn't know the term *McMansion;* I just thought it was the biggest house I'd ever lived in, complete with an acre of land in the back, a huge wooden swing set, a basketball hoop in the driveway, a fireplace inside, a nearby pond, and plenty of wooded area that bordered our backyard that I found myself staring at from behind a window at night, wondering what horrors lurked there. In the daytime, however, it was quiet, bucolic. I remember one late-summer evening watching a small group of hot air balloons flying right over our little piece of dream; it felt so surreal, like something out of a movie.

But so did everything else, really. I'd walk down the street from my house to this great wide field with nothing in it save for a green metal box, about four feet high and four feet wide, that did . . . something. I'd stare at the box and wonder what it was for and who put it there. When I was a teenager, I heard somebody refer to a similar box as a pad-mounted transformer that distributed electricity to a nearby house, but when I was eight or nine, I believed that box held all sorts of wonders. It was something explorers had left behind or some magic box that recorded all the conversations of the neighbors, something out of a Ray Bradbury story long before I'd read him. All around me there were other indicators that humans had conquered nature and bent and reshaped it into something *resembling* natural. I'd stand in the middle of my yard and listen to the birds and crickets, trying to figure out what the slow, strange hum was that always mixed into the little symphony that kicked up just before dusk. Once, I followed the sound and realized it was simply wires hidden from view, doing what, I was never quite sure.

These were the earliest examples I can recall of when I tried to paint my own version of the world, where I used my imagination to fill in suburbia's gaps. It's also the first time I can remember thinking something was off to me, that either I didn't fit in the suburbs or something about my setting just wasn't right. Everything on our street in Long Grove looked nice; the neighbors next door had two sons and a pair of golden retrievers; the house on the other side was home to a younger couple with a pair of twins; some of the dads or sons mowed their lawns on the weekends while others hired people to do their mowing; we kids

spent time at each other's houses, for birthday parties and to watch football. It was a little community, but Long Grove, and every suburb I lived in after it, seemed strange to me for reasons my young mind couldn't put a finger on.

And I did as soon as I could. By eighteen, I got out, sort of. I'd started going to college in the suburbs, but moved to Chicago by the end of the first semester, ending up in what I'd say was a pretty large apartment for a fraction of what I pay now for a much smaller place in Brooklyn.

I look back on those first few months in the city as nothing short of magical, the way I imagine most teens who finally move to the city and experience freedom from suburbia do: I read books on the fire escape, sometimes putting a candle in an old forty-ounce beer bottle to lend a little romantic flair; I went to parties at art galleries that were around for only a month or two; I went to see a free jazz performance in the basement of a bookstore; I started hanging out at a coffee shop where all the cool artists and people and bands were known to congregate, and I eventually got a job slinging lattes and carrying trays of coffee at a similar café. I'd grown up on a steady diet of seeing places like Central Perk on *Friends* and the Peach Pit from *Beverly Hills, 90210* to know that if you didn't have a career choice in mind, there was nothing cooler than working in a place that served coffee to young, good-looking people.

On the other hand, I was always broke, my health was pretty lousy, I ate dollar slices of pizza and a free soda for nearly every other meal, things in my apartment didn't work for months on end, and I found myself missing silence. Little did I realize that this was the start of my new life as a city person, that for the next twenty years my address would always be in Chicago and later in New York City. But none of that mattered. Nothing fazed me in those early days. I was young. I walked or rode my bike everywhere and had a strong enough metabolism that I could digest all the packets of ramen and veggie burgers I pretty much lived on.

I also watched a lot of movies. Thanks to a film-buff roommate, I got my fill of work by Alejandro Jodorowsky and Spike Lee, French new

wave, classic Hollywood cinema, and a hearty dose of opinions on which of the newer films he'd bring back from the cool indie video store where he worked were good or total garbage. His was a little master class in enjoying cinema in ways I'd never experienced, complete with him loaning me books on Alfred Hitchcock and Orson Welles or collections of reviews by film critics like Pauline Kael. Two of the movies we watched—one that was new at the time and another that had been around for a decade but I hadn't seen before—resonated with me maybe more than all the others as I was trying to justify shedding my suburban skin and never looking back.

I couldn't help thinking of that green metal box in the middle of that field in Long Grove the first time we popped *The Truman Show* into the VCR, about those creeping thoughts that something wasn't totally right, that everything looks in the right place and nice—almost too nice. Jim Carey's Truman Burbank believes his hometown of Seahaven Island is just like any other place, even though he doesn't have much to compare it to, since he's never actually left his hometown, a place that's really just a huge television studio disguised as a Norman Rockwell painting come to life. Seahaven Island is housed underneath a giant dome, and nearly everybody on the planet is watching Truman's every move. They're watching him live his life and do day-to-day stuff. He's a celebrity just for being a dorky suburbanite. It's reality television that almost sounds like an early version of the "SimStim" from William Gibson's work, the watching of a reality-like program, the experiencing of life entirely from the point of view of one person—the kind of show that experienced a boom in the real world in the 2000s, like *Big Brother* and *Survivor*. It also sounds like it could be from a *Twilight Zone* episode, because that's what the film was inspired by, albeit the 1985 revival of the show and not something Rod Serling wrote. The *Twilight Zone* episode follows a man named John Selig, who, like Truman Burbank, starts to realize his entire life is being filmed and watched by millions of viewers. But *The Truman Show* has an Eisenhower-era look; every little thing is where it is for a reason, everybody smiles, and everything is spotless. Whether it's Llewellyn Solomon Haskell's vision for Llewellyn Park as such a perfect

place that it could tempt Christ to return to earth or William Levitt promising the American Dream to people, the suburbs are sold on this idea of utopianism; *The Truman Show* just takes the idea and twists it a little. Truman thinks he's living in a utopia, but it's really the opposite. It's that false sense of security that the suburbs enable.

I couldn't find any green metal boxes when I visited the real-life setting for Seahaven Island on the Gulf Coast of Florida. I also noticed an absence of cameras keeping an eye on things, a rarity in our age of surveillance (but then again, the cameras in the movie are mostly hidden). That, and I *walked* past people; people smiled and said hello to me; it was always warm; and I couldn't find a speck of trash whirling around or an abandoned storefront anywhere. I know enough that there's no such thing as a true utopia, but I could see how Jim Carey's character would be lured into a false sense of comfort in such a picturesque setting. It didn't feel like your typical suburb, but that's sort of the point.

Seahaven Island isn't a movie set. It's a real place called Seaside. A master-planned community on the Florida Panhandle, almost smack between Tallahassee and Pensacola, it was called "the most celebrated new American town of the decade" by the *Atlantic Monthly* in 1988, just three years after it was completed.[5] The first town built according to the ideas and philosophies of the New Urbanism movement, which aims to create walkable neighborhoods that cut all the unnecessary fat of most modern suburbs. They're aesthetically more pleasing than other developments: the blocks are shorter, the homes are painted in colors that call to mind a basket full of Easter candy, the homes are closer to the curb and designed to look more inviting, calling to mind different eras of architecture, from Victorian to midcentury—"new traditionalism" as the *Atlantic Monthly* article put it. Although, as Leigh Gallagher points out in *The End of the Suburbs,* "New Urbanism is not architecture; New Urbanisms are almost agnostic to what the houses' exteriors look like, or even the architectural style of the neighborhood."[6] So Seaside doesn't need to look like "the future of tomorrow . . . today," and, in fact, the homes don't reflect one single style, giving the town a somewhat odd, quirky look. Unlike your typical American suburb,

there's no feeling of sameness when you look around Seaside, which means looking at a postmodern home next to one built in a Victorian style isn't out of the ordinary—yet it all works on some level in the community where the motto is A Simple, Beautiful Life.

And I fell for it. On an assignment that had me driving throughout the entire state of Florida, I decided to see the town that had served as the backdrop for the movie I had first seen nearly twenty years earlier, one that stuck with me and that I found myself thinking about often. I loved seeing an older couple whom I clocked in their sixties walking hand in hand, barefoot through the sand. I marveled at the cute little post office and how the last of the sun warmed the top of the Coleman Beach Pavilion, one of nine such pavilions in the community, each one created by different designers. As I made my way around Seaside, I thought about how forward thinking its creator, Robert Davis, was when envisioning the perfect little beach town nearly forty years earlier, how everything looked like it would make for the perfect Instagram selfie. I thought about how comfortable I felt.

Yet the more I looked, the clearer it became that this new version of a small American community did share a resemblance to one idea people tend to have about the American suburbs of the last half century: I saw only white people. Now, I could be wrong. I didn't spend a day or so getting to know all the people living in Seaside. Everything I learned about Seaside, I had to find out by asking residents, like the one who told me crime "doesn't exist" there, and another who proudly stated, "This is what the suburbs and the rest of America should aim to be." I asked him if he'd ever seen the movie *The Truman Show*.

"I did. Great movie," the sunbaked man wearing a Tampa Bay Lightning shirt, who I'd say was in his fifties, replied. "Sometimes I feel like I'm living on a TV show and don't know it," he cheerfully told me before telling me to have a nice day. It felt as if either he'd been told to say that if anybody ever asked him about the city's most famous contribution to film or he was just messing with me. I'd normally wager the latter, since I have a pretty good bullshit detector, but something in his tone and the way he said it after telling me what a safe and wonderful

place Seaside is struck me as a little eerie. My mind rushed to place Seaside alongside those sinister fictional towns I'd read about: Bradbury's Green Town; Stepford, Connecticut; or perhaps Ursula Le Guin's Omelas, a town where "all smiles have become archaic."[7] It's a utopia that, like the town in Shirley Jackson's "The Lottery," "sounds in my words like a city in a fairy tale."[8] There's no king, no slaves, no soldiers, and no clergy. What there is, however, is one young child left to suffer . . . beneath the surface, in a basement room "three paces long and two wide: a mere broom closet or disused tool room."[9] The child suffers so the rest of the town can be happy. God, I'm terrified of the idea of a supposedly perfect small town. I don't know if it's because I'm paranoid or I've read too much, but it all makes me think that the best thing to do is hop in my car and get out of Seaside. As I drive east, I wonder if my twenty years of city living has hardened me too much, if seeing so much cleanliness, so many smiling faces, such a nice, compact little town, has thrown me off, or if the place really is just strange. Both are possible, I guess.

That's what it was always about, wasn't it? Underneath all the childhood daydreaming of what could be hidden in green metal boxes and who lives in the weird house at the end of the street, it's really about you and whether you feel like you belong someplace or you don't. That's what Truman realizes at the end of *The Truman Show*. He takes a sailboat as far as the waters will carry him in the large, dome-world film set that is the only home he's ever known and finds a door that will take him out. Before he can exit through it, a voice comes from the sky like the voice of God, a voice identifying itself as "the creator"; it's Ed Harris as Christof, the literal creator of the show. Truman asks, "Was nothing real?" Christof replies, "You were real," before telling Truman, "There is no more truth out there than there is in the world I created for you . . . But in my world, you have nothing to fear." That was the general feeling I got from people in Seaside, that they had nothing to fear. And that was the general pitch of suburbia in the first place: that you didn't have the fear and worries you'd have in urban areas.

That isn't true, of course. You have plenty to fear in suburbia just as you would anywhere else. That's why almost anytime there's a tragedy

in the suburbs, you always see one resident say something to the effect of, "We didn't think this sort of thing could happen here." And while I did find the overall layout of Seaside to be a step in the right direction toward cutting down the sprawl we've built over the last few decades, the presentation felt like a lie, like the continuation of the suburb as a place of facades, a place people move to believing they'll have nothing to fear. Seaside offered the illusion of safety, if you could afford the average $2,540,615 price for "a simple, beautiful life" by the water.[10]

Two days later, I found myself six hours and over four hundred miles south of Seaside in another place sometimes identified with the New Urbanism tag: Celebration, Florida.

By now most people have heard of Celebration, or the Walt Disney Company's little town not too far from the Magic Kingdom. It's literally the Disneyfied version of New Urbanism: just over ten square miles of land, with developers that include the former dean of the Yale School of Architecture and the creators of Battery Park City in Lower Manhattan—which itself feels like a tiny city within a city—as well as boasting work from famous architects Philip Johnson, Michael Graves, and others. When I first get to Celebration, much like Seaside, I can't help thinking of Michael J. Fox's Marty McFly in *Back to the Future* stepping foot in the Hill Valley of 1955, a totally different, cleaner, more vibrant place than the version he knew from thirty years in the future. I feel a little disoriented, much like I have the times I've gone to Disney's various theme parks. Seaside was a little off-putting, mostly because of its connection to *The Truman Show* and the general feeling that I wasn't quite in the same tax bracket as most of the residents. Celebration is downright creepy. As Kelsey Campbell-Dollaghan wrote for the website Gizmodo's Utopia Week in 2014, "The 'town' of, today, almost 8,000 people, is situated on eleven square miles of carefully engineered Floridian swamp. It is, in the simplest sense, just another suburb."[11]

And that is what makes it so unsettling: *it's Disney's version of a suburb*. Disney, the company with a theme park where every little thing is in its right place, the "Happiest Place on Earth" that often feels like

anything but when you factor in the screaming kids and disgruntled parents baking underneath the hot Florida sun. Celebration feels more like an art instillation than a place where people live. There's nothing here that feels real; in many ways, it reminds me of the fictional place that gave us the term *utopia,* Thomas More's 1516 book of the same name. While More's island is a socialist community, the exact opposite of the corporate Disney town, I am instantly struck by how nothing looks like it is owned by anybody besides the massive corporation that built it. There's hardly a feeling of individualism or community. Instead, the people who live in Celebration seem more like they're living in a company town, or like they're part of some sort of experiment or religious sect not unlike the ones that guided the building of Llewellyn Park and Zion. Unlike those places and More's fictional Utopia, there are bars and restaurants, gathering spots for locals and out-of-towners; there's an Applebee's and a Starbucks, for instance. Again, nothing feels real or individual in Celebration. It all feels corporate, like every little thing is accounted for, and everywhere you go somebody is watching you, like an experiment. It is literally a new model of a stately old town in a part of central Florida that is relatively young from a development standpoint. While the idea of a town like Celebration is a smart one, it's simply that it's fake; there's no soul to the place. It's the modern suburban idea coming full circle, right down to the white picket fences like the ones found in Levittown.

But people do indeed live there, and sometimes they die there, as was the case when Disney's perfect little town experienced its first murder, a shocking event that became a story across the globe in 2010. Twenty-eight-year-old David-Israel Zenon Murillo bludgeoned fifty-eight-year-old Celebration resident and retired teacher Matteo Patrick Giovanditto with an ax, then tied a shoelace around his neck to make sure his victim was truly dead. The media characterized Murillo as a disturbed drifter who robbed the man who was only trying to give him a helping hand. Murillo claimed Giovanditto was a sexual predator who drugged and tried to rape him, and that Giovanditto had done that to other young men in his position.[12]

A few days after the Giovanditto murder, just as the first early-December Christmas decorations were going up, Craig Foushee, a fifty-two-year-old former pilot for American Airlines who had served in the U.S. Air Force, barricaded himself in another Celebration home after his wife called the police on him. Upset over an impending divorce, Foushee spent fourteen hours in a standoff with police, firing several shots at officers before turning the gun on himself.[13]

Nobody I talked to in Celebration seemed to remember these events from just six years earlier. Not that I figured residents would want to talk to a stranger about some horrific deaths in their neighborhood, even if they could remember much. Still, the responses I got were, to put it mildly, strange. One person smiled and nodded when he told me, "No, I didn't know about that." It felt like everybody I talked to in Celebration was a publicist working to maintain the town's image.

Life went on in the town even after Disney sold Celebration to Lexin Capital in 2004, and when I visited in 2016, something else was noticeable: stagnation. Music from the years after the Second World War played from speakers I could never seem to find, and everything was still manicured and preserved. Twenty years earlier, when I first visited the town on a trip to Disney World when I was fifteen in 1996, there was a feeling of something special, something new, something different, and, yes, something magical. That was long gone. When it was new, Celebration didn't feel like any other town I'd ever seen, and the nostalgia of the baby boomer years that was so noticeable in pop culture when I was growing up in the eighties and nineties was slapped onto Celebration like a thick coat of paint. Parents and grandparents were genuinely intrigued by this cute little town that looked like a place they once knew or dreamed of knowing, so of course kids like me were enthusiastic about it.

But then came news the houses were built poorly by out-of-town contractors.[14] The local pubic K–8 school, which used experimental education, pushing up to eighty kids from different grades into the same classroom, had a hard time keeping teachers and administrators. There were foreclosures, then the 2010 murder and suicide. Even the

town movie theater, described in a *Business Insider* article as "one of the crown jewels of the Town Center downtown area," a white, space-age palace that doubled as a church in the town's early days, closed in 2010 and (as of this writing) is still shuttered.[15] Celebration was deemed a failure. Media from *Bloomberg* to the *Guardian* reported on the town's various ills with a certain sense of glee. The *Daily Mail,* the British newspaper that loves to use a good controversy to get clicks, reported that "some complain that Celebration's wholesome exterior hides a suffocating 'incestuous' community which is rife with divorce and where neighbors even resort to wife-swapping to relieve the boredom."[16]

The truth is that Celebration in many ways is a great idea and a step in the right direction as to what the future of urban planning should be. It's more walkable than your normal suburb, it's clean, and, despite the gruesome 2010 deaths, it's safe.

But ultimately, it's a place that lacks soul. Over twenty years after its founding, Celebration still feels like an experiment or an advertisement for the company that initially built and eventually abandoned it. Whereas the postwar suburbs were initially sold as a different, cleaner, brighter, safer way of life outside cities, Celebration was packaged as a way to get all that while living the Disney lifestyle. What hasn't changed since Mickey Mouse left town is that nothing in Celebration seems unplanned, like everything has to be the way it has to be, that one blade of grass growing longer than the others could throw everything off. The design idea is future thinking, but Celebration feels constrictive and stuck in the past, with a newer, creepy dystopian sheen applied to it, forced perfection on a shoddy foundation. And nothing is ever perfect, not even in Utopia.

Part 2: There Was Our World and the World Was Dark

Jimmy had blond hair, blue eyes, and freckles. He called every elder Mr. This or Mrs. That. He was a Cub Scout. He played little league. He couldn't do anything on Sundays because his family went to church, but nobody ever talked about Jesus in his house and I never saw a cross

anywhere. He had a common last name that could've been Smith or Jones, Anderson or Miller. It wasn't any of those, but you get the picture. He was the stereotypical all-American suburban white boy, the type everybody likes, the type other parents wish their child was more like, the sort that caused a little good-natured trouble every now and then but was really a good kid through and through. Jimmy was half Tom Sawyer and a young George Bailey from *It's a Wonderful Life,* always down for some mischief, but nothing too bad. He always had the best of intentions and always did the right thing.

My friend fit the real-life version of an image that really developed with the proliferation of media throughout the twentieth century. He could have been on the cover of some Truman-era issue of a magazine like *Boys' Life,* in the *Archie* comics, or on an early television show like *Leave It to Beaver* or *Dennis the Menace.* You look at culture in the years following the Second World War, and you'll find Jimmys everywhere.

Parents trusted Jimmy. So when I told my dad I was going to ride bikes with him on some overcast day in the spring when I was ten, he didn't think twice. No questions were asked. I just went on my way and that was that.

I remember the path from our home in Long Grove. We went down a small blacktop hill and past three houses and a manmade pond. There was a bend in the road that led us to a small stretch of street that was canopied by trees. We'd ride that until we hit a busy road that had thin ribbons of sidewalk that weren't wide enough for us to take our bikes on, but nobody ever walked on them, so it didn't matter much. We'd get up just far enough, and I vividly remember the exact location in my mind, and Jimmy would stop and tell me we'd just ridden our bikes one whole mile. I'd watch the cars zoom past, then look to my other side and see huge fields, the last remnants of Illinois prairie.

The mile was usually the marker for us to turn around. Any farther was asking for trouble. That was normally how things went, but on that day, Jimmy grinned and asked if I wanted to see something weird.

Deep down I didn't, but I couldn't say no and disappoint my friend. So we kept riding. We rode past the golf course, and I don't know why,

but as the rain started falling, I distinctly recall a solitary man on the course, putting on a green. As the rain kept falling harder and harder, we pressed on, down the terrifyingly named Robert Parker Coffin Road (named after a former village president), through the historic downtown area with its buildings from the 1800s, when German farmers settled there, and with the newer ones that were built to look like they were from that same period. We passed the Long Grove Covered Bridge, something that you'd likely see driving in some quaint New England town out east, less so in our section of Illinois. I felt safe for a few minutes as the rain turned to mist and then went away completely. Then we hit another stretch of fields, then woods, and suddenly the dread came back. We kept pedaling up the road a little more, until finally, Jimmy stopped his bike and did that thing kids do where they stand and peddle just enough to push a few times, then glide around, then repeat. When he finally stopped, I pulled up next to him and asked what we were doing.

"We're going to see a haunted house," he said with a smile. I remember thinking that cute little Jimmy, with his messy hair and his freckles, was going to get us into trouble.

I'll save you the dramatics—we didn't get into any trouble. What we did was ride our bikes around the subdivision called Country Club Estates, around the luxury homes built a decade prior, places that cost over $100,000 when they were built in the late seventies. I specifically recall wondering if anybody lived in the houses, because I didn't see a single person for at least ten or fifteen minutes until a guy in a Princeton sweatshirt jogged past us and waved. I asked what we were looking for. Jimmy pointed at a house and told me, with a hint of uncertainty in his voice, that it was that one; that was the haunted house.

It was an unassuming, two-floor Tudor revival. Three triangles jutted out over the roof, leading to an even bigger triangle gable roof over the garage. The house looked lifeless. We laid our bikes in the middle of the street, something that we did regularly without fear of a car driving over them. We walked to the edge of the lawn, which looked as if it had been cut recently, and Jimmy explained that a decade ago, a

schoolteacher killed her husband in that house, which was supposedly built, and I'm quoting Jimmy here, on an old German cemetery that was also an old Native American burial ground that was cursed. Mind you, I was in fourth grade, so all of this seemed completely plausible in my *Scary Stories to Tell in the Dark*–addled mind.

We stood there for a few minutes, taking it all in, wondering what ghosts and demons were swirling around in the house that looked like so many of the others. We didn't move until a man opened the front door slowly and yelled, "Can I help you?" It sent Jimmy and I scuttling to retrieve our bikes and hurry away, back to the safety of my home that, as far as I knew, wasn't haunted.

My experience with the supposedly haunted house stuck with me well into adulthood for some reason or another. I remembered it very clearly, because in a neighborhood where nothing was really ever supposed to happen, it felt exciting and scary and out of the ordinary enough that it left a lasting impression. Even though I never heard anything else about a home filled with ghouls and ghosts in Long Grove, I was still curious to know if there was indeed a home where the restless spirit of some murdered man still roamed.

My investigation, which started with me Googling "Long Grove haunted house," then "Long Grove IL murder," quickly uncovered that Jimmy wasn't totally wrong, although his story was your typical embellished suburban legend about a relatively new home being haunted. The part about the burial grounds, to no surprise, was also false according to local historians I contacted. The home he pointed to, the Tudor, also wasn't the right house.

What he was looking for was another house, one not too far from the Tudor, one that, on December 5, 1977, Nola Jean Weaver rushed out of into the cold of a northern Illinois early morning. At 1:30 a.m. the physical education teacher pounded at the door of her neighbors, the Goodfellows. When Cindy Goodfellow went to see what the commotion was, she saw Nola Jean wearing a nightgown and holding her nine-year-old daughter, Tiffany. Nola Jean was frantic. "There's a fire! Call the fire department and the police," she screamed at Mrs. Goodfellow,

also saying that there were men still in the house and they had guns. After calling the police, Mrs. Goodfellow looked out the window, but she didn't see a fire or men with guns. When the firefighters and police officers arrived, they made their way into the home using the sliding glass door Nola Jean left slightly opened as she rushed out. The house was freezing, but as the authorities made their way around, officers noted a burning smell coming from one of the bedrooms. When the police tried to open the door to the master bedroom and found it hot to the touch, they summoned the firefighters, who made it in by breaking a bedroom window. Inside, as court records show, "the bed was observed to be a glowing, smoldering object which was extinguished with a hand-held extinguisher and a stream of water from a 1½-inch fire hose."[17] They put the fire out and found a body burned beyond recognition. As the *Chicago Tribune* reported, the teeth of the corpse "glisten[ed] eerily from his blackened skull" and would soon prove the body to be that of Larry Weaver, Nola Jean's husband.[18] And he didn't burn to death—he'd been shot in the head. A .22-caliber copper-covered bullet was extracted from his skull, and the burns his body suffered "occurred anywhere between one minute to one hour after his death."[19]

According to Nola Jean, her husband, after hearing some suspicious noises downstairs, told his wife to get his .22-caliber rifle and run away, that he'd stay behind and protect the house. As Nola Jean was returning with the gun, she ran into the two men, who snatched the gun from her. From Larry they demanded money. Larry said he didn't have that sort of cash in the home but could drive the burglars to a place where he could get it. So he did that while one of the men sat with Nola Jean. When Larry and the other robber arrived back, one of the men took Larry upstairs. Nola Jean said she heard gunshots, the man who went upstairs with her husband came rushing down the stairs, and that's when she took off running with her daughter to the Goodfellows' house.

That's what Nola Jean told the police, that it was a robbery that had turned into murder. The neighbors confirmed they had seen a suspicious green pickup truck creeping slowly past the Weavers' house, which backed up the story. The poor young widow, everybody thought.

But then the cracks started to appear. Investigators noticed the engine on Larry's car was cold; Nola Jean's was warm, indicating it had been driven, but there was no way the six-foot husband could've driven his wife's car in the position the seat was in. Then there was the matter of Larry's body: why was it under the covers? And why did Nola Jean agree to a lie detector test, then decide not to go through with a second test after the first one proved inconclusive? There was also the matter of footprints: they found Nola Jean's, but no other sets, not from her husband or from the burglars, were found in the snow. The police pieced together a different story, one that the widow wasn't telling them. Once they had their motive—that she was carrying on two affairs, one with her boss at the high school and the other with her brother-in-law—and discovered that there had been violent fights between the couple in the weeks before Larry's murder, not to mention that there was a sizeable insurance policy on Larry's life, well, you can guess where it went from there. Less than a year later, Nola Jean went on trial for the murder of her husband. On November 1, 1978, after ten hours of deliberation, the jury found her guilty. She was given a sentence of forty to sixty years in prison. In an ironic twist, in the part of the Illinois suburbs that would become the center of lighthearted teen movie fame thanks to films like *Sixteen Candles* and *Ferris Bueller's Day Off,* the judge that sentenced Weaver was Judge John Hughes.

The Weaver murder was a blip on the national radar that came and went by the dawn of the new decade. A little over ten years later, Pamela Smart, a high school media coordinator in the suburbs of New Hampshire, would convince her fifteen-year-old student and lover to kill her husband. The murder would inspire the book, and its film adaptation, *To Die For,* but the Weaver case was largely forgotten, save for a few people who lived in Long Grove when it happened, and the kids like Jimmy whose whispers about a haunted house in Country Club Estates helped keep Larry Weaver around as a ghost.

But learning the story of the murder, the one that turned into a local legend, made me look at the place I once lived very differently. This dark tale of murder in the affluent and supposedly safe suburb, a

place where murders just didn't happen, where people were supposed to be happy and content, flipped things around. It pulled up the neat landscaping and showed there was something rotten under the surface. The more I read about the Weaver murder, the more I started to view the place I lived in through the lens of another movie I watched with my film-nerd roommate when I was eighteen, one that had a profound impact on me: David Lynch's *Blue Velvet.*

In October 2018, over fourteen hundred new words, senses, and sub-entries were added to the *Oxford English Dictionary.* Along with *arse-kisser, bump and grind,* and one of my personal favorites, *douchebaggery,* the adjective *Lynchian* was added, making it an official, real word and not just something your friend who took a film class likes to call almost everything.[20]

Victorian London gave us *Dickensian.* The unending terrors and frustrations that sprung from the mind of Prague's most famous son, Franz Kafka, gave us *Kafkaesque.* While it's a term associated with the director, the Lynchian trope was given to us by the suburbs and small towns of postwar America. On its face, the term describes the weird-ness of everyday life twisted into something surreal and grotesque. Nothing is as it seems; all the smiles and happy neighbors are hiding something dark and sinister: the homecoming queen is also a drug addict who sells her body for money; the mother hires a hit man to kill her daughter's rockabilly boyfriend. It's the oddballs and outliers like the lady who shares a deep, psychic connection with a log. It's the fictional Pacific Northwest town of Twin Peaks, Washington, yes, but to me, the work that best encapsulates the Lynchian idea is 1986's *Blue Velvet,* a nightmarish masterpiece starring Isabella Rossellini, Kyle MacLachlan, Dennis Hopper, and others that sums up the dark side of the suburbs that we tend to overlook. No, it's not about a wife who kills her husband because she's sleeping with her brother-in-law to collect the life insur-ance, like the real-life Weaver murder. What it is about, however, is what we see and choose to ignore, and how close to terror and evil our lives always are no matter where we live.

There had been works portraying the suburbs as a downright terrifying place before Lynch started making films. Some were based in suburbia, and others derived influence from them. Sometimes, like in the stories of Shirley Jackson or episodes of *The Twilight Zone,* there was an underlying message behind the setting. In other cases, like the fiction of John Cheever, the fiction was often steeped in realism. What Lynch did in *Blue Velvet,* and a few years later with *Twin Peaks,* was take the facade of the happy, all-American town, dangle it in front of you to show you how absurd that idea is, then peel back the surface to show off something terrifying and ugly.

The movie starts with a scene that feels like a modern, colorized version of some late-fifties television show, or a short film showing people in that modern house of tomorrow . . . today, in suburbia! We get the opening credits: blue velvet sways before our eyes. It's hypnotic, luring you into a state of comfort. I recall the first time I watched the film, how Angelo Badalamenti's sweeping theme plays over the velvet as the credits roll in cursive. It feels melodramatic, like something dark and awful is about to be unleashed on you.

The fabric melts away and leaves a blue residue that gets brighter and brighter until we realize it's a perfect sky. The shot pans down as Bobby Vinton's song that shares a name with the film plays, and we see a white picket fence, that all-American symbol that William Levitt made sure was around all the homes in Levittown. Perfect red roses, symbols of balance and tranquility but also secrecy, border Lynch's fence. In Roman times and the Middle Ages, hanging roses from a door or a ceiling meant everything said in that room was not to leave it. Beauty and secrecy; I don't know if Lynch meant to do that, and I'm sure there are a thousand essays on the subject, but I always found the juxtaposition interesting. Then we get shots of an old fire truck driving by with a firefighter standing on its side, a Dalmatian at his feet. He's waving as it moves in slow motion. We get another white picket fence, and more shots of the perfect-looking American town that lead to the man watering his lawn, that American tradition of wasting water to keep your grass looking greener than your neighbor's. Nothing could be more innocent.

Except it's while doing this mundane chore that the man, who we soon find is Jeffrey Beaumont's father, suffers a stroke. The beauty is interrupted, the fifties pop song slowly starts to fade away, and Lynch does something truly frightening by taking us under the grass, literally. The camera moves slowly to find ants swarming; the noise is horrific. We're seeing what's underneath the surface of the perfect suburb.

Like I said, there are probably a thousand essays on metaphors in Lynch's work, on his style, the music he picks; everything Lynchian has been examined from nearly every possible angle. So I'm not doing that.

Instead what I'm focused on is that one particular sequence and what it represents, and this one quote of Lynch's you find whenever you Google him and see roundups of his best quotes: "I learned that just beneath the surface there's another world, and still different worlds as you dig deeper. I knew it as a kid, but I couldn't find the proof. It was just a kind of feeling. There is goodness in blue skies and flowers, but another force—a wild pain and decay—also accompanies everything."[21]

That to me is the epitome of Lynchian. Looking at what's beneath the surface, down the street, or across the tracks. Showing you that, if you look a little closer, it's all the same: everything can be distorted a little to show that nothing is as it seems.

Of course, writers and directors before Lynch were telling stories about what went on when you walked across the lawn and through the front door of some picture-perfect suburban home. Lynch just took it and twisted things a little bit more, hence people routinely critique his work by shrugging and saying, "I don't get it."

Lynch, born in 1946, is just on the baby boomer line, and part of that first suburban generation. So it shouldn't come as a surprise that he'd want to explore the dark side of these places that he and other people in his age group had been told were happy and safe. It's why Stephen King has a killer clown lurking in the sewers of Derry, Maine; why slasher films from the eighties, like 1987's *The Stepfather,* and the same year's erotic psychological thriller *Fatal Attraction,* had more of a suburban vibe. The happy family could hide a dark secret or a member with a terrible past; while *Fatal Attraction*'s Dan Gallagher (played by Michael Douglas) lives

a perfect suburban life with his wife and daughter, when he goes into the city for his job, he ends up having an affair with Alex Forrest (Glenn Close), which becomes, well, fatal. There are vampires living next door in a sweet little suburban neighborhood in 1985's *Fright Night,* and another set of blood drinkers feast on suburbanites in 1987's *Lost Boys.* People are curious about Edward with his hands made of scissors and love him when they find out he can cut hair, but the locals of the colorful suburb in *Edward Scissorhands* quickly turn on him when they realize he's never going to be like them. This book and these films all came out when Lynch was an anomaly, a buzzy director who had a few weird but acclaimed films and a network show with a cult of viewers who were obsessed with it but couldn't quite make out what it was about besides trying to figure out who killed Laura Palmer. They're all part of the same suburban gothic, but Lynch's influence has grown in a way maybe those other works have not. With King's work, for instance, you're dealing with monsters: Pennywise the killer clown, a demonic car in *Christine,* or, the scariest of all, humans, in *Carrie.* In Lynch's work, it's not quite clear what you're dealing with most of the time, but you realize it's evil, and it could be anybody or anything in your quaint little neighborhood.

But I'm letting this turn into exactly what I didn't want: a breakdown on David Lynch, so I'll stop. I just figure a little context can't hurt to explain that Lynch has given us an entirely different way at looking at the suburbs.

And I believe people *have* thought about it. We talk about the Lynchian, but what's overlooked is how often his work has influenced how we tell suburban stories. His influence can be felt in a literal sense in episodes of *The Sopranos,* most notably in "Funhouse," one of the most critically acclaimed episodes from a series with lots of critically acclaimed episodes. The sequences conjured by suburban-dwelling gangster Tony's food poisoning–induced fever dream call to mind some of Lynch's work. Films like 2001's *Donnie Darko,* too, about a troubled suburban teenager played by Jake Gyllenhaal, or the early works of the director Todd Solondz, all owe a debt to Lynch's vision. And while a show like *Buffy the Vampire Slayer* might sound like it has more in

common with films like *Fright Night* or *The Lost Boys,* there's something far more sinister lurking underneath the quaint California suburb of Sunnydale. Sure, vampires are bad, but there are things the rest of the residents besides Buffy and her friends seem almost totally ignorant of. It's very Lynchian in that way.

Like *Buffy, Veronica Mars,* another comedy aimed at a younger audience when it came out, also featured plots that smacked of Lynch's influence, from the weird (teenage) detective trying to solve crime in a nice town to the cast of shady figures. There was also *Desperate Housewives,* which starts with the suspicious suicide of Mary Alice Young and goes on to uncover the sordid lives of the residents of Wisteria Lane. (It should be noted that the Universal Studios Hollywood back-lot street set used for *Desperate Housewives,* Colonial Street, was used for everything from *Leave It to Beaver* and *The Munsters* to the 1989 film *The 'Burbs,* the "Bad Boy 4 Life" Diddy music video where the rapper/producer takes over a nice, quiet suburb, and, yes, *Buffy the Vampire Slayer.* Colonial Street, you could say, represents the circle of our suburban fascination.)

Lynch's influence continued to grow into 2017 when he debuted *Twin Peaks: The Return,* a fresh set of episodes of his iconic television show. While the show was a critical success with a modest viewership, just a few months earlier The cw premiered a show that was an outright homage to his work, one that didn't just take the campy dramas from the fifties and sixties that Lynch was so fond of playing with and shake them around. It used an American icon as a springboard for exploring the dark side of America.

Riverdale is based on the popular *Archie* series of comics and its spin-offs that have been a staple of American preteen and teenage life since the forties. Archie Andrews and his friends embody that idea of the all-American teens who are cute and wholesome, but who never shy away from getting into a little bit of good old-fashioned trouble. These qualities were held up as the American ideal since the days of Mark Twain: his Tom Sawyer and Huckleberry Finn connect to Owen Johnson's early twentieth-century prankster Dink Stover, who connects to midcentury fictional touchstones from Holden Caulfield to

James Dean's character in *Rebel Without a Cause,* and even to Dennis the Menace and Beaver Cleaver. My friend Jimmy, the one who tried to show me the haunted house where he thought the Weaver murder had taken place, was a real-life version of those characters in some ways: he might cause a little harmless trouble or go looking for adventure where he shouldn't, but more often than not, he had a sort of "aw-shucks, I'm sorry" attitude in the end (not so for Caulfield and Dean's character, of course).

The original Archie Andrews, the one in the comics, is just like that, and so is the *Riverdale* version in many ways. Except instead of having problems like whether to date Betty or Veronica or getting his buddy Jughead to stop always eating hamburgers like he does in the comics, on *Riverdale,* Archie, and his friends, in their picture-perfect town of the same name, has to deal with everything from serial killers, gangs, drugs, and cults, to, of course, parents who just won't listen. It even starts with a Lynchian twist: a dead kid in the woods. It's all delivered in this highly stylized, very good-looking way, with lots of hat tips to the Eisenhower era in terms of wardrobe, music, and cars, and more often than not, the storylines really go off the rails.

Still, *Riverdale,* with its over-a-million weekly viewers and music video aesthetic, has brought the Lynchian point of view of the suburbs as a dark and terrifying place to the masses. And once something is brought to such a wide, not to mention young, audience like *Riverdale* has, it means something. It means that the Lynchian view of suburbia, that there's a darkness hiding in the corner of the room or standing on the nice lawn, has gone mainstream, that it's accepted. And while some purists and rabid fans of Lynch's work might disagree or say it's cynicism, I think that's a good thing. It's an acknowledgment that things are far from perfect. That you can't hide from evil, and that if left unattended, places and people can rot.

The same year that *Riverdale* premiered, I learned something new about the place I believe prepared me for my own fascination with the more Lynchian side of suburbia.

Long Grove had become a "ghost town," according to the *Chicago Tribune*.[22] Gone were the tourists who flocked to the yearly chocolate and strawberry festivals. The cute little boutiques and antique shops, some left vacant for years, had mostly all closed. Realtors couldn't convince people to buy, and the town faced difficulties raising money for roadwork and other necessary projects. To add insult to injury, the famed covered bridge was badly damaged by a truck driver who didn't pay attention to the dimensions of the bridge or the signs banning vehicles over three tons.

Some said the 2008 financial crash caused all the bad luck, or that the lack of property taxes made it hard for the local government to find the money to make necessary fixes. Also, the big box stores, malls, and online shopping retailers made its quaint little downtown seem old-fashioned and irrelevant.

Those factors all probably had something to do with Long Grove's downfall. But I can't help thinking that maybe things go a little deeper to that cold December night a few decades earlier, when Nola Jean Weaver killed her husband. That maybe the spirits of things we wanted to ignore or forget came back to haunt Long Grove. That in some Lynchian way, the quaint little suburb was rotting from the inside for years, and nobody tried to cure it.

Mousepacks

Tokyo's Ginza district is considered one of the city's premiere shopping and entertainment areas. You can see landmarks like the Kabuki-za theater or shop at many high-end luxury stores, from Apple to Gucci. It was also the hot place to be in the summer of 1964, when Japan was preparing to host the Summer Olympics and show the world the comeback the country had made following the devastation of World War II. Japan was eager to ensure the area, which was sure to attract countless foreign tourists, was spotless.

Then, one hot August evening, weeks before the games would begin, police switchboards started to pop with dozens of frantic calls to the area. Police arrived on the scene in minutes. The problem they found was, as W. David Marx writes in *Ametora: How Japan Saved American Style*, "young men wearing shirts made from thick wrinkled cloth with unusual buttons holding down the collar, suit jackets with a superfluous third button high up on the chest, loud madras and tartan plaids, shrunken chino pants or shorts with strange straps on the back, long black knee-high socks, and leather shoes with intricate broguing." Marx goes on, "Police soon learned that this style was called *aibii,* from the English word 'Ivy.'"[1] The group of young men, whom tabloids quickly dubbed a scourge, were labeled the Miyuki Tribe (Miyuki-zoku). Even though they weren't breaking any laws—aibii was simply their way of

emulating college students from elite East Coast American schools like Harvard and Princeton, dressing how they *perceived* the cream-of-the-crop teens and twentysomethings in the United States dressed—the group's appearance upset some people, who perceived it as dangerous.

So one month before the opening of the Olympics, police swept anybody who looked like a member of the Miyuki Tribe—anybody in a sack suit or wearing penny loafers—off the streets of Ginza, arresting eighty-five for doing nothing.

I bring up the Miyuki Tribe because it's the perfect example of a time when society was just coming to grips with teenagers and their newly found freedoms and freaking out for all the wrong reasons. Madison Avenue realized young people were a target demographic and started marketing to them; after all, they could drive, they wanted to dress their own way, and all this new subversive music and art was popping up. The same year as the Ginza raid, you had *A Hard Day's Night* by the Beatles, the first two albums by the Rolling Stones, Bob Dylan singing how "the times they are a-changin'," and Sam Cooke telling listeners "a change is gonna come," not to mention iconic albums by everybody from the Ronettes to Eric Dolphy, the Kinks, and Simon and Garfunkel.

Critics and historians like to talk up how certain years changed everything. It was 1967 that gave the world *Sgt. Pepper's Lonely Hearts Club Band,* the Velvet Underground's debut album, *Are You Experienced* by the Jimi Hendrix Experience, and several other game-changing records. Woodstock was 1969; 1977 was the year punk broke; 1988 and 1994 usually duel for title of best year in hip-hop; and 1991 was the year punk broke . . . again. You can connect any number of important sociopolitical causes to those years having such impressive musical bounties, and although the ground didn't totally shift thanks to albums that came out in 1964, it started to. You probably wouldn't have many of the important records that came later if not for that year, and the thing that connects them all to that time is youth and change. Cooke and Dylan both sang about change, and the Beatles and Stones showed just where the future was headed and who ruled it, and it terrified the hell out of the elders.

One young person was scary; a group of them signaled that civilization was headed toward a quick downfall. Just search for videos or articles on all the riots the Rolling Stones caused in 1964 alone. Thousands of girls and boys went from screaming their heads off, willing to tear each other apart to get Mick Jagger's attention at one Blackpool concert, to smashing a piano on the stage and tearing out seats. The band was banned from the seaside resort until 2008. You can see how adults in 1964 started to show just how terrified they were of young people and the damage they might cause, be they music fans, American greasers, or the Miyuki Tribe in Japan. In February 1964, the *New York Times* ran an article with the headline, "300,000 French Students Can't Be Wrong; jammed into ancient universities built to accommodate one-tenth their number, rebellious French undergraduates are taking to the streets to demand a new deal" after a strike was called against overcrowding and inadequate facilities at the University of Paris.[2] At the same school four years later, in 1968, the students once again protested. The government's hostile response lead to riots, general strikes, and occupations throughout the country, nearly collapsing all of France. In the u.k. in 1964, the BBC reported on fights between the groups known as mods and rockers that spilled out across several resort towns in Southern England.[3] That same year, the Canadian magazine *Maclean's* ran "The Invention of the Teenager," an article on how the teens of the forties "take on a glow of existential heroes," and how that generation created the modern teenager. The 1964 teenagers, according to the writer, were reaping the fruits of their generation's labor and were being catered to by Madison Avenue and disk jockeys on the radio, who would "pick records for them and nobody else."[4] In the u.s., while a teenager in Oklahoma named Susan Eloise Hinton was writing a story about gangs of poor-kid "greasers" that would go on to become the American classic *The Outsiders,* Gay Talese, then a reporter for the *New York Times,* reported that "battling gangs reported waning." Talese wrote, "The belligerent 'bopping' gangs of New York—long the plague of the police and the sorrow of social agencies—are apparently going out of style." One psychologist the article quotes explains the decline in this way: "The energy

of young people today is displaced in two directions: by a civil rights militancy and also by a stagnation, a sort of isolation in marijuana and drugs, and the 'cool' pattern. . . . What has replaced the gang is probably more destructive to the human spirit, although it does not cause as much overt inconvenience to the larger society."[5]

That wasn't always the case in urban centers like Manhattan, Chicago, and Los Angeles. Those cities went on to see the rise of gangs, from the Almighty Vice Lord Nation to the Bloods and the Crips, largely made up of young people. But in the suburbs, in 1964, gangs of trouble-making young people basically didn't exist, if you go by the media reports. There was hardly a blip—no drugs, no violence, no crime. Nada.

Except, it seems, in Darien, Connecticut. The affluent suburb, a stop on the Metro-North just outside New York, played the awkward role of being the town that the nation fixed its eyes on.

Darien is one of those places you know only if you live there or you pass through it on your way from New York to somewhere in New England. Or you're possibly familiar with the 1947 Oscar-winning film directed by Elia Kazan, *Gentleman's Agreement,* in which Gregory Peck plays a journalist who poses as Jewish to uncover anti-Semitism in the well-to-do Connecticut suburbs—including Darien, a "restricted" community that didn't allow Jews or black people to live there, or in some cases even visit, until the mid-twentieth century.

"Gentlemen's agreements" kept minorities out of suburbs, and were common throughout affluent white northern suburbs during the first half of the twentieth century. The Fair Housing Act of 1968 finally made them illegal. But before that, in 1964, Darien faced a crisis of sorts: the kids, it seemed, were rebelling.

It started after the Council of Darien School Parents issued "a sort of little Kinsey report" that looked at petty crime like shoplifting and vandalism, as well as drinking, gang activity, and sexual activity among some teenagers. A year earlier, a local seventeen-year-old girl who lived in the area had been killed in a car accident after leaving a house party. Twelve adults, "including business and professional men and their wives,"

as one reports puts it, were arrested after the death for serving liquor to minors. Not long after, another teen was killed "in what authorities called apparently similar circumstances," according to the *New York Times*. The national media became interested in what was happening in the town, where the average yearly household income was $15,000, or about $118,606.45 in 2017. As the *Times* pointed out, some of the twenty-one thousand residents felt "that the town [was] being made to serve as a national symbol of modern suburban moral decay, on the upper-income, upper-educational plateau." In one of his sermons, Rev. Michael F. Blanchard, the pastor at the local St. John's Roman Catholic Church, complained that the accidents could've happened anywhere in the country, but because Darien was so well-to-do, the national media "made us the victims of their editorial guillotines."[6]

The local media also didn't take it easy on the parents. In late October 1964, an editorial ran in the local newspaper criticizing parents because "children are allowed to roam the streets and beaches at all hours." It went on to add that "clandestine pre-dawn dating is so general and flagrant it, alone, is a terrible indictment of our parents." The editorial, "Reform, Not Defense," complains that children are too pampered and calls on parents to be a "community more concerned with real accomplishment than social status."[7]

Darien didn't sink into some abyss or turn into some hotbed of sin. The community remains one of the richest in the u.s. and finds itself on lists of the safest cities in America year after year. The case of Darien in 1964 was simply gawking: a rich suburb with a few problems that, back then, seemed highly unusual for a place of its kind. It made news because it was an anomaly to people—a posh suburb had—*gasp*—problems. But it also made headlines because young people captivated and terrified adults in 1964.

Thirty years later, in a 1994 *New Yorker* profile on then-nineteen-year-old "It Girl" Chloë Sevigny, Jay McInerney called her hometown of Darien "that ur-suburb," and mentioned that Sevigny told her parents how much she hated them for raising her there, taking any chance she could to sneak off into Manhattan.[8] At the time, Sevigny was

known for her modeling, showing up in Sonic Youth videos and her star turn in the Larry Clark movie *Kids*. She'd go on to become something of an indie movie icon, appearing in acclaimed films and television shows, and nabbing an Oscar nomination for 2000's *Boys Don't Cry* as well as a Golden Globe for her work on the show *Big Love*.

Twenty-three years after the *New Yorker* profile, it all comes full circle with a 2017 *New York Times T Magazine* profile that brought Sevigny back to Darien. The writer, Amanda Fortini, describes Sevigny as "suburban as they come," and Sevigny even calls her childhood in the town "idyllic." She goes back to the single-story ranch house she grew up in, the one she says was great for sneaking out of, and eventually visits the appropriately named Weed Beach, "where all the kids who'd climbed out their windows at night would make out and experiment with homemade bongs."[9]

It's ironic that fifty years after Darien experienced a moral panic that made it the center of national attention, one of its most famous former residents went back.[10] It wasn't so much to show off all her accolades and accomplishments as it was to simply show off the place that shaped her, highlighting activities that, half a century earlier, would've made residents think the town was coming apart.

"None of it seems all that different from any suburban teenager acting out," Fortini writes. Yet it's exactly because she had that time to act out as a teen in Darien that Fortini believes Sevigny succeeded in the long run. As she puts it, "Although Sevigny's fame is often portrayed as a divine stroke of luck, her staying power likely has more to do with her good, solid suburbanness."[11]

Whether in Japan or the u.k. or Darien, the year 1964 signaled the coming of a new fear: the terrifying realization the baby boom had created lots of young people who were coming of age, and that there was a good chance they would overthrow the established order. The times were a-changin', a change was gonna come, and time was on the side of people like Mick Jagger and Keith Richards; that scared adults and continues to even today. Just pick up a newspaper, and there's sure to be some moral

panic over teenagers, either because they're joining gangs or a few tragi-
cally overdosed on some new crazy drug and people fear an epidemic
of deaths is sure to follow. But after 1964, the fear started to reverber-
ate throughout the culture. You see it in films like 1968's *If. . . .*, which
depicts rebellious boarding school kids who revolt against the adults,
and Stanley Kubrick's 1971 adaptation of the Anthony Burgess novel
A Clockwork Orange, which features Alex (played by Malcolm McDowell)
and his gang of teenage droogs committing all sorts of crimes from bur-
glary to rape. In 1979, another film adaptation, this time of Sol Yurick's
1965 novel, *The Warriors,* showed a New York City overrun by gangs of
cartoonish but really cool-looking young people like the Baseball Furies
and the Lizzies. *If. . . .* and *The Warriors* were supposed to be set against
a modern backdrop, while *A Clockwork Orange* was a disturbing look
into a future where teens run free. What all three films share is that
parental and authority figures usually do a horrible job trying to control
or help young people, or they're totally absent from the lives of the teens
and the kids have no choice but to cause destruction.

While most of the movies about teenage rebellion, save for a few like
Rebel Without a Cause, are based in cities, the same year *The Warriors*
came out, in 1979, another movie about rebellious teens causing trouble
was also released. This one didn't cause such a big sensation. It earned
positive reviews and eventually fell under the "cult classic" label. Yet two
things make the film *Over the Edge* stand out. First, this story of a group
of normal teens bored out of their minds and acting out in an isolated
community is based on real events and real teens. Second, unlike the
bucolic English countryside of *If. . . .* or the decaying streets of New York
City or London, *Over the Edge* takes place in the suburbs (it even has a
fake utopian name: New Granada). *Over the Edge* might not be the best
known of the teenage rebellion films that came out after 1964, but it feels
like the beginning of a broader realization that there was trouble among
suburban youth, and that if they started coming together, bonding over
their shared anger and confusion, they could do a lot of damage.

Thirty years after 1964, and fifteen after the release of *Over the Edge,* in
1994, I was your stereotypical angsty, angry, confused fourteen-year-old

and the film was on HBO almost every day during summer vacation. I had recently bleached my hair blond and let a punk girl cut it into some messy, spikey situation. I listened to bands born out of the previous decade's hardcore scene, like Bad Religion and Minor Threat, whose lyrics synced with my general worldview, which could be summed up as "everybody is bad and everything stinks." *Over the Edge,* with its zero-fucks-given, late-seventies looks (Matt Dillon's sleeveless T-shirt and pot leaf belt buckle, long hair like you'd see at a Kiss concert, and that one kid who skateboarded on a banana board) and soundtrack that included songs by the Ramones, Van Halen, the Cars, Jimi Hendrix, and one of the greatest rock anthems ever, Cheap Trick's "Surrender," was aesthetically everything I could ask for in a movie at the time. But it was the message of pure teenage rebellion that resonated most with me.

The movie also resonated with the band that defined the times I was living in, Nirvana, who used *Over the Edge* as the inspiration for their iconic 1991 video for their breakout hit, "Smells Like Teen Spirit." That summer break, which started a little over a month after Kurt Cobain, the band's lead singer, killed himself in April, had a pall over it. The spring was all about mourning Cobain's death, but by the summer, all anybody could talk about was whether O. J. Simpson brutally murdered his ex-wife, Nicole Brown Simpson, and her friend, Ronald Goldman, whose family lived up the street from me when I was a kid. But I was still in mourning. Even though I wasn't the biggest Nirvana fan, as a kid who stayed up to watch shows like *120 Minutes* on MTV, I thought of Cobain like a big brother, a guy who couldn't tell me why everything in the world made me so sad and angry, but who could make me feel like it was perfectly O.K. to feel that way. It was more honest than the adults in my life trying to talk to me or give me medication to try to "help" me.

I was depressed, too young to drive, and I had nowhere to go, so I did a lot of what a lot of people in a similar position do: I sat on my couch and zoned out watching television. My house was a mile away from anything in every direction, so a normal routine would be

to wake up, eat some cereal, maybe go outside and skateboard in my driveway for a bit, go inside and listen to music, see what was on television, and find the answer was usually *Over the Edge*. The other options included throwing rocks at nearby abandoned houses, going to the local Walgreens parking lot to play shopping cart bumper cars with a friend or two, or lighting firecrackers and throwing them over the bridge, watching them explode in midair. I typically chose the skateboarding, music, and watching *Over the Edge* regimen. The movie about all the cool teens from twenty years earlier looking for fun wherever they could find it—whether that meant having sex, committing petty crimes, or blowing things up—was more relevant to my interests in 1994 than just about anything else. These kids were bored and stuck in the suburbs, and they made it look cool. I related on a deep level because no matter the decade or generation, there are always bored suburban teens, kids confined to their surroundings and their sadness. And in many cases, they lash out. The parents in the movie try to find things to pin the blame on, but never accept that the boring surroundings or their own lack of parenting could be the root of the problem that eventually boils over.

Viewed with the benefit of hindsight, the film feels like a warning, of a harbinger of things to come.

Ten years after *Over the Edge* came out, in October of 1989, one *Chicago Tribune* headline cautioned, "Kids Bring City Gangs to Suburbs," and I assume it must've felt like the nightmares of so many parents coming true. But it wasn't so bad, yet. "Our shootings have been with BB guns and fights with baseball bats, not guns," Rolling Meadows Police Chief Richard Hammer told the paper, making it sound almost old-timey and whimsical.[12] This wasn't the penultimate scene of *Over the Edge,* where the kids of New Granada lock all the adults inside the school during a town meeting while they blow up and burn everything around them; in the real world, everything would be fine.

The article blames the fact that "minorities in Du Page and suburban Cook County public high schools have increased dramatically in the last 10 years," and says, "Often, suburban black and Hispanic gang

members are poor students and poorer members of a well-off student body." Yet the teen they talk to, Dennis, who moved from the city to the suburbs when he was fifteen, is white, and his record at the time included auto theft, possession of burglary tools and marijuana, fighting, and graffiti. He dropped out of school, but the article, trying to end on a cheery note, mentions he had a full-time job at a fast-food place and was studying to get his GED.

"He's doing marvelously," Dennis's mother told the newspaper.[13]

Juxtapose that with articles from the same newspaper about gangs in the city, and you get a much starker picture.

"I'm scared I'll be shot," one twelve-year-old boy tells the *Chicago Tribune* in the October 6, 1989, article, "Gang Wars Terrorizing Englewood."[14]

The message was that minorities, immigrants, and poor people were to blame for gangs, and if there were gangs in suburbs, they were isolated problems and not an issue in more affluent suburbs. Still, police departments and government officials across the country would spend the next decade asking for money to fund programs to keep gangs out of suburbia.

"Street gangs are the fad of the nineties for many suburbs," one detective warned the *Chicago Tribune* less than a year after the same newspaper reported on the violence plaguing the South Side. "That's where the money is at now."[15] Less than a year later, in March of 1991, the *Tribune* ran a story with the headline "Suburban Police Trying to Nip Gangs in the Bud." Again, the cities were to blame, namely "the children of those who flee the inner city to escape such crime and violence," and the key to stopping the violence before it got out of hand was to be open and honest and to keep the discussion going.[16]

It was the same old suburban delusion: keep certain people away, and everything will be O.K. If you grew up in the suburbs in the eighties and nineties, there's a good chance you saw an antigang PSA, or had an adult (who usually heard it on the news) who told you to avoid wearing certain colors so gangbangers wouldn't drive by and shoot you for dressing like their rivals. Like the "Just Say No" and D.A.R.E. campaigns

against drugs, the remedy was the old familiar suburban idea to put up a facade and stop the bad people from getting in.

Most of this was fantasy, at least in the suburbs; it was reality for people like the twelve-year-old in Englewood. But in suburbia, it was xenophobia, those worries that people from outside the suburbs were going to come in and ruin them for everybody else. The parents in *Over the Edge* fret about similar problems. They fear that a couple of kids—the ones from poor families who live on the edge of town—will make crime jump, hook other kids on drugs, and tank property values.

Except that facade crumbled a decade after the suburban Chicago police chief claimed kids were fighting with bats instead of guns on April 20, 1999, when an eighteen-year-old shift manager at a local pizzeria and a seventeen-year-old he worked with walked into Columbine High School in Littleton, Colorado, and started opening fire, killing twelve of their fellow students, a teacher, then themselves. A little over fifty years after the first Levittown homes went on sale, reality slapped people in the face: it wasn't about keeping people out; rather, it was knowing who was already in.

It's horrible to think, but reading about something as horrific as a person walking into a school, opening fire, and killing children feels like something you need to be prepared to see in the news these days. But in 1999, I was a few months removed from being a high school student myself and the same age as one of the killers, and the Littleton shooting affected me in a way I don't think, and certainly hope, I'll never feel again. As details on the shooters emerged, I found myself unsurprised that the pair had worked meaningless minimum wage jobs; that they lived in nice, safe, suburban neighborhoods; that one had been taking an antidepressant I'd also been prescribed; that they listened to weird music and hung out in AOL chat rooms. That, as one of their friends in the documentary *Columbine Killers* put it, "They were the bottom two kids in the entire school. Not just out of the senior class—the entire school. They were the two uncoolest kids. They were the losers of the losers."[17] I wasn't surprised because I knew those kinds of kids; I *was* one of those kids. The only difference between the

shooters and me was that the thought of killing my fellow students and teachers never crossed my mind. I maybe didn't like the people I went to school with, but destruction and harm on that level wasn't even a consideration. Still, I couldn't shake the familiarity of it all.

What struck me as most odd, however, was something a friend of mine who was a year younger and still in high school relayed. We sat in a coffee shop on a Saturday night a few weeks after the shooting, and my friend with spiked, dyed-black hair told me, "They're watching us."

Thinking he sounded a little paranoid, like he'd had too much caffeine, I asked what he was talking about. He explained that in the aftermath of the shooting, details had wrongly emerged that the shooters were part of a group called the Trenchcoat Mafia. One *New York Times* article five days after the shooting screamed, "TERROR IN LITTLETON: THE GROUP; Society of Outcasts Began With a $99 Black Coat," and described the group as "devoted to dark, Gothic music and culture, computer video games with names like Doom, and all things German, including Hitler, whose birthday coincided with Tuesday's carnage."[18] It's the one thing the Columbine massacre shared with the Miyuki Tribe in Japan, or the greasers, mods, and other youth groups: every moral panic needs a uniform.

I say "moral panic" because it eventually came out that the shooters weren't part of the group, just friendly with members of it.[19] But the term "Trenchcoat Mafia" affixed itself to any group of kids who seemed different because of the way they dressed or the music they liked, people like me and my friends. In the weeks and months after the shooting, my friend felt like the school administration was paying extra close attention to his group as the media reported on how the killers were influenced by music and video games. And even though my friend didn't listen to the same music the killers did (he was more into punk than "industrial heavy metal," as one newspaper described the killers' preferred music), his appearance meant teachers pegged him as a fan of an artist the shooters liked, an artist who became a scapegoat in the wake of the shootings: Marilyn Manson. The then-reigning king of shock rock, who, as Neil Strauss pointed out for the *New York Times*,

"takes his last name from a cult leader, Charles Manson," was "a member of the Church of Satan and tears up bibles onstage . . . sings about rape, murder, blasphemy and suicide," and was "known to expose and mutilate himself during concerts."[20]

But my friend and I knew otherwise. It wasn't the shock-rock "Antichrist Superstar" or the video games that were to blame. It wasn't any one single thing, but a mixture of influences and events, including the very suburbs kids like the killers came from.

The suburbs started to come under scrutiny not long after the shooting. A few months after the massacre in Colorado, as America looked for answers, CBS News looked deeper into our world. The headline asked, "Do Suburbs Create Teen Rage?" and pointed to child psychologists who researched the impact of the very layout of the suburbs on young people. One teen described their town as "boring," while another complained there was nothing to do. "While that could be taken as a typical teen-age lament, child psychologists say it is a symptom of a deeper problem. They suggest that the design of suburban life has made young people feel left out, ignored, and alienated."[21]

As Dr. Brian Brody, a child psychologist who had "been warning about the hidden dangers in the suburbs for a decade," put it, the suburban facade is meaningless. "If it's all structure and buildings without the connection and the teaching kids of self-discipline and the coping skills they need—without that, this all crumbles. The great suburban dream has been shattered," he said.

The article ends on an ominous note: "According to a recent Gallup Poll, 46 percent of suburban teen-agers say they could see a fellow teen turning violent. Just 29 percent of city teens say the same."

Today, what happened in 1999 feels like the end of a circle, as if we were so afraid of teenagers but never quite sure what about them frightened us. In 1964, it was this growing realization that they could be individuals, band together, and cause chaos; but exactly *how,* people weren't sure. Fifteen years later, *Over the Edge* took that idea and placed it in the middle of the suburbs. The violent outburst on the screen seemed impossible in 1979, a work of fiction and nothing else.

But twenty years after that, as the very layout of a place like Littleton, Colorado, came under scrutiny, it became clear that people in the suburbs had been worrying about all the wrong things.

As a former teen, I can say that yes, teens can be stupid. Really, really stupid. But as a former teen, and somebody who's spent countless hours watching movies and television shows about teenagers in the suburbs, I also feel comfortable saying it's parents and other adults who often share at least half the blame for every teenager's trouble. Sure, hormones and other kids are awful as well, but parents are almost always just as guilty, whether it's James Dean's bickering parents in *Rebel Without a Cause;* Paul Gleason as Assistant Principal Vernon, one of the worst bad guys with little to no power, in *The Breakfast Club;* Larry Miller as Walter Stratford, a father with a creepy obsession with his daughters' virginity in *10 Things I Hate About You;* or the parents on *Riverdale,* who seem to do everything they can to screw up their kids' lives. Case in point: Alice Cooper joins a cult and gives all her daughter Betty's college money to it, and this is right after it's exposed that Betty's dad is a serial killer known as the Black Hood. Veronica's father is a mob boss and her mom is complicit. Jughead's dad is the leader of a gang before he steps aside and lets Jughead take over, despite having some reservations about *his son leading a gang.* And don't get me started on Cheryl Blossom's creepy mother and her drug dealer dad, who's gone after the first season. As long as there have been stories of teenagers on screens, there have been parents holding them back.

Sometimes there are other factors: Molly Ringwald's Andie Walsh in *Pretty in Pink,* for instance, literally lives on the wrong side of the tracks from the rich boy she has a crush on. But a bigger issue in Andie's life is her father, played by Harry Dean Stanton, who won't find a job. He *could* probably get one, but he's been depressed since his wife left, putting more pressure on his teenage daughter to provide. In other cases, there are characters like Lara Jean Covey in Jenny Han's 2014 young adult novel and 2018 Netflix movie of the same name, *To All the Boys I've Loved Before.* She's a nice, well-adjusted high schooler, but her story

wouldn't be the same if her mother hadn't passed away when she was younger and if her older sister hadn't left to go to school in another country. It's a sweet and funny romance story, but there's loss hanging over it. The same could be said of Kelly Fremon Craig's 2016's film, *Edge of Seventeen*. Nadine Franklin (played by Hailee Steinfeld) is your typical sixteen-going-on-seventeen-year-old, but the added weight of losing her father a few years earlier leaves her adrift, without that anchor every kid desperately needs. Lara Jean's and Nadine's parents aren't holding them back; it's the grief they feel at having lost their parents that is.

So you can blame some of the problems the teen protagonists have on adults, but those issues might also be due to a *lack* of adults in their lives, and it's hard to find fault in that. In most cases, however, parents and other adults get in the way, and there's a real simple explanation as to why they do that: they're parents and adults. They're the guardians of these youths, the ones in charge.

What John Hughes got right in every script he wrote that involved kids—from the parents forgetting Ringwald's character's birthday (again) in *Sixteen Candles* to Macaulay Culkin's Kevin McCallister getting left behind by his parents in *Home Alone*—was that adults don't always know or do what's best for kids. In fictional settings, even if they play a minor role, elders hold all the power over teens. This power forces young people to act certain ways, to live in places they might hate, or to have goals they don't care about, like getting into a specific college or hanging out with certain kids. People who write shows and movies often wisely exploit that fact and use it to a plot's advantage.

In my mind, no film uses the formula of parents and adult authority figures as the root cause of teenagers' problems like *Over the Edge*. It's the parents who moved the kids there, and it's the parents who won't listen to the kids suggesting that they need something, *anything* fun in their lives. All they have is a small rec center, drugs, mindless entertainment, and no adults who understand them.

In the case of the real-life events that influenced *Over the Edge*—a rash of crimes committed by preteen gangs labeled "mousepacks" in the planned community of Foster City in the early seventies—no solutions

are offered. The gangs were reported to "rampage" through the suburb and have members as young as nine doing everything from snapping radio antennae off cars to shooting out street lights with BB guns, pouring liquid cement down public sinks, and setting fires.

"It sounds like the scenario for an underage *Clockwork Orange*, a futuristic nightmare fantasy," as a November 1973 *San Francisco Examiner* article put it. While the writers can't decide if it's all a fluke or a sign of things to come, they write that the crimes "can have confirmed liberals talking 'law and order.'"[22]

Had things gone really wrong in Foster City, or was it a case of overreacting? The suburb had been built on so many promises, but if you took the press at its word, things unraveled quickly. In the early 1970s, suburbia was still considered the ideal by many Americans, so the slightest sign of trouble was bound to get people worrying. But in the case of Foster City, it's easy to understand why those slight signs could have been blown up out of proportion.

Thirteen years before the *Examiner* article, in 1960, it was announced in the *San Mateo Times* that developer T. Jack Foster had filed the necessary paperwork to build "America's first 'new town,' the first completely planned [community] from raw land to the tallest building, with all the utilities, roads, and other developments pre-determined prior to commencement of the city's construction" all atop landfill.[23] Unlike William Levitt, whose main goal was to build as many homes as possible, Foster and his company wanted to take things a step further and design *everything* in the small city built for thirty-five thousand residents. But to fill those homes and to make the city run, they needed to attract people and business. When the groundbreaking ceremony for Foster City was announced in August 1961, the local papers reported that it would take about fifteen years to build and become a self-sustaining community. That all depended on those two vital things: homeowners and business. To do that, local real estate brokers touted Foster City as "a whole new concept of living, 21st century style."[24] Companies like Wells Fargo were lured into the community, and in 1965, construction started for Foster City's first school. Everything was

going to plan. Reports stated that property owners were already turning profits when they sold their land or homes, and the community that made big promises to become one of America's premier suburbs seemed like it very well could pull it off.

And then little cracks started showing up, mainly when it came to the children of Foster City. A February 1967 *San Mateo Times* article points out that although the city finally had its own school, they were nothing but "portables," small units about the size of a modern-day trailer home, "hardly appetizing intellectually." Although houses in the area usually fetched from $21,000 to $40,000 for waterfront property (over $320,000 today), there wasn't room for the kids to learn. The writer goes on to compare the conditions Foster City children faced to what he dealt with growing up during the Great Depression.[25] A few months later, in July of the same year, William O'Brien of the *San Francisco Examiner* took a look at "a new town's problems," writing, "The natives are restless and they got troubles right here in Foster City." O'Brien compares the citizens of Foster City to "Boston patriots at the time of the tea party," noting the community management company was offering a fifty-dollar reward for anybody willing to rat out the person behind a pamphlet that had been circulating and stirring up dissent à la Thomas Paine. Like the colonists, he argues, they were taxed without representation, and bureaucrats who had absolutely no clue were in charge.[26] It was a public relations nightmare, but regardless, by the fall Foster City was reportedly still selling homes and land like hotcakes. People filed into the suburb of tomorrow for any number of reasons, but one that sticks out is that there was rarely any crime reported. Foster City sold itself as a wholesome, safe place and people bought it, even if their kids had to sit in packed mobile schoolrooms.

Finding any reports of crimes in Foster City isn't easy. In fact, I couldn't find much until one small item in the *San Mateo Times* on April 17, 1969. A Foster City woman reported that somebody had come into her house and snatched her four-diamond wedding ring (valued at $250), which she'd taken off and put by the sink when she went outside to do some gardening.[27] Three months later, in a *San Francisco Examiner*

article, it was announced that "Foster City, that beleaguered 'new town'" was for sale.[28] Ten thousand people lived there—not exactly the number they'd hoped for by that point.

Judging by how things went after that, the powers that be in the small San Mateo County city figured out how to fix—or at least to cover up—the small crime problem and keep the suburb attractive to the growing number of people moving into the area despite its problems. As the news reported on cities like nearby San Francisco raging with crime, drugs, and protest, a place like Foster City seemed like a safe bet. The population started to increase as people fled the big city.

And then came the mousepacks, which, as far as one can tell studying records and old newspapers, sort of appear from nowhere. It was shocking to the residents and became a cautionary tale "of having too much, too soon," as resident Dorothy Lawrence wrote to the *Examiner*. A reader from nearby San Francisco—a city in the grip of unprecedented violence and tragedy, from a wave of drugs that swept in with the hippies a few years earlier; the Zodiac Killer murders; several seemingly random killings by a group of black Muslims that came to be known as the Zebra murders; and the shooting death of a school superintendent in nearby Oakland by the Symbionese Liberation Army—wrote that the article shook her. "The story on the Mousepacks distressed me more than I already was after reading constantly about murder, violence, viciousness, vandalism, etc. And now in the suburbs!"[29]

By 1974, the article was all but forgotten. Like the years that predated it, you can't find many reports on criminal activity in Foster City, because either there wasn't any, or, as one resident I talked to who grew up there around the time of the article told me, "the officials didn't want people knowing about anything illegal or bad happening." People were more concerned with Watergate or with the Patty Hearst kidnapping that took place in Berkeley in February; they just didn't care that much about kids in an upper-middle-class suburb committing petty crimes. Foster City didn't turn into some dystopian hellscape. In fact, what little crime had been previously reported dropped even as the big city nearby saw violence spike. Today, Foster City is routinely

listed among the safest cities in America. In 2018, it came in at number ninety-eight on the list of the hundred safest cities in America on the web-based platform NeighborhoodScout, which ranks violent crimes per one thousand people.[30] The city fixed its school problem, boasting four public schools today. Business also picked up when Visa moved its headquarters there in 1993.[31] IBM, the biotech firm Gilead Science, and many other companies also moved in over the years, making Foster City a place that some consider part of Silicon Valley, or, at the very least, a place where people from Silicon Valley live. (Although I should point out when I asked some locals whether they considered Foster City part of the region, answers varied from absolutely not to "Where is Foster City again?")

I have this weird obsession: I like to seek out places connected to movies and shows I love. So, for instance, I could jump in a car from anywhere near Winnetka, Illinois, and get you to the house used in *Home Alone;* I had to see the vintage store Love Saves the Day when I visited New York City before I moved there because it makes an appearance in the 1985 Susan Seidelman film starring Madonna, *Desperately Seeking Susan;* and I've eaten at nearly every restaurant featured on *The Sopranos.*

So when I found myself in the Bay Area with a car and a day to kill, I decided to find the place that influenced *Over the Edge.* Google Maps told me the drive from my hotel in Berkeley would take a little over a half hour, but I hit traffic reminiscent of the kind you find in Los Angeles, so it was more like forty-five minutes. When I arrived, I was stunned, frankly. It was hardly the sad suburban wasteland I'd envisioned ever since I first read that New Granada from *Over the Edge* was based on a real place. I'd imagined large plots of underdeveloped land, houses that looked stuck in the early seventies, sad-looking teens wandering the streets looking for kicks. What I got was, well, a lovely, boring place that looked pretty much like everything else in the Bay Area and pretty much anywhere else in America.

Located on the San Francisco Bay, Foster City's makeup is, as of the 2010 census, mostly white (45 percent) and Asian (also 45 percent).

With a median household income at over $152,446, Foster City is a tough place to afford, even though it looks like any other suburb.[32] Foster City Boulevard, with its towering power lines stretching for miles, feels like it goes on forever; the buildings are uninspiring; and everything is planted by a human hand. There are stunning views of the San Francisco Bay, but besides that, I can't tell what makes this place any different from the suburbs outside Austin, Texas, or West Palm Beach, Florida. Nothing about it reminds me of *Over the Edge.* The only reason Foster City—whose only claim to fame is that PayPal founder Peter Thiel grew up there after his family moved to America, as far as I can tell—exists is so people can be close to San Francisco without being there. Foster City is a prime example of what people don't like about suburbia, and as I drove through it, although it looks modernized and updated, I still felt restless. I thought of those kids from the early seventies, the ones who inspired my favorite movie, and I sympathized with them, because, subtracting the crime and fast-forwarding twenty years, I was just like them, part of a lineage of bored kids in small towns and suburbs.

But what about the kids in modern-day Foster City? I considered reaching out to one of the local schools to see if I could pull the old "I'm an author doing research and I'd love to talk to some of your students about how bored they are for my book" trick, but my first attempt was quickly rebuffed, so I figured that wasn't the route. Instead, I went to one of several Starbucks I saw in the area, one next to a Costco, where I saw more than a few teens hanging out: a pack of girls, another girl studying by herself, and two younger guys both in hooded sweatshirts with the hoods up sitting at the same table, looking at their phones, and not talking to each other. I thought of approaching some of those kids to ask them what modern teenage life is like in Foster City, what the cliques are, what they do for fun. I wondered if I should Google cool teen lingo to ask them if they think their town is *totally lame* or not. I was curious if any of them had ever seen *Over the Edge.* Considering its status as a cult film, I wagered no, but then again, the town's Wikipedia page mentions that Foster City inspired the movie.

I decided to leave them alone. I'm sure the kids would've said what I wanted, that they either love or hate their hometown. They'd unknowingly echo the characters from *Over the Edge* and real suburban kids from 1989, 1999, 2019, 2029, or any other period. They might have different slang, dress in new ways, or have different values than the generations that came before, but they were going to be teens with teenage problems, half of which could be blamed on their bodies and the mess of hormones swimming inside them. But the other half would always be their location and the adults who lord over them. I wouldn't have found out anything new by being the creepy thirtysomething guy who tried to start a conversation with them at the coffee shop. Adults have been bothering suburban kids for far too long. It's probably better to give them space.

In the Garage

I'm fascinated by what makes a person nostalgic for the suburbs, the sensory reaction that pops up even if they swear they hate their hometown or they'll never move back. One friend told me that even though he lives in Manhattan, a city where you can get a decent slice of pizza walking in every direction, he sometimes craves a pie from Little Caesars, the "official" pizza of birthday parties on his block when he was a kid. Another said that on the rare occasion they find themselves pumping gas when they rent a car to get out of the city, they're instantly brought back to the Shell station near the little subdivision where their parents still live. One friend likes to just walk around Target because it reminds her of her boring teenage years, when hanging out at the local twenty-four-hour Wal-Mart was considered entertainment.

I have my own list: the smell of freshly cut grass always makes me think of being twelve or thirteen in the summer. I sometimes remember the short pause between my father hitting the garage-door clicker and us pulling in, how those five seconds were always filled with a nameless anxiety. Charcoal lighter fluid set aflame on a Weber grill always brings me back, as does the taste of slightly burnt ribs with a sweet bottled barbecue sauce. The first sight of lightning bugs also makes me think of childhood, when our backyard turned into a little light show. All those things make me think of the suburbs, but the soundtrack to

suburbia, in my mind, is noisy. It's unchecked teenage hormones and angst. It's a couple of band kids who don't know how to play their instruments but are totally unself-conscious about it. What I tend to identify as the suburban sound is usually a group of white teens from the sixties trying to sound like the Rolling Stones without hearing much Muddy Waters, Chuck Berry, or the other African American Chess Records artists who influenced the Beatles or Mick and Keith. It's three black kids creating a sound known as "Detroit techno" a half hour outside the city. It's crunching, buzz-saw guitars, drums pounding at a million miles an hour, and a person screaming their head off. It's homemade rap tracks uploaded to SoundCloud. It sounds like boredom and alienation, but it's born of having the opportunity to do whatever you want because there's a good chance nobody will care. You're making music because you need to create, like you can see there's something beyond the horizon and you're going to go wherever that is and make an even bigger noise.

When Stephen Malkmus of the indie rock band Pavement sings "I had to get the fuck out of this town" and head to a place called Box Elder in the song of the same name, it sounds like he's singing about getting out of the central California sprawl of his hometown of Stockton. When Rivers Cuomo of Weezer sings of feeling safe and secure and being able to play Dungeons and Dragons and listen to Kiss records in his garage, it's a feeling anybody who grew up in the suburbs can relate to—you have so much space, but it always feels like nothing is yours. You need a place where you can be yourself. Rapper Lil Yachty summed it up in a 2017 interview when he said his music was so different from the music of other rappers who grew up in the city of Atlanta proper because "I'm a nineteen-year-old kid from the suburbs."[1]

While there will always be hardcore bands started in basements and kids playing with the latest production equipment on their laptops, there's no genre of music I can think of that has a name as suburban sounding as garage rock. It conjures a mental picture of a bunch of young, amateur musicians jamming where their dad's station wagon would

normally be parked. While bands from across the country through-
out the early part of the sixties eventually earned the tag, the earliest-
known print use of the term that uses the part of a house where a car
usually rests to define the sound of amateurs playing music came in a
1971 *Rolling Stone* review of the Rod Stewart–led Faces album *Long
Player*. Of their rollicking, sloppy version of the Big Bill Broonzy blues
song "I Feel So Good," John Mendelsohn wrote, "In these dark days
of Blood, Sweat & Tears, Keith Emerson, and every last punk teenage
garage band having its Own Original Approach," the Faces did some-
thing he considered "awfully refreshing."[2]

The label "garage rock" could really apply to any music made by a
bunch of jokers with dreams of being the American version of the Who
or the Yardbirds, whether they're in their parents' garage, down in the
basement, or in the shed out back. It's Pacific Northwest bands like the
Kingsmen mumbling their way through their now-iconic version of
the Richard Berry song "Louie Louie" in 1963. It's four Chicano kids from
the Los Angeles suburb of San Gabriel calling themselves the Premiers
getting on American Bandstand to do their own "Louie Louie"–ized
version of an obscure early rock-and-roll hit by the duo Don and Dewey,
"Farmer John." It's a band called the Subterraneans doing a cover of
"Shout" at sweet sixteen birthday parties across the suburbs of Detroit
a few years before one of the members, Glenn Frey, went on to sell
more records than nearly any other artist in history with the Eagles. It's
Fred Savage as Kevin Arnold on the television show *The Wonder Years*
learning on the fly after starting a truly terrible band called the Electric
Shoes for the same purpose most teenage boys start playing music: to
impress girls.

For every one-hit and no-hit wonder discovered by collectors a decade
or two after the band members abandoned their dreams of fame and
fortune, you had guys like Frey going on to bigger things like the
Eagles; you had James Osterberg Jr., nicknamed Iggy Pop after the
band he was in as a teen, the Iguanas; and you had Chris Bell and Alex
Chilton doing time in bands nobody cared about before going on to
start Big Star and influencing every jangle-pop band to come after.

Some did it for fun because they were young and didn't have much else to do, and a few saw it as a career.

You'll notice a pattern here. The early garage rock wave in the sixties was made of mostly suburban, largely white young men, save for a handful of groups like the Premiers, Cannibal and the Headhunters, and maybe most famously, the Mysterians, best known for the anthem "96 Tears." Those bands had mostly Mexican American members, but were still all male.

That's one of the things that makes the Pleasure Seekers stick out in the crowded group of sixties bands lumped into the same garage. The all-girl group was louder and faster and created a sound so raw I'm sure it made their male counterparts blush. Their song "What a Way to Die," a minor regional hit when it came out in 1965, is in my estimation one of the greatest rock-and-roll songs ever. It's everything you could want in under two minutes and thirty seconds: teenage fatalism, shout-outs to regional beers like Schlitz and Stroh's, and blood-curdling screams backed by a sped-up surf-rock sound. It's future glam rocker Suzi Quatro, best known for her role on the show *Happy Days* as Leather Tuscadero, her sister Patti, and any other girls from their neighborhood in Grosse Pointe, just next to Detroit. Years before the Slits, the Raincoats, the Go-Go's, or Bikini Kill, the Pleasure Seekers were an all-teenage girl band screaming at some guy that they love him, but he shouldn't make them decide between him and a bottle of beer, proclaiming, "Well I may not live past twenty-one, but (woo!) what a way to die!"

It's sort of impossible not to mention drinking and drugs when you talk about American music. Other cultures celebrate the joys and sorrows too much booze can bring, but there's some strange mix of cockiness and fatalism embedded in the American psyche that keeps moving the wheel of young musicians; they knowingly enter into a life where illicit substances will be available to them all the time, and even the legends succumb to those substances early. Charlie Parker died at age thirty-four in the Stanhope Hotel, his body giving out after he abused it too much during his short life. Billie Holiday died a few years later, in

1959, at the age of forty-four after her heart and lungs had had enough. Jimi Hendrix, Janis Joplin, Jim Morrison, Kurt Cobain, and the rest of the "27 Club" all lived fast, hard lives that weren't designed to make it past thirty.

Nearly a decade before Robert Johnson sang about going to the crossroads and changed the course of music forever, another bluesman, Tommy Johnson (no relation), sang "Cool Drink of Water Blues" in 1928. In it he sings about asking a woman he's in love with for a glass of water, and she gives him gasoline. From the haunting way Johnson delivers the song, it sounds like he's going to drink it just to prove a point. He had another song come out that year, "Canned Heat Blues," where he moans about knowing how bad drinking canned heat is for him, since it's literally a fuel made from denatured and jellied alcohol, but he can't get enough. People in the hills of Appalachia sang songs of drinking and dying. Jazz musicians, country singers, and punk rockers alike have all given us songs that both wallow in and celebrate the hard life, and usually for good reason: they lived it. Tommy Johnson and his other black Mississippi Delta musician contemporaries didn't have an easy life in the Jim Crow South by any means. The blues came from that existence.

Suzi Quatro, on the other hand, grew up in what she called a "very nice" neighborhood when she and the Pleasure Seekers sang about drinking and dying. She lived around first- and second-generation Italians, Germans, Poles, and people of Bohemian origin, most of whom, like her Italian father, worked for one of the big car companies. They lived in a nice ranch home with green grass trimmed until it almost felt like you were walking on carpet. Life on her street in Grosse Pointe was easy, "doors were never locked, within a four-block radius everyone knew everyone."[3] As she tells it in her memoir, her childhood was largely free of conflict. The Quatros were your stable American family, and Suzi and her sisters didn't seem to be troublemakers. "What a Way to Die" isn't autobiographical; as far as one can tell, the Quatro girls weren't beer-drinking, hell-raising teens. But the way they deliver it makes you think the Pleasure Seekers had seen some shit, and they really didn't care about life. While the boys

in other bands were trying to impress the opposite sex, Quatro and her band were raw and unhinged. When you hear "What a Way to Die," you're listening to suburban teenage nihilism boiled down to its essence: banging on instruments, screaming and proclaiming they aren't afraid of anything because the couple of streets that make up their frame of reference don't offer them much. Boredom provides the heart of the song, just like it fuels nearly every other band or kid who starts making music in the suburbs.

To understand the Quatros' rallying cry of not caring that they might not make it to twenty-one, you have to go three decades into the future. Another girl from the same Michigan suburb of Grosse Pointe would echo their brand of nihilism: the doomed Cecilia Lisbon in Sofia Coppola's 1999 hazy adaptation of the Jeffrey Eugenides novel, *The Virgin Suicides,* the first of the five Lisbon sisters to take her own life. When an adult tells Cecilia after her first suicide attempt is unsuccessful that she's not old enough to know how bad life gets, she says, "Obviously, doctor, you've never been a thirteen-year-old girl." We then flash to a brief shot of the manicured neighborhood in all its summertime glory as the film's narrator explains how the Lisbon sisters' suicides coincided with the area's downfall. "Everyone dates the demise of our neighborhood from the suicides of the Lisbon girls. People saw their clairvoyance in the wiped-out elms, the harsh sunlight, and the continuing decline of our auto industry."[4]

Listening to the Pleasure Seekers or reading or watching *The Virgin Suicides,* you've got bored teen girls. They're bored with their neighborhood, bored with the restrictions adults put on their lives, and bored with being confined to their homes, their blocks, and their little Michigan town. Besides location, what these Grosse Pointe stories show us is the difference between kids in the suburbs and kids who grow up in cities; kids who get to see different things and experience different cultures versus kids who have only a couple of blocks to roam. When you read about anybody growing up in cities like New York or Chicago or L.A., it's always a bit more colorful. You hear stories of the marginally famous people who lived in the same building, or the cool museums or clubs

even normal teens had access to. "The city is a playground," people say. In the suburbs, the playground is just the playground, and that's usually one of the few places kids can go.

As author Megan Abbott writes in the essay that accompanies the film's Criterion edition, Coppola's movie is less concerned with the boys' longing for the young girls than the book version of the story is, and it focuses instead on "the sisters' harsh reality: the misery of their mother's oppressive rules, their father's impotence, the smothering feeling of their home, its wall-to-wall carpet sometimes seeming to swallow them up."[5] From that point of view, the fictional Lisbon girls may be a decade younger than the real-life Quatro sisters and the rest of the Pleasure Seekers, but they're spiritually (not to mention geographically) connected: the Quatros singing about the joys of underage drinking, the Lisbons so sick of the rules imposed on them that they engage in a suicide pact—it seems far-fetched or melodramatic, but it shows the longing so many young people have in the suburbs. While other bands that came out around the same time as the Pleasure Seekers were writing songs about looking for kicks and catching waves, or covering Bo Diddley, the Quatro girls and their bandmates, like the Lisbon sisters, were looking for any way out. That's what defines the teenage sound of the suburbs, but it's also what living in them feels like for many. It's the sound of escaping. As Quatro told her father once she got her first taste of rock-and-roll stardom, "There's nothing for me in Grosse Pointe." Then she dropped out of school and gave up the comforts of her safe neighborhood for the road.[6] It just seemed better to her, going from one city to the next. That life was more appealing.

Everything is romantic when you're a teen; you indulge every single feeling, good or bad. You're a living poem. "I have been half in love with easeful Death," a young John Keats wrote in his "Ode to a Nightingale." With "What a Way to Die," the Pleasure Seekers replied over a century later.

Over fifty years after "What a Way to Die" came and went without much notice, Gustav Åhr, a Long Beach high school dropout, had the

opportunity to do something he'd never done: he stepped into an actual recording studio. Up until that point, the rapper known as Lil Peep had done the bulk of his recordings on his laptop. Whether it was in his bedroom in his mom's house on Long Island or in one of the apartments he crashed at on skid row in Los Angeles didn't matter; he had to make music. While the media focused on his pink hair, his face tattoos, and what some called his "emo rap," the amount of music he put into the world in such a short time and at such an early age shows how determined Lil Peep was to create. In a few short years he released four mixtapes and over a dozen EPs and singles. In 2017, after two years of self-releasing his songs online and becoming what Jon Caramanica of the *New York Times*[7] dubbed the "heartthrob" of the SoundCloud rap scene,[8] he released his first studio album, *Come Over When You're Sober, Pt. 1*.

Lil Peep went from being mostly internet famous and working in his bedroom to becoming one of the biggest up-and-coming names in music when the album peaked at number thirty-eight on the US Billboard 200 chart. One track off the album sticks out: "Better Off (Dying)." The hook goes:

> Chains on shining, you can see me riding
> Cocaine lined up, secrets that I'm hidin'
> You don't wanna find out, better off lying
> You don't wanna cry now, better off dyin'

Given the way culture has evolved in the last half century, it's not difficult to read Lil Peep's lyrics as a modern version of the Pleasure Seekers' celebration of substance abuse and dying young. There's also the connection to the fictional Cecilia Lisbon—I can't imagine the rapper, like Cecilia's doctor, knew much about being a thirteen-year-old girl. But he probably could've related to the way Eugenides conceived her as an outcast: the suburban outsider.

"Cecilia was weird, but we're not," her sister Therese says at one point in the book.

"Life is weird," Lil Peep tweeted on August 28, 2017, two weeks after his album came out. Less than two months later, on November 15, he was found dead in his tour bus of an overdose from a combination of fentanyl and Xanax. Blood and urine tests found traces of everything from cocaine to cannabis, oxycodone, and other painkillers.

Lil Peep's overdose added a celebrity face to the growing opioid crisis in 2017, something that, a few months earlier, was new news to most Americans; the fact that it was affecting the suburbs was downright shocking. "Strung Out in Suburbia: Opioid Drug Crisis Hits the Suburbs," reported *Modern Healthcare*. "The drug crisis has grown exponentially in big city suburbs in recent years. Areas once thought immune find themselves subjected to the same societal issues that were traditionally associated with hollowed-out urban centers or economically devastated exurbs."[9]

Sure, Lil Peep was a kid with dyed hair and a broken heart tattooed under his eye who rapped about suicide, and he was a musician—they have a habit of dying young. But he also grew up in a suburb like any other. Even before his death, people wondered what had gone wrong with this young, bright (he made dean's list in high school before dropping out) person. Why did he look that way, and why did he think that way? Despite what seemed like a normal family life and growing up in a nice place, Lil Peep drifted farther away until finally he drowned.

Like the Pleasure Seekers in the midsixties and the fictional Lisbon sisters, Lil Peep was looking for a way out—of the suburbs, his depression, boredom, and alienation. And sadly, he found it. He didn't live past twenty-one, like the "What a Way to Die" lyric says.

The term *garage rock* appeared nearly a decade after the bands associated with the sound's first wave had already grown up and probably stopped playing music. The definition tends to be that of a raw, fuzzed-out, snotty take on classic R and B or first-wave rock and roll, usually from bands from the sixties. But bands like Mudhoney in the late eighties and early nineties or the White Stripes in the early 2000s also count. When you're talking sound, Lil Peep is about as far away from

the Seeds, the Count Five, the Music Machine, or the Pleasure Seekers—the bands most associated with the term—as you can get. But the idea is the same. In many ways, all the most important music imported from the suburbs was and continues to be garage rock, or at least it carries on the same idea. The Pleasure Seekers and their contemporaries were influenced by rock and roll, R and B, and country created by African Americans and white rural Southerners. Lil Peep took hip-hop, a musical form also created by African Americans, fused it with emo, another subgenre connected to punk and hardcore music, and put his spin on it. For both the Pleasure Seekers and Lil Peep the results are raw, emotional, usually cheaply produced versions of the original sounds that end up being totally different. That, more than anything, is what connects all suburban music no matter the genre: making the sound you want despite limitations like having a proper studio to record in or more than a handful of people in your hometown who care about your music. The hope is that you'll get noticed and get more popular. Then, sooner or later, you could leave your hometown and move somewhere where more people would hear and appreciate the music you're making, either L.A. or New York. Maybe you could make a living from it. There is the small chance you could even get famous.

That was the idea by the eighties, when you loved and celebrated the place you were from (Bruce Springsteen with New Jersey, Prince never leaving the Twin Cities far behind, and the countless heartland rockers who made music that appealed to rock kids in California and farm kids in Iowa). Or you wore your hatred for the place that made you on your sleeve (punk bands). While Springsteen's heroes and losers came from the backstreets and rode the highways on their motorcycles and in classic American cars, and Run DMC shouted out Hollis, Queens, any chance they got, one of the biggest superstars of the decade barely hinted at where she came from. She moved as far away from her hometown as she could and never looked back, reinventing herself in the big city.

Madonna Louise Ciccone, best known by her first name, escaped the Detroit suburbs of her teenage years (Pontiac and Rochester Hills) for New York City, sculpted her iconic persona, and the rest is history.

She hardly ever mentioned the town of her birth, Bay City, Michigan, and, in turn, it hardly recognizes its most famous citizen. Madonna seems fine with that.

When the writer Alina Simone went to Bay City to see why the city hasn't done more to celebrate the performer who gave the world hits like "Borderline," "Vogue," and countless others, she noted the "woozy suburban ennui," and that the house where this larger-than-life singer and actress spent important moments of her life "is a single-story ranch house with a brown-shingled roof that sits on the corner of the most normal-looking street in America."[10] Not exactly the sort of place you imagine a person who would shift the entire culture to come from. Our pop idols are special; we don't think of them as coming from the same sort of place so many of us come from. I think Madonna understood that. Although she grew up not too far from the Quatro sisters, and in the same neck of the woods as the fictional Lisbon sisters, the future star always had designs on getting out and ruling the world, as she told Dick Clark on *American Bandstand* early in her career. Madonna knew she was going to leave the middle-class Michigan towns that raised her, head to the city, and get huge. Hers might seem like the exact opposite outlook of the doomed Detroit suburbs the Pleasure Seekers sang about or *The Virgin Suicides* portrays, but it's the same.

When asked in a 2015 interview what she loved about growing up in suburban Michigan, the singer replied, "Oh, nothing."[11]

While Madonna got out of there as fast as possible, it can sometimes seem like all roads lead back to the Detroit area. It might be Grosse Pointe, or it could be Rochester Adams High School where Madonna went, but after the big auto boom following the Second World War all the way until the gas shortages of the seventies, the suburbs outside Detroit were, as the Michigan Public Service Commission spokesman put it in 1964, "one of the most rapidly expanding areas in the United States."[12] Three years later, as Motor City burned during the 1967 riot, people say the downfall of the area, the one the narrator of *The Virgin Suicides* pinned to the death of the Lisbon sisters, truly started. The racial

tension, the motor industry's collapse, and the ups and downs of the housing market all added to it. But by the 1980 census, places like the small suburb of Belleville were thriving as people wanted to get away from Detroit while still having access to it. The quaint little town, once a summer retreat for the wealthy, grew from 2,406 in 1970 to 3,366 ten years later.

It was somewhere between that period that three of the few African American students at Belleville High School, Juan Atkins, Derrick May, and Kevin Saunderson, started hanging out after Saunderson punched May for not paying up after a bet. Saunderson and his friend Atkins were fans of the popular Detroit deejay the Electrifying Mojo, who played everything from Prince to the German band Kraftwerk on his influential radio show. All three of the young men especially liked the futuristic-sounding stuff like Kraftwerk, but they were also fans of funk like Bootsy Collins. When you read interviews with any of the members of the Belleville Three, as people eventually called them, their hometown and its influence often comes up. Yes, they'd go on to create what would be known as Detroit techno, but the sound that would go on to change electronic music forever was dreamed up in basements in the suburbs outside Motor City. The space and freedom to play, to stretch the sounds they liked into something all their own, was vital to creating a strain of music that originated in the suburbs before making its way into clubs from Manhattan to Manchester.

Atkins, May, and Saunderson did it themselves. They had an idea for what they wanted to make and grew it into something larger. And around the same time as the trio from Belleville was creating Detroit techno, a little over an hour to the north, another sound was being nurtured. It didn't sound anything like what the Belleville Three created, but there was a similar spirit, a craving for something different, something better, and something that belonged to the musicians and the people who truly cared about the music.

East Lansing is neighbor to Lansing, the state capital. Booze was prohibited in East Lansing starting in 1907 all the way until 1968. Google cofounder Larry Page and statistician and writer Nate Silver

are both from East Lansing. It's also home to the world's only Moist Towelette Museum.

Since it was settled in the mid-nineteenth century, however, East Lansing has been primarily known for one thing, and that's being home to Michigan State University and its legions of green-clad fans cheering on their beloved Spartans. Some people think Magic Johnson is from there, but he's not; the NBA legend is from Lansing proper and went to MSU for two years before jumping to the pros. East Lansing is a college town. Nothing too exciting happens there unless the Spartans win, and that's really what you want from a place where young minds go to further their education.

East Lansing plays a small role in a bigger story, one that impacted American culture but I'm guessing MSU campus tour guides don't talk about. Namely it was where Dave Stimson and Robert Vermeulen, who's better known as Tesco Vee, decided to start a hardcore punk fanzine and call it *Touch and Go*. The zine was started out of boredom in the town Vee described as "benign" and lasted just under three years; twenty-two issues were published. In those three years and twenty-two issues, however, one of the most important fanzines in the then-burgeoning hardcore scene helped reshape America's musical landscape.

Stimson and Vee were a couple of bored young guys looking to talk about the music they loved. And in the fertile new underground scene, the little zine they photocopied in their school library or wherever they could do it for free became like a printed radio signal to the rest of the country. Because of *Touch and Go* and the network of zines like it, many of which came out of suburbs and college towns, kids in Boise or Corpus Christi could hear what a couple of guys in the Midwest thought about records *Rolling Stone* and other music publications wouldn't touch. They could learn about bands and scenes they might never have had an opportunity to hear in pre-internet times. The zine eventually ceased publication and *Touch and Go* turned into a record label, but looking through old issues is a way to understand the American underground scene that took shape as a small but connected network of bands and labels in the era of Ronald Reagan. It shows that punk, especially the hardcore

version, with all its brutishness and pent-up young male aggression spilling over, was largely a scene that was born in New York City and London but that had its teenage years in the suburbs.

To understand hardcore, you do have to try to listen to it. Go on Spotify and find *Victim in Pain* by the New York City band Agnostic Front, the album containing the first two seven-inch records by Washington, DC's Minor Threat. Or try the iconic self-titled debut by Bad Brains, who started in DC but moved to NYC. What you'll hear is a blazing-fast, angry, primitive sound that would have hardly any chance of finding mainstream success today, one that smacked of the end of the world to many when it first came out in the late seventies and early eighties. Many of those quintessential albums were products of big cities, as were albums by X of Los Angeles, the Replacements from Minneapolis, and other touchstones of the scene that grew out of the first wave of punk. You can find videos of bands like the Circle Jerks and Negative Approach playing to sometimes hundreds of kids in any all-ages venue that would have them, but most of those kids didn't come from Manhattan or Austin or San Francisco; they were from the suburbs of those cities, and sometimes even farther out.

"We were writing the soul music of the suburbs," said John Brannon of the Detroit band Negative Approach, who was featured on the cover of *Touch and Go* #19, about hardcore. "If you want to nail what soul music was for that time, the scene—even though it's basically a white scene—it is our soul music, man. We're creative, we're bored, we've got nothing going on—man, we're creating this shit."[13]

The hardcore in the early eighties was united by its small, independent zines, record labels, show promoters, and bands. And one of the few places that united all those things, sort of a phone book for the scene, was a bigger punk magazine, *Maximum Rocknroll,* which ran ads and reviews for some of those labels and bands and had scene reports and gave exact addresses of how to get in touch with the people who booked shows in St. Louis, or the kid who sometimes did shows in his parents' house in a subdivision somewhere in the middle of Alabama.

Over thirty years later, in 2014, Marc Fischer and Public Collectors, a resource that collects pre-internet music ephemera from zines to show flyers, used the then-popular blogging platform Tumblr to start Hardcore Architecture, a site created to explore "the relationship between the architecture of living spaces and the history of underground American hardcore bands in the 1980s" using Google Maps to look up the houses that served as the mailing addresses for the places listed in those *Maximum Rocknroll* reviews from 1982 to 1989.[14]

Just a few minutes of browsing Hardcore Architecture and you'll come across the image of a quaint colonial revival underneath a canopy of trees in Montclair, New Jersey, where the band Mechanized Death sent their tape from. The review was positive, with "lots of well-executed stop-and-go action, excellent vocals, and heavy bass and drums [that] make this worth checking out."[15] In 2015 there were a couple of palm trees and a PT Cruiser in front of a little home in Mission Viejo, California, but in 1986 there was a chance you would hear a "piledriving thrash and slower bulldozing noise with personal/positive lyrics" coming from the garage.[16] The cassette with the "harsh abrasive thrash" of the band No Comply came from a little ranch home in Clearwater, Florida. There's a pickup in the driveway and another car parked outside the home in Belle Fourche, South Dakota, where Society's Trash wrote songs about "animal rights, anti-war, anti-racism" that the reviewer appreciated but found "a bit cli-chéd, both musically and lyrically." Damage, from Winter Park, Florida, lived in a McMansion.[17] The landscaping in front of the house in San Carlos, California, where the band Anxiety lived, is immaculate. If you told me the nicest, happiest family lived in the home where the Iowa City band Suburban Death Trip sent their tape from, I'd believe you. Some of the bands featured on Hardcore Architecture operated out of homes in forgotten Pennsylvanian steel towns, and others were from Brooklyn or Queens, but the bulk of the bands were from the suburbs.

American music wasn't preoccupied with the suburban lifestyle before hardcore. Sure, Chuck Berry singing about someone driving aimlessly in "No Particular Place to Go" spoke to countless teens all over the country who just cruised their boring towns looking for something, anything,

to do. The kids in Berry's song are bored, but the people singing so many of the best hardcore songs a few decades later *were* kids and they *were* bored. But besides that, there was one common observation hit on whenever the suburbs were tackled by musicians: how everything looked the same.

In 1962, Malvina Reynolds wrote about the people that "all look the same." Seven years later, the Kinks from the u.k. seared the "paradise" of the character Arthur in the song "Shangri-La," a place where "the houses on the street have got a name, 'cause all the houses in the street they look the same," and nobody has anything to worry about except paying off the debts on their homes and cars and television sets. They "just can't get any higher," Ray Davies sings. Gerry Goffin and Carole King also wrote of the "rows of houses that are all the same" in "status symbol land" in "Pleasant Valley Sunday," a song popularized by the Monkees. The song came out in 1967, the same year as *The Graduate* and a year before the film adaptation of "The Swimmer." It's a pretty damning indictment of suburban culture wrapped in the psychedelic bubblegum-pop tones of Micky Dolenz, with Michael Nesmith backing on harmony vocals, singing about how "creature comfort goals, they only numb my soul" and "I need a change of scenery." Listening to it today, it almost sounds like it's being sung by a bored kid stuck in the suburbs.

But by the early seventies, something happened in American culture as baby boomers hit their twenties and thirties: nostalgia crept in. The previous decade, which saw social norms upended by everyone from the Beats and black power activists to the hippies and second-wave feminists, had died. That's how you almost always see it written: the sixties *died*. JFK, MLK, Malcolm X, Fred Hampton of the Black Panthers, all assassinated; the Manson Family murders; the chaos and murder at the free Rolling Stones concert at Altamont Speedway toward the end of 1969. Not to get too cliché with the terminology, but the sixties had turned into a bad trip in a lot of ways, and the seventies was culture trying to come down from it. And nothing is as comforting as nostalgia, even if it's draped in commentary on the present: Robert Altman's

MASH in 1970 and Peter Bogdanovich's *The Last Picture Show* in 1971 are both great examples of this. Altman's film, set during the Korean War in the fifties, felt like it could've just as easily been about the war in Vietnam, which was still going on at the time. While Bogdanovich's film took place around the same time as *MASH,* it felt like it could've been commenting on the death of America's small towns and ways of life even in 1971. But it was 1973's *American Graffiti*—a coming-of-age film set in suburban California and directed by George Lucas that somewhat inexplicably precedes the *Star Wars* and *Indiana Jones* franchises he'd become famous for—that revels in the way things supposedly once were. Before Luke Skywalker and whip-cracking archeologists, Lucas presented an ode to the decade earlier, the film's poster asking, "Where were you in '62?" There isn't much in the way of drama save for young people trying to get laid and win drag races.

Unlike the songs and movies about the suburbs from the end of the sixties, *American Graffiti* celebrates a simpler time before Kennedy was gunned down in Dallas, before the war in Vietnam went sour for America, and before the counterculture gained influence in America. The film is largely concerned with the feeling of being young and uncertain, and the characters seem to get the most pleasure from one thing: driving around. In the postwar era, that became a particularly American pastime, especially in the suburbs. Chuck Berry called it over a decade earlier, and an unlikely voice responded to his "No Particular Place to Go" with a song first recorded in 1972. That song, "Roadrunner" by Jonathan Richman, eventually resonated with a small group of bored young people who just wanted to make music. And while it might not sound like it at first, it's the link between Berry and hardcore.

While it didn't get much commercial radio play when independent label Beserkley Records finally released it in 1976, "Roadrunner" slowly got onto the turntables of a select few across the country and in the U.K. The weird, nasal, almost sleepy-sounding singer counts off with "one, two, three, four, five, six," then Jonathan Richman and his band, the Modern Lovers, deliver the perfect ode to just driving around. A teenager from suburban Massachusetts obsessed with the Velvet Underground

when he first wrote the song in 1970, Richman connects the past with what was then the present, singing about the joys of aimless driving like Chuck Berry did a few years earlier:

> Roadrunner, roadrunner
> Going faster miles an hour
> Gonna drive past the Stop and Shop
> With the radio on

It's such an odd but perfect song, one that's an unlikely catalyst for so many punk and new wave bands that went on to shift music a few years later. We go from the dorky Richman singing about driving past the local supermarket and neon signs, about getting on the highway for the hell of it, and "suburban trees, suburban speed and it smells like heaven," to the Sex Pistols and the Clash talking about how the song played a part in two of the most important British punk bands origin stories. If you didn't have that one song about some kid from the American suburbs, you'd probably have no "Anarchy in the U.K." If you had no Jonathan Richman singing about the pleasure of getting the hell off his street and heading nowhere, you might not have bands like the Talking Heads or the Cars, both of which counted members of the Modern Lovers among their ranks.

But "Roadrunner" is one of the only true celebrations of the suburbs I can think of. And not long after the bands it influenced disintegrated, a new crop of groups filled with angry young men appeared. Bands like the Descendents sang about people in the suburbs the same way the Kinks and the Monkees did except faster ("I want to be stereotyped, I want to be classified" singer Milo Aukerman says in the intro), while Henry Rollins in the title track for the largely spoken word Black Flag album *Family Man* hisses, "You're such a man when you're puttin' up your Christmas lights, first on the block"; Rollins says he wants to crucify the suburban dad archetype. The suburbs in these songs feel a million miles away from the places and experiences Richman celebrated in "Roadrunner," but they're the same streets in the same kind of subdivisions.

People in the early hardcore scene raged at everything from Ronald Reagan and Margaret Thatcher to people doing drugs and getting wasted to society holding young people back. Suburbia, where conformists supposedly lived, were also an easy target.

Still, as Hardcore Architecture revealed, just because hardcore bands routinely targeted the suburbs didn't mean they didn't live and thrive there. And as evidenced by show and flyer archives, hardcore shows were often just as likely to take place in no-name bars, vfw halls, and even suburban homes as they were clubs in big cities. The critic Robert Palmer, in the 1984 *New York Times* article "New Rock from the Suburbs," focusing on bands like the Minutemen, Hüsker Dü, and T.S.O.L., wrote, "Most of the suburban bands inspired by the Hollywood punk rock scene played the same sort of music—loud, angry and extremely fast, with buzz-saw dynamics and an overwhelming adrenaline rush," but that the music and people playing it by that time seemed "to be in a state of perpetual transition as the musicians [matured] and [expanded] their musical range."[18] The anger slowly fizzled out, or members of the hardcore scene found different ways to direct it. Some dropped out completely. Others, like the Boston band SSD, tried to look and sound more like hair metal bands, like Mötley Crüe, which were becoming popular, while bands like X "moved in the direction of country and blues roots" and bands like "Black Flag [moved] toward a kind of hardcore-jazz-noise fusion," according to Palmer.

Hardcore was growing up. Out of hardcore, that "new rock from the suburbs," something was emerging. It can be seen on the Hardcore Architecture blog, in the entry for an ep sent from a lush and leafy little part of Stockton, California, from a band that doesn't sound like Damage or Society's Trash or Chuck Berry or Jonathan Richman and the Modern Lovers.[19] Instead, Pavement gets compared to the English postpunk band Wire. The California band, along with others, like Dinosaur Jr. from Amherst, Massachusetts; Big Black from Evanston and Chicago; and Nirvana from the sleepy town of Aberdeen, Washington, grew out of the hardcore scene. All those bands have members who were either in hardcore bands before they found success, started bands after seeing how other hardcore bands took a DIY approach to creating

music and scenes, or in many cases, released their first records on labels associated with hardcore. The kinds of music often labeled indie rock or grunge are a direct result of Black Flag and the Descendents, which are a direct result of the Sex Pistols and the Ramones, who owe a good deal of their success to Jonathan Richman and Chuck Berry singing about driving around for the hell of it, and so on and so on.

It's all connected.

There's one house I don't see on the Hardcore Architecture blog, so I drive to Lodi, New Jersey, to see it for myself. It's on a street that looks like any other street in America; there are cracks in the pavement and telephone wires hanging above. It's an unremarkable house on an unremarkable street, but if there's one thing I've learned, it's how that combination can often lead to remarkable things.

This is the house where Glenn Allen Anzalone, better known to fans as Glenn Danzig, started Blank Records so he could put out the debut seven-inch record by his band, the Misfits. And I'm totally serious when I say that despite never having any mainstream success, the Misfits are one of the most important rock bands in American history. They're one of the best, and one of the most incredible overall, when you think of where they came from and the foresight they had when they put out that "Cough/Cool" single in 1977. From that moment until 1983 when they broke up, there was nothing like the Misfits. Nobody sounded like them and nobody looked like them. They weren't really a hardcore band, but the hardcore scene took them in as one of their own. Instead of shaved heads and t-shirts, they dressed up to look like greasers risen from the dead, with their devil locks of hair slicked down the middle of their faces, corpse paint, and bare chests to show off their impressive physiques. They could be fast, but generally the Misfits were melodic and catchy, Danzig sounding more like Elvis Presley and Jim Morrison than his screaming contemporaries. That, and they sang about weird stuff, mostly b-horror films.

And that's what's most interesting to me, how incredibly suburban they were. How they seemed to hatch a plan to do something totally

different and strange and unlike anybody else in the punk scene—which was already different and strange from mainstream music—but that plan was to sing about and dress like characters from movies only bored suburban kids cared about. Not only that, but they stuck to it for close to a decade, and people got into it. The entire idea of the Misfits seems ingenious in retrospect, especially when you see over nine hundred thousand people a month listen to them on Spotify, compared to the just over four hundred thousand who stream Black Flag and two hundred fifty thousand who play songs by Bad Brains. You can see the band's Crimson Ghost logo on sneakers and t-shirts everywhere.[20] Their influence is noticeable in many of today's punk and even metal bands; they influenced Metallica just as much as any of the countless hardcore bands that went on to cover them.

And all that started in Lodi, a town that, as I drive through it, I recognize instantly. It's the sort of New Jersey town I've heard about in a hundred of Bruce Springsteen's songs and could see any member of the Soprano family living in. It's working class and largely Italian. By car, Lodi is about forty minutes from Midtown Manhattan. Jon DeRosa, in an essay he wrote for Pitchfork about sharing similar roots with Danzig and his band, calls New York City "the metropolis that taunts Lodi from across the Hudson River."[21]

As of the 2010 census, there were fewer than twenty-five thousand people in Lodi, and not much to do there if you're young. While plenty of people have written about the Misfits, DeRosa's essay from 2005 resonates with me because he understands where the band comes from. He writes, "If you're born in Lodi, you tend to live there all your life. You live at home until you're married and then move into the house down the block." Danzig eventually got out of Lodi and moved west to Los Angeles, but before he did, as DeRosa writes, the Misfits took aspects of the Ramones, "shed the 'cool' vibe, and set the music firmly in the milieu of suburban alienation, speaking in a language every pissed-off kid in Middle America might understand."

Lodi is a suburb, but it doesn't feel typical. The Italian heritage is noticeable, and heritage isn't something you normally get in a lot of other

suburbs. Nothing about Lodi stuck out to me as especially important to the type of sound the Misfits created, which some labeled "horror punk." No spooky houses out of a Shirley Jackson novel, no old-school hearses driving around, and no women walking the streets looking like Elvira, Mistress of the Dark, or Morticia Addams from *The Addams Family*. What part did Lodi have in shaping this band that, in 1977, did something totally unique and strange that I'm certain they had total faith would catch on in some way or another? It took a few decades after they'd broken up for the band's audience to grow, but still, there's enough mystery around how this band of ghoulish-looking, muscle-bound guys from Lodi became one of the most influential punk bands ever to try to understand what role their quiet New Jersey suburb played in their story.

I tried to put myself in the shoes of a young person in the early seventies when Danzig and his bandmates were teenagers. People born before the internet often talk about how hard it was to track down certain records or learn what people in big cities were wearing. And it was. I was born almost thirty years after Glenn Danzig, and still, in the midnineties, to hear this band all the older kids I skateboarded with worshipped, I had to go through what felt like a series of tasks. I can recall a friend's older sister putting a CD on in their parents' stereo room and seeing the name "Misfits" with that familiar skull behind it. I liked it and wanted to hear more. But after that, if I wanted to hear the band again, and really listen, I needed to procure my own CD or, more likely, a dubbed cassette. I could maybe borrow a CD from somebody, or possibly find a used copy at a record store, but perpetually low on funds, I eventually settled for a cassette of the band's *Collection 1* album filled with some of their earliest and best-known songs. To get that cassette, I needed to not eat lunch at school for one day, save the two or three dollars, ride my bike two miles to a store where I could buy blank cassettes, then ride another mile in the other direction to my friend's house so he could record the CD to the cassette for me.

Getting that Misfits album pretty much sums up how I got almost all the stuff I wanted to listen to, watch, or read when I was a teenager.

When I think back to what it must've been like twenty years earlier, when somebody like Glenn Danzig was growing up, where you remove advantages I had like basic cable, readily available VHS tapes and DVDs, as well as cassettes and CDs to record music onto, it feels like a different century, because, well, it was. I can't imagine what that all sounds like to somebody who's grown up being able to type "Misfits" into Apple Music and choose any song from the band's catalog in seconds, but I imagine in twenty years' time the way the first truly plugged-in generation does things will feel quaint and dated.

And that's what makes the Misfits so interesting to me. Whereas the hardcore bands they played with largely commented on the world they saw and the things that made them angry, Glenn Danzig wrote songs about comic books he read and movies he watched, the stuff that filled his bored suburban mind, the black-and-white horror movies most people either totally ignored or had long forgotten, the ones that played long past most peoples' bedtimes and were introduced by hosts with names like Dr. Shock, the Cool Ghoul, or Svengoolie, depending on which part of the country you lived in. These kinds of shows were low-budget affairs, much like the movies they presented, with schlocky jokes and cheap special effects.

Those cheap B movies, comic books (namely *Mad* and *Tales from the Crypt*), science fiction, transgressive fiction by writers like William Burroughs, and magazines like *National Lampoon,* which trafficked in irreverent, and often lewd, humor, were all scraps of strange or forgotten culture that baby boomer and Generation X suburbanites like Glenn Danzig and others picked up, consumed, and in some cases, turned back into art. That was the suburban teenage experience through the bulk of the second half of the twentieth century: you took what you could get, and you tried to make something out of it. Glenn Danzig and the Misfits celebrated the things that made living in the suburbs a little more bearable and used them as inspiration. "Teenagers from Mars," "Astro Zombies," and the boppiest little ditty about a demon who collects skulls that's ever been written are just a few of the songs that make up the band's two collections of greatest hits. It's easy to

dismiss the band as a bunch of goons from New Jersey dressed like it's Halloween (another name of a Misfits song, not surprisingly) and singing about creepy stuff like killing babies and how "an omelet of disease awaits your noontime meal," but I see something deeper. The Misfits, to me, sound like a bunch of bored young people from the suburbs creating the things they want to hear using the things they know. Lodi seems like a nice place, but I can imagine living there and wanting to get out. I can also imagine that before all the punk and metal posturing, the band was just a couple of guys looking for something to do.

What ties this all together, whether it's Madonna's massive pop hits, the Belleville Three reshaping electronic music, or hardcore, is that belief that you're doing something bigger than the place you're from. When you're stuck in the suburbs, you're able to dream big. You likely don't have the looming presence of national media or of celebrities living down the street. Yes, there's a certain kind of pressure that comes with the suburban existence to fit in and get by, to make as much as your neighbor, to have a nice lawn or a nice car, and to not stick out. Hardcore has long been opposed to all that. You can hear Mike Muir of Suicidal Tendencies screaming about it in "Institutionalized" as the teen saying he's struggling and needs some time to figure stuff out (oh, and that he wants a Pepsi), but his parents and teachers just don't get him. Or it's Bad Religion singing about the "21st Century (Digital Boy)," who has everything he needs but doesn't know how to live or be happy. You can find commentary on the suburban condition listening to any classic album filed under the first wave of hardcore. Whether it's about rallying against conformity or people doing drugs to escape the banality of their everyday lives, the suburbs make great fodder for a music that's fueled by anger about the way the world works.

You don't get a lot of that with the Misfits. They didn't write songs about the suburban experience; instead, they channeled it. Of course, the band probably wouldn't have existed if New York City bands from the Velvet Underground to the Ramones and Blondie hadn't come before them. But again, it's that idea that everything is connected; something

is likely influenced by another thing, city bands influenced the Misfits, and the Misfits in turn influenced kids living in cities and suburbs alike.

It's striking to listen to the band or to look at pictures from their heyday and juxtapose those with the continued success they've had nearly four decades since calling it quits. It shows that the Misfits are a testament to having one big weird idea, free from the trends and financial hand-tying that might curb such ideas in the city, and just going with it.

Mondo-Condo-Shopping-Mall-Hell

Part 1: Ghosts of the Gap

In late 2017, sick of the news, my job, and pretty much everything else, I found myself searching for any slice of nostalgia I could find. Any little thing to get me out of my modern-day malaise and take me away for a small period. I'd fall down nightly YouTube wormholes searching for old commercials from my childhood, cartoons, and odd moments of television that came and went so quickly that I almost thought I'd made them up in my head.

And then, somehow, I found it. Well, more I stumbled upon it while looking at some lo-fi student film from 1994 obviously transferred from vhs to digital. I was sure this haunting little video was some guerrilla-marketing stunt for a zombie film, like I was being lured into a false sense of security but at any second legions of undead brain eaters would come lunging at the screen. You have to be ready for internet stunts like that today. But I kept watching "Toto- Africa (playing in an empty shopping centre)," and nothing happened. It was just the 1982 soft rock hit playing on what sounded like an old shopping mall PA system, echoing from a spot a little bit away from the point of view of the video itself. That POV was a shot of a couple of plants, the tile, and lots of glass, the absolute banality of the mall captured in a single frame while this song I've mocked a thousand times keeps it company.

It was a very moving experience.

Jia Tolentino from the *New Yorker* felt something similar when experiencing the video. She fell down a hole exploring the work of the then-twenty-year-old creator working under the name Cecil Robert.

"I listened to them all, and got progressively more emotional," Tolentino wrote. "Hearing a song you love when it's playing from elsewhere is a reassuring, isolating experience: you feel solitary and cared for at the same time."[1]

As Tolentino notes, people taking songs, playing with the frequencies, and adding a little reverb to make them sound like they're playing in another room had already been popular on sites like Tumblr for a few years at that point. But the Toto mall video was different; it struck a nerve. It was a viral hit by a person whose entire existence had been lived in the "tiny paper mill town of Kaukauna, Wisconsin," when the *New Yorker* decided to document his work. He was somebody who would've missed the golden age of the shopping mall as American Main Street. By the time Cecil Robert was a teenager, around 2011, the nearby Fox River Mall in Appleton, with its American Eagle, JCPenny, and Hot Topic, still attracted young people, but it wasn't the same. The mall was fading from memory. It had become a relic. Most of the stuff you could get there could be bought from an online retailer with a mouse click, and often for less. After the century turned from the twentieth to the twenty-first, malls started shuttering. By the 2008 economic crash, the downfall of our suburban shopping centers was symbolic of something bigger. Around the time of the *New Yorker* article, the term "retail apocalypse" became a buzzy catchall for the shuttering of brick-and-mortar places where people once shopped. For Cecil Robert, he made those videos because, as Tolentino puts it, the young person "was overwhelmed with a placeless nostalgia."[2]

Cecil isn't alone. People really do long for the golden days of going places to shop, or at least for the golden days of going places where you know you'll be around other people. For those who've lived most of their lives with Amazon and the ability to purchase some hat or sweatshirt from some hot streetwear brand from the comfort of their own

home, the only interaction they might have when experiencing these things is with the delivery person. I grew up going to record stores to search for albums I maybe couldn't find anywhere else and let the jaded people who worked there tell me something I liked sucked and that I should listen to some totally obscure sixties garage rock band from Berlin instead. Today, I go on Spotify and there's a weekly playlist catered to what the algorithm thinks I'll like. My friends and I used to hang out in a grocery store parking lot where we'd skateboard; now the grocery store is gone, and there's new housing there that I've read has had a hard time selling. No new place to shop for food has been built in the area, and my friend who still lives there told me "everybody just orders it online and somebody brings it to you."

There's something so cold about it all. Whatever you blame— technology, capitalism, our addiction to convenience—the fact is, we're drifting further and further apart from each other, and we could use more places like the mall. Maybe not the same mall where your food choices are Sbarro and Cinnabon and you're forced to deal with the scent of whatever cologne they're pumping out of Abercrombie and Fitch, but something closer to the original idea of the mall. A place for people to go.

In his book *Bowling Alone,* Robert D. Putnam looks at the decline of American social interaction by using hard data to show the massive dip in club memberships from religious organizations to the PTA. Putnam lays out how disconnected we're becoming as a country. At one point, Putnam wonders if our suburbs are to blame for this, pointing out that "suburbanization meant greater separation of workplace and residence and greater segregation by race and class." He goes on to note that as more people moved out of the cities, "the suburbs themselves fragmented into a sociological mosaic—collectively heterogeneous but individually homogeneous, as people fleeing the city sorted themselves into more and more finely distinguished 'lifestyle enclaves,' segregated by race, class, education, life stage, and so on."[3]

Putnam is right: the suburbs do break us into different groups. Living in New York City, I always hear the subway is the great equalizer; that

everybody has to take the train whether you're an immigrant finishing your graveyard shift or a millionaire on your way to your office uptown. There's something undeniably beautiful about the city's messed-up transportation system and how it's a shared, communal experience. I get on a train and there are two Muslim men, a few old Russian grandmothers, some incredibly beautiful people who may be models, people speaking Spanish next to people speaking French—virtually every other sort of person you can think of in that one crowded car. The city's subway system, in all its never-on-time, always-raising-our-fares-but-never-giving-us-anything-in-return glory, brings people together out of necessity. We all need to get to our jobs so we can pay rent and buy things.

Grocery stores, restaurants, record stores, funky indie coffee shops on the outskirts of town, as well as the types of civic organizations that Putnam writes about, have always been, in their own way, the suburban version of the subway. They give people a reason to get out of the house and be around other people. These places, but especially the mall, force us to interact with society. And now they're vanishing, replaced by one-click convenience that means you never have to leave your home if you don't want to.

The mall represents a time people like Cecil never knew. And he's not alone.

In 2019 I started reading more and more about teens' love for the mall. Hussein Kesvani, for the website MEL wrote about a Kentucky teen obsessed with "mallwave," a DIY version of the genre known as "vaporwave," which gained fans in some corners of the internet during the Obama administration. Mallwave sounds like something you might hear if you broke into a mall in 1992 at night and somebody left the muzak on . . . except you're tripping on psychedelics so everything is a bit slower and more wobbly. For teens, mallwave brings them back to a time before all the often-weird and terrifying realities of the twenty-first century settled in. Every time comes with its own horrors, sure; but history always feels a little cozier than the present day. "Maybe it's fantasy. Maybe it's not accurate in real life," the teenager tells Kesvani. "But it's better compared to the way we're living now."[4]

Generation Z's love of the mall, it seems, translates into the real world. As soothing mallwave flowed through their earbuds and laptop speakers, in April 2019, *Bloomberg Businessweek* reported that young people born in the late 1990s into the middle of the 2000s (people anywhere from seven to twenty-two when the article came out) could "save" the mall.[5] According to a study by the International Council of Shopping Centers, a whopping 95 percent of the Gen Z people polled had visited a mall over a three-month period in 2018. That's obviously a huge number, and even bigger when compared to the 75 percent of millennials, 58 percent of Gen Xers, and 53 percent of baby boomers who went to buy pants at the Gap or get ice cream at the Cold Stone Creamery in that same period.[6] While retailers obviously weren't ready for the tidal wave that was the internet, that combination of nostalgia and an understanding of these young consumers and what they want may be the mall's saving grace.

But what's most important, and something both Tolentino and Kesvani touch on in their articles, is the existential wrestling match that is longing for the mall. Mallwave is just as much a critique of the "shop till you drop" decade as it is an exercise in nostalgia, and today we're so keyed in to our virtual lives that something, anything, that will make us feel some sense of connection to other humans, is desirable. If the mall is going to survive thanks to younger people who'll utilize it as a place to go in order to connect and not just a place to buy jeans or Apple products, it will mean that in some ways, things have come full circle back to the man who created the concept of the mall, Victor Gruen. Sort of.

In 2004, Malcolm Gladwell, a few years removed from the success of his book *The Tipping Point,* wrote for the *New Yorker* about Gruen, a Jewish socialist architect who escaped from the Nazis in his home of Vienna the same week Dr. Sigmund Freud did. The article focused on Gruen's disillusionment with his creation, the modern shopping mall, starting with fully enclosed Southdale Center in Edina, Minnesota. For Gruen, the idea was to bring Americans in the sprawling suburbs together, to bring the walkable streets of Europe to the middle of places

where people were more likely to drive everywhere and isolate themselves. The idea was connection. The mall, with what Gruen dubbed the "Garden Court of Perpetual Spring"—an airy space with a goldfish pond and bird aviary, sculptures and a café that felt more like prewar Vienna than the American Midwest—opened in 1956 and cost $20 million to build. Gruen considered it a utopian experiment, not unlike so many of the people before him who had ideas about humans finding peace and happiness in the suburbs. But as Gladwell points out, "Gruen didn't design a building; he designed an archetype," and that was the problem: that archetype in its time and place better suited capitalism than Gruen's socialist ideals. The mall became our great shrine to the mighty dollar. Gruen hated what his creation became. Toward the end of his life, after designing over twenty-five of them, he disavowed the mall and gave up trying to unite and enlighten Americans. He moved back to his home country.[7]

What's interesting to me about Gladwell's piece is the context of its publication. It was published before the economic crash of 2008, before the iPhone, before Amazon Prime, and really before everything could be bought or experienced online. It was published before some members of Gen Z could even talk. It was published before "ruin porn" became a buzzword, before images of abandoned buildings became a reason people found forgotten factories, theaters, and, yes, malls, so fascinating.

But in 2004, the mall still served a purpose. Amazon was still primarily known as an online bookseller and wasn't at the point where it could force nearly every brick-and-mortar chain to compete online. The idea of the places we went to buy things being abandoned and left to rot was still unthinkable back then.

Fast-forward ten years after the Gladwell piece. Articles like "Eerie Photos of Abandoned Malls Reveal a Decaying Side of Our Consumer Culture" at *HuffPost*[8] or "Completely Surreal Photos of America's Abandoned Malls" at *BuzzFeed* were commonplace.[9] Entire blogs dedicated to images of forgotten malls started popping up, filled with spooky shots of totally lifeless places. In one, a ceiling has caved in and pieces of

it sit at the foot of an escalator; in another, the glass ceiling looks to have been busted open, allowing an entire sheet of fresh snowfall to cover places shoppers once sat while relaxing from a long afternoon of browsing for things they didn't need but wanted. Windows are broken, storefronts are spray-painted and smashed, the plants have all died, and each scene resembles a vision of the apocalypse. Our monuments to capitalism—left as reminders of what we cherished so dearly. In 2014, a decade after Gladwell's article, you could buy books in mostly abandoned malls. You could also browse videos of urban explorers equipped with night-vision goggles, breaking into them; sometimes the videos were edited to make it seem like a noise in the distance was the ghost of a dead employee from a long-closed Sharper Image.

Just two years earlier, in 2012, JoAnn Greco wrote about "the psychology of ruin porn" for CityLab. Abandoned malls didn't come up, but Greco points out our obsession with these kinds of images isn't anything new. "Renaissance painters romanticized Greek ruins. Piranesi's etchings memorialized Roman antiquity as it was being torn up. Photographer Eugene Atget sought out whatever bits of a rapidly disappearing Paris he could find in a post-Haussmann era."[10] Still, I feel our cultural obsession with dying or dead malls signaled something deeper, like Victor Gruen was having his revenge. He was Dr. Frankenstein, the mall was his monster, and the monster was finally dead.

Or so it seemed.

In the fifteen years between Gladwell's article and the 2019 *Bloomberg Business* article about Gen Z giving CPR to the monster's corpse and revving it, well, a lot happened. Without giving you a history lesson, in the middle of all the chaos and turmoil that is modern life, people started rethinking the mall, its history, what it means to our culture, and what we could use it for. The most interesting article I read on the mall in that time was by the British historian Sam Wetherell in the socialist magazine *Jacobin* in 2014. Gruen comes up, as do dead malls (specifically the New South China Mall in Dongguan, considered the biggest mall in the world). But Wetherell adds a twist to the idea of the mall as a utopian paradise: "When the anarchist planner Ebenezer Howard

outlined his utopian vision for British 'garden cities' in 1898, he looked to create in each settlement a 'crystal palace' which would combine the functions of London shopping arcades and indoor winter pleasure gardens entirely under one roof." Wetherell is largely critical of the mall for being "neoliberalism's most precocious architectural form, instruments for enclosing and segregating public space, for fusing leisure and consumption and annihilating small independently run retailers," but he sees Howard, Gruen, and British architect Donald Gibson—who, after the Second World War, convinced the government to nationalize the city of Coventry, where he built a "holistically planned, partly enclosed multi-story shopping center" that was run by the people who lived around it—as being on to something. Yes, Gruen's mall ended up becoming the opposite of what he had dreamed of, Wetherell argues, but we shouldn't totally abandon the idea of the mall just yet.[11] Maybe those lonely younger people nostalgic for a time they didn't experience will realize there's more potential in the mall than as just a place to go to spend money on things they probably don't need.

Still, I can't help wonder, had Gruen lived a little longer, how he would've felt about the way malls actually became a place where people met up. Sure, it was mostly teens and young people who made the mall a place to go and hang out, but that was sort of what he wanted, right? As the eighties pop singer Tiffany—who, along with other singers like Debbie Gibson, made her career out of playing concerts in malls in the Reagan era—points out in a 2018 interview, "There was something magical about the mall. Everybody went there on a Saturday and you met your girlfriends for lunch." While she adds that it was a place to shop and give kids "an opportunity to look at things that you probably couldn't afford," it was also just a place to hang out.[12] As somebody who came of age in the following decade, and who spent a lot of time hanging out in malls with names like Spring Hill, Gurnee Mills, Hawthorn, and Northbrook Court, places where I'd meet my friends or actually go on to meet new ones, the mall played a huge role in my development. Truth is, I hardly recall ever buying anything from age fourteen to about eighteen besides the occasional order of fries or a used CD

from the independent music store. Sure, I coveted things I couldn't afford, from pairs of Air Jordans to a bigger, better television set, but ads in magazines and on television just as likely fueled my wanting of those things. At least the mall gave me and my friends a place to go. And while I'm just as guilty of clicking on image galleries of abandoned places where people once shopped and of watching countless videos on the topic, I miss the mall. I miss it as a place to just *be*. That's not what the mall owners wanted, but who cares? That's what made the mall special: the feeling that my friends and I were planting a flag in the food court or on a bench by Pacific Sunwear, saying that it was our place, and we were going to enjoy our time there. As Tolentino points out in her *New Yorker* piece, younger people are "trying to reintroduce a sense of physical space into a listening environment of digital isolation."[13] These places that served as the new Main Street in the second half of the suburban century make young people feel connected and a little less alone in a world that feels increasingly lonely, in a time when we hardly ever have to leave our houses. It's a small act of rebellion, but maybe more of those kids will look for places to connect offline. The malls are there, waiting to be taken over by a new generation of bored young people.

I think Victor Gruen would've loved that.

When we think of the shopping mall in the classic sense, we may think they all feel pretty much the same, much like suburban neighborhoods do. They're all just warm enough, like a perfect spring day; you can usually catch the scent of fresh-baked Cinnabon in the distance; there's the echo of any number of conversations bouncing off the walls. The floors always shine and fluorescent lighting illuminates everything.

There are over one thousand malls scattered across the u.s. Gruen's idea also spread to Canada, India, the Persian Gulf, and places like Singapore, where a 2015 *Singapore Business* article asked if the over one hundred malls in the city-state are too many.[14]

The answer is probably yes. The fact is, malls will always be around in some way or another; the question is in what form. You take the fifteen

or twenty minute drive from Gruen's first fully enclosed mall in Edina to the Mall of America in Bloomington, Minnesota, two places that opened thirty-six years apart, and you see the evolution of the mall, how it went from a European socialist's idea of uniting Americans to a place you could be all day and spend your money on clothes and toys and electronics, food to keep you going, and even entertainment, from video games to roller coasters. The modern mall strives to provide *experiences,* ways to keep people there for as long as possible, getting them to spend as much capital as they can. Where does the amusement park begin and end if you're just as keen to go to a mall to try the latest virtual reality equipment or to ride a rollercoaster rather than to shop for a new blender or to buy hair dye at Hot Topic?

The truth is that no matter the data saying any given generation is shopping at the mall more, those numbers won't be enough to sustain businesses that probably make more online. Kiosks alone can cost anywhere from $2,000 to $10,000 up front, and storefront prices vary across the country; I've seen numbers go as low as $15 per square foot all the way to $30. That's why, yes, the mall as we knew it is dying. It's an irrelevant idea, one that really works only for big corporations with a lot of money, which is why every mall usually has a Macy's or another department store, an American Eagle, a Lids, a Victoria's Secret, and so on. If you've been to one mall in South Carolina, you get the general idea what a mall in Michigan will be like. Maybe the one exception to this, besides the hybrid amusement park/place to shop like the Mall of America, is a place like Plaza Fiesta. A "mall/cultural gathering spot" on the outskirts of Atlanta, it was previously known as the Oriental Mall and retrofitted in 2000 into a place for the area's sizeable Latinx community.[15] It's a place people can go to and eat food and buy goods from Mexico and talk to people in their native language. It's still a mall, but that idea of engaging people and of letting them go somewhere they can feel connected to a community seems more along the lines of what Victor Gruen wanted.

Like the suburbs that house many of them, the mall is a great analogy for America since the Second World War: From a utopian idea to

an extravagant place to shop, from the eighties and nineties, when malls came to symbolize everything wrong with our consumer culture, to today, when most malls are these bloated, gaudy places or a sad reminder of better times. My hope is that the nostalgia younger people feel for malls can be channeled into making the ones that remain into places that serve a greater purpose.

Still, I believe there must be some middle ground, that the mall can function as something closer to Gruen's vision while remaining sustainable. For the most part, malls that are still around today are massive structures taking up acres of land. You go into a mall and you see a lot of bright lights and negative space. They're a huge energy suck and a massive waste of resources for the most part. If we could find ways to combat that by making the mall a more localized, community-based place where smaller businesses can thrive next to an Anthropologie and Panda Express, a place where people are openly welcomed to just have somewhere to be, then maybe the soul of the mall can be saved.

Part 2: The Same Old Thing We Did Last Week

There's this painting I spend a lot of time looking at. It's *4504 Van Nuys Boulevard* by the Los Angeles–based painter Marc Trujillo. I first saw it over a decade ago in an issue of *Harper's* taking up a quarter of a page toward the front of the magazine. I liked it so much I cut it out and framed it.

The first painting I ever connected with was Edward Hopper's *Nighthawks*. I saw it up close when I was five or six, after a long bus ride from the suburbs to the city on a school field trip to the Art Institute of Chicago. I still have a strong memory of just standing there, captured by something I couldn't put my finger on.

I feel a similar way about Trujillo's painting, even though I've seen only the small version that sits on my bookshelf. The painting features a couple, a woman and a man. You can't see much of her, but he's wearing shorts and a polo shirt on what I assume is one of those great warm California nights. They're buying movie tickets from a guy in his little

glass ticket booth; he looks bored as he pounds a few computer keys. It's dusk. There's just the tiniest bit of light in the dark blue sky. The whole scene is sterile and lonely but beautiful for reasons I've never quite been able to figure out. This scene is familiar to me as somebody who grew up in suburbia. Whenever I look at *4504 Van Nuys Boulevard,* my first thoughts go to how lonely the scene looks. But then I find myself comforted by it, by how familiar it feels.

Trujillo draws a lot of influence from the "purgatory" of the American suburbs, as his bio puts it. There's the movie theater I'm obsessed with, but there are also gas stations as well as cold and careless big box stores in his paintings. His work is a descendant of Hopper's, as is other art I obsess over, from the films of David Lynch to some of the shots of the fictional Texas suburb in the television version of *Friday Night Lights.* And while I've found Hopper's influence in the vision of filmmakers from Wim Wenders traversing the American West to the dystopian future of *Blade Runner* and Pedro Almodóvar's Spain, more often than not, I see his vision of American isolation playing out in art connected to the suburbs.

I see a painting like *4504 Van Nuys Boulevard,* and I wonder how future generations will look at it, and if they'll understand the strange feeling of being lonely and isolated in suburbia. If they'll get that the movie theater, the grocery store, the nearly extinct video rental store, the Applebee's, and especially the mall were lifelines as well as places where we went to buy things. They were the spots where we congregated; those bland places of business were often where we went so we wouldn't feel so alone.

I can picture myself in Trujillo's work because so many moments in my life were similar. I can see myself sitting on my skateboard all alone in a bank parking lot at night when I was fifteen. I don't know what I was thinking, but I recall my deepest moments of teenage contemplation coming at times like that. I can see myself at eighteen: alone and disconnected from my family, wandering the bright aisles of a desolate Dominick's grocery store around midnight for no real reason whatsoever. Another vision is of me on a swing set behind where I

went to elementary school; I'm in my twenties, and I just found out somebody I cared about has passed away. It's a weekend and drizzling rain, so nobody else is there. There's also the image of me with two of my friends—hanging out at one in the morning at a twenty-four-hour Denny's near Woodfield Mall, downing cups of hot coffee and a plate of lukewarm fries we ordered only as an excuse to sit for as long as we pleased. Just some teenage suburban nighthawks at the diner talking about whatever, the pie case a few feet away from us showing off lemon meringue and coconut cake. In those moments, I see myself as stuck in the sort of suburban purgatory Trujillo's work captures, yet these moments comfort me. Sure, I was younger, thinner, and had more hair, but besides that, there was just something nice about the pace and the lack of expectations. Those places—the bank parking lot, the grocery store, the playground, and the chain diner—all gave me somewhere to be. There was no pretense, and besides the french fries and coffee at the diner, I don't think I had to spend much money, and what I got back were some of the happiest moments of my teenage life.

My childhood, and especially my teenage years, was turbulent. It was a time marked by abuse, anger, and sadness, and the last two years of my high school life were spent drifting from one home to another. After my father lost visitation rights when I was twelve, and my mother was living one thousand miles away by the time I was sixteen, I was adrift. The popular comparison is a boat lost at sea, but I was more a little dinghy tied to the dock as a storm raged on, the rope keeping me tied to the rest of the world barely staying tethered. I like to joke that I saw a lot of the Chicagoland suburbs in those years. A little too much, maybe. Without parents to give me any guidance or a constant roof over my head, I drifted, somehow keeping myself together. That's probably why I look back on those moments and they're so clear and peaceful.

As I got older, I decided to really tackle the issues that came with basically being a homeless teen.[16] I found myself sitting a lot, scanning my body, counting my breaths, and trying to not think about much save for the air going in and out of my lungs. Meditation became part

of my daily practice when I was in my twenties, and with it came a willingness to sign up for daily emails from several blogs I followed on the subject. Most of them were written in new age flowery language—like something a college freshman would write when they were trying to be poetic about philosophy—and I unsubscribed from most of them nearly as quickly as I signed up.

But there was one I liked. It was some guy who lived in the wilds of the Pacific Northwest who had escaped city life a few years earlier. He had a blog around 2005 that he updated every so often that was more Henry David Thoreau and John Muir than Deepak Chopra. He was, for the most part, off the grid, but he wanted to document his life so others might better understand his decision and maybe be inspired by it. So it was more about watching a woodpecker do its work, or baking a loaf of bread, things that I guess are pretty meditative when I think back on it, but at the time I just registered it as some guy in his early thirties finding himself. He meditated twice a day, but his little blogspot.com blog was really about his daily life; not so much how food tasted, but the thought that went into preparing it; nothing about the things he purchased, but the things he used. But most of all, it was about place, and the place he was at, it seemed, had little around it that was manmade. No mention of getting chicken nuggets at McDonald's, no talk of auto dealerships, no Target runs; the guy lived in his little home that, according to his writing, was small and in the woods, and he made mention of how he went into town to use the internet at a coffee shop. He had very little and he seemed content and happy with that.

Sometimes weeks would go by between posts, and after one of the longest spells without posting anything, he wrote what would be his final transmission on the blog, complaining about Blogger's move to Google's servers or something being the last straw. Unfortunately, as much as I've looked, I can't find any trace of this person's existence or his writing, but I remember the gist of that final post, because it fundamentally altered me in many ways. It was the man's back story, or a short version of it. He came from a suburb in Colorado, a place not much different from the place I'm from, and he ended up in a big city that he called just

that. He wrote that although he made the choice to move to the place he did, he wanted to get away from the corporate life (he was vague, but he seemed to have held some upper-management job in his previous life). He was generally scornful when writing about that life, so I'd always wondered when his great takedown of the suburban lifestyle would come. I figured he had it in him, some screed about some boring place that looks like every other boring place, with its streets that are given names to lull people into a false sense of comfort, like Pleasant Avenue and Crystal Stream Way. The kind of place he turned his back on. This was possibly a route for me, since I'd moved from the suburbs to the city and, at the time, was feeling quite burnt out with the daily grind and was weighing my options.

But no, that was just my hang-up, my desperate hope he'd one day reveal he felt the way I did about the type of place we'd come from. I chose to live in the city to try to make it as a writer, working at coffee shops and restaurants and generally trying to enjoy every second. He moved to the middle of nowhere where he lived a life of mostly quiet and tried to enjoy every second of it.

So I was a little surprised when I read that last blog post, and it was about going back to a place. Not physically, but how when he closed his eyes to meditate, after he took a few deep breaths, his mind automatically went back to the backyard of his childhood home. For just a second he'd see the green grass his father mowed all the time, the grass his father eventually made the writer mow once he was old enough. The sky was blue, there was a picnic table, and everything was still and beautiful.

Since the blog has gone away or the writer took it down himself, I'm left to paraphrase. But he wrote something about how he'd run away from the place he was from, but once he went back there in his mind, he started to feel some sense of peace and freedom. He embraced the calm vision of his childhood home in its little enclave surrounded by other homes covered in vinyl siding (I specifically recall him mentioning that material). The memory that came to mind wasn't of a specific moment but of a representation of something he hadn't realized was actually calm and beautiful. The man of the woods living this idyllic

life wrote without a hint of irony how this otherwise-mundane setting from his past life in the suburbs was his happy place.

Something about that shook me a little. I thought more about some of those moments I'd experienced, of how life is just a series of those moments happening in real time—seconds and breaths, colors and lights flashing before our eyes, words and noises streaming through the air. Things we consider mundane are actually spectacular and we're never paying enough attention to them. I thought about how, when I was a kid in the suburbs, time moved at an exceptionally slow pace, enough that those supposedly nothing seconds on my skateboard in the bank parking lot or standing in the middle of a Walgreens while Starship's "We Built This City" played from speakers on the other side of the store have a really good place in my memory bank. I realized how much I missed those particular moments—in small doses, at least.

These days, a little over a decade after reading that blog post, I find comfort in the mundane. I could say it's because I'm getting older, and that's part of it, but it's not the entire story. My embrace of the banal is part of a shift a lot of people are experiencing.

For instance, according to a 2019 article by *Vanity Fair* television critic Sonia Saraiya, Netflix subscribers spent a combined fifty-two billion minutes watching the show *The Office.* That's a lot of time watching a show about a bunch of people who probably commute from a nearby suburb for a job at a paper company in a nondescript office in Scranton, PA. As Saraiya points out, it's not that the show simply "occupies the familiar mundane, but also that it depicts a cast of characters trying to build their lives despite the obvious crappiness of their world." And the people who are the most obsessed with *The Office,* Saraiya points out, are members of Generation Z, who, as Saraiya notes, have "a way of adoring some of the most bizarre artifacts from the final years of the pre-online world in a way that combines irony with nostalgia."[17]

Normal and boring also became a legit fashion trend in the 2010s when everybody from Kanye West to Shia LaBeouf championed "normcore." Described in a 2018 post on the fashion blog *Man Repeller* as

reminiscent of something "a suburban dad might wear,"[18] you add the white sneakers and Patagonia fleeces of the style, the billions of minutes humans spent watching *The Office*, and teens obsessed with the mall culture from a few decades earlier, and you have proof that after ten years or so of the new millennium, people were already pretty sick of what was once *the future*. We were all looking for something authentic and safe in a world that rapidly felt anything but.

That probably explains why, around 2016, I started stealing away to places not unlike the boring suburban stores and chain restaurants I mindlessly frequented growing up. After the election and the escalation of partisan fighting, coupled with all the gun violence, constant war, threats of terrorist attacks, news about the devastation of global warming, and the millions of little curveballs life throws at you, I started to embrace the humdrum, anything to disrupt the routine: riding in the car to just walk around a Bed Bath & Beyond or volunteering to take a trip to the mall to pick something up for my mother-in-law when we'd visit. I'd go to these places for an opportunity to reconnect with something simple. I mean, sure, the temperature is regulated, the music is regulated, and there's a corporate code to everything. But I realized that whenever I found myself in the suburbs, I couldn't get enough of sneaking out on a Saturday to sit at a Chili's and watch a college football game I didn't care about, or of standing in line wearing an old Patagonia fleece and some beat-up boat shoes with throngs of other people dressed the same to get a cup of coffee on a Sunday morning. I spent the last months of 2016 and deep into 2017 traveling all over the country, reading about how we were in the thick of a culture war, how Americans hadn't been as split over political differences in my lifetime. Yet no matter where I was, north, south, liberal oasis, or old Southern Republican stronghold, it didn't matter: I could go to a suburban McDonald's or Barnes & Noble and the experience was the same if I were outside Portland, Oregon, or in the Florida panhandle. It became sort of a pastime of mine, getting out of the city and going to grocery stores just to browse the aisles, looking at the paint color samples at Lowe's, or eating a couple of bean burritos at a Taco Bell.

I embraced the comforts of the sprawl. I learned to appreciate everything I'd sworn I hated because it represented some sense of normalcy, something I was familiar with that I didn't have to fear would radically change.

There's a term for this, I think. It's a term I started noticing around the same time *normcore* began infiltrating mainstream fashion and when people started to notice teens were obsessed with the fictional employees of Dunder Mifflin (that's the company in *The Office* in case you aren't one of the people who spent fifty-two billion minutes watching the show).

This was me accepting that I was *washed*.

In a July 2018 *GQ* article, writer Zach Baron points out that people tend to use the term *washed,* which gained traction on Twitter and Reddit, as a pejorative. But he argues that there's something sort of nice about being washed. As Baron puts it, to be washed doesn't mean you're washed up or some pathetic version of the person you once were or could've been. Instead, being washed is "more about that transitive moment: There you are in the train station of life, waving goodbye to your edge and your youth as they depart." Giving in to being washed is "cutting yourself some slack."[19]

The suburbs, if I may, are about as washed as it gets, and trying to find some moment of happiness in them is something a person who has come to grips with being washed might do. At least as opposed to cities, where there's always the feeling you're performing for all the other people you pass. It doesn't matter if you're in Pittsburgh or New Orleans, Mexico City, or Moscow; there's always more movement in bigger cities. People dress differently, act differently; there are hot spots the hip, rich, and good-looking flock to, things to try to see. Not so much in the suburbs, and I find that incredibly relaxing now. It's the exact opposite of when I was a kid and wanted to do anything but relax. I wanted to create and walk around and talk to people and eat a slice of pizza for lunch and have my choice of food from any number of countries for dinner. Suburbia didn't seem to offer that, and, as far as I can tell, it still doesn't.

When I drive through the suburbs anywhere in the country, I notice all the same corporate boxes that anybody from any background can fit

into. You might find some indie record store or a great Mexican restaurant owned by a family who moved from Oaxaca less than a decade ago and who recreate the food from their home better than anywhere else for hundreds of miles, but it isn't likely. Your chances of finding a Walgreens or a Buffalo Wild Wings, on the other hand, are high.

I'm not a fan of those kinds of places per se. I'd really like to have some sort of relationship with the people filling my prescriptions or offering me home improvement advice. We don't have to be friends, but the whole corporate vibe just makes any interaction between people feel synthetic. And what good is a restaurant that has hundreds of locations across the country but offers no regional variance? So no, I don't *like* suburban chain places. What I do enjoy, however, is that comforting feeling of knowing what you're getting, no strings attached. You don't go to the IHOP because some famous food critic raved about the boysenberry syrup, and the Irish pub tucked next to the empty space where Circuit City used to be probably isn't a celebrity hot spot the way someplace in Los Angeles might be—and there's something nice about that to me. My getaways into the "purgatory" of suburbia Trujillo depicts is the epitome of being washed, and I'm fine with that.

The Battle for the Soul of Nod Road

After nearly two years of reading everything I could about suburbia and driving through subdivisions across the country, everything came full circle. On an afternoon grocery run from my in-laws house in suburban Connecticut, I spotted a green sign stuck in a lawn—Save Nod Road—and it changed the way I imagined what people could do in the suburbs if they started talking to each other and working together.

At the heart of the suburb is the idea of the pastoral. It's usually faux pastoral, sure, since I'm guessing not too many people buy a ranch home with a small backyard in a mixed-use area and think they'll use the little plot of grass to farm on. I've never heard of any cases of a family buying a house in a nice area somewhere outside a city and using the garage to house cattle. If you told me it's happened, I wouldn't be surprised, but the point is that there's this idea that the suburbs are somehow more in tune with nature than the cities but not as isolating to live in as rural areas can often be. The older suburbs, the ones that predate Levittown, were built with the idea of humans living closer to nature while still having access to the modern world, but that idea was traded for convenience. Gone is the wild; it's been replaced by the hand-planted, the fenced-in, and the chemically treated to keep pests away from the lawn. Everything is usually ready for you when you move into a newer suburb.

And that's part of the problem with modern suburbs. They were conceived as a pastoral getaway and quickly evolved into what we see today with rows of houses and corporate businesses. As historian Leo Marx writes in his book *The Machine in the Garden,* "What is attractive in pastoralism is the felicity represented by an image of a natural landscape, a terrain either unspoiled or, if cultivated, rural." Deep down so many of us are drawn to the pastoral, but most people aren't willing to give up the modern comforts it takes to pull it off. The suburbs have come to represent some happy middle ground between what we want and what we can handle. Marx goes on to write about the impulse to move toward a supposedly more pastoral existence, and how sometimes people do it to get away from a life or place that might feel artificial. "When this impulse is unchecked, the result is a simple-minded wistfulness, a romantic perversion of thought and feeling," he writes.[1]

I thought about that *idea* of the bucolic as I drove through the town where my in-laws live, Avon, Connecticut, in the summer of 2018. Sitting in the heart of the Farmington Valley, with Talcott Mountain overlooking it, and about fifteen minutes outside Hartford, Avon, which was first settled in the mid-seventeenth century, would look to sit closer to the pastoral idea than most American suburbs. It's the peak of quaint New England, all lush with native red maples and towering pines. It's a place that more than a few people have noted resembles television's coziest small town, Stars Hollow, home of Amy Sherman-Palladino's *Gilmore Girls.* It looks less like your typical suburb and more like a small village, save for all the long stretches of street that keep all the homes and businesses apart. It's impossible to walk around, thanks to a lack of sidewalks.

The layout and the population's growth, from just over three thousand after the Second World War to eleven thousand in the eighties, prove Avon is one of those places that's grown into a suburb.[2] While there are plenty of historical buildings and farms scattered around, most of the homes along one of its main streets, Nod Road, were built during the big population boom between the eighties and nineties. And many of those homes are what one might consider McMansions,

built in the last thirty or so years. It's quiet, clean, and the foliage is lovely, but Avon is still the suburbs. It's just surrounded by enough nature that people can say otherwise. People from Manhattan could own a home there, visit it on weekends, and call it their country place if they wanted. Likewise, executives from insurance companies who call Hartford County home might live there. It's a little slice of charming, rural-feeling Connecticut life.

That sense of country life is all within a few minutes of a Subway, two charming independently owned coffee shops, a bagel place, an auto dealership, a Wal-Mart, and a handful of other businesses up and down Main Street, which leads to nearby Canton, where you can wander the outdoor Shops at Farmington Valley and grab lunch at Chipotle or buy a sweater at J. Crew. Avon may be quaint, but it's hardly cut off. There's a sense of the pastoral, much more than you get in other suburbs, but just like parts of Westchester County in New York, the North Shore of Chicago, or a place like Terrell Hills, just outside San Antonio, Texas, it's because people can afford it. They can pay for larger plots of land to keep things feeling more spaced out. It *feels* like the country.

And just like all those other places, and nearly every other upscale suburban neighborhood across the country, there's a golf course nearby. A few, in fact, including the Golf Club of Avon, Farmington Woods, and Blue Fox Run, all call Avon home.

Golf is the perfect suburban sport. You play it outside on a course with grass that's constantly maintained, it's slow, and you can take a motorized cart to get from one hole to the next. You could theoretically walk it, but most people don't want to lug their clubs. Also, like some suburbs, golf courses some are exclusive about who they let in. That might have something to do with the fact that of the 25.7 or so million golfers across the country, 20.3 million were listed as white according to a 2013 study published by *Golf* magazine.[3] Twenty *million*. That's nearly the population of the state of Florida.[4] In comparison, 3.1 million Latino people, 1.3 million African Americans, and 1 million Asian people play golf.

And there are plenty of people who don't like golf, or, at the very least, who don't see the point of it, just like there are plenty of people who don't like or see the point of the suburbs. There's the sheer amount of land used, which is usually over two hundred acres, and the money lost on courses. Spencer Gardner, a transportation planner in Madison, Wisconsin, explored how much money his town was losing on the four municipal golf courses in the city in 2016. Looking at property taxes in the area, he found that if the forty-two acres that made up one course had never been set aside for golf, and instead had been developed like similar neighborhoods, the missing tax revenue would have amounted to nearly $660,000. As Gardner puts it, "The opportunity cost of reserving 750 acres of land as golf courses is that the city cannot collect tax revenue on the productive use of that land," meaning the city loses millions in taxable revenue, money that could go to funding schools or helping the homeless population.[5]

Unlike Madison, Wisconsin, Avon doesn't have a visible homeless population. It is, for all intents and purposes, a well-to-do area. I'm not sure why it has three golf courses, but financially speaking, they don't look to be as much of a suck on the local economy as they might be in other cities. Avon and its surrounding area are full of people who love to golf. Golf is part of the package that tries to lure businesses and businesspeople there. Is it a waste? Visit any of the courses on a given day and you'll see maybe a dozen people using the two hundred acres. Then, factor in the water it takes to keep the greens green and all the things you might hear locals complain they don't have—from more public parks to bike paths—and you be the judge. I'm fine with golf and having some golf courses here and there, but no, I don't think you need three within a town that's less than twenty-five square miles.

Yet when a developer proposed building a freestanding condo of ninety-five units and three houses on the Blue Fox Run course on bucolic Nod Road in 2018, knocking the number of holes from twenty-seven to eighteen, I found myself paying attention. Normally I'd say shrinking the size of a golf course and using the land for more than a few members was a great thing. But the battle to "Save Nod Road," as

the local campaign that propped itself up to fight the development was called, was about more than keeping the course—which one local who plays at all three told me was the "worst" in the area—intact.

"The other side is just pushing, pushing, pushing for this, and when you look back at the town's plan of conservation and development, which this commission, the planning and zoning commission, created, and it gets revised every ten years, and it started back in 1956, and there's several different versions of it, it references this property, this land right here that we're talking about, as unlikely for development," Robin Baran, one of the cofounders of Save Nod Road, tells me over coffee. Sitting next to her is her partner on the project, Christopher Carville. The two have been neighbors for years, and Carville even owns the popular Pickin' Patch, where locals get their seasonal produce. It's the eve of the planning and zoning commission meeting, the one where Keystone Companies LLC and Sunlight Construction Inc. would try to convince the commission to let them convert nearly forty acres of land from agricultural use to residential. "It's in a floodplain, not recommended for building. And so that's one of our points we're driving home, is that, 'Dear commission, this is what you've been saying since 1956 about this land,'" Baran contests.[6]

Early in 2018, Keystone Companies proposed an informal development plan on the course to the planning and zoning meeting. Soon, the plan was revised to include a freestanding condominium of ninety-five units that would live on the golf course, as well as three houses along Nod Road. The developer promised that everybody from empty nesters looking to downsize to small families and young professionals would be attracted to the area, which had had a difficult time attracting those sorts of people. It would've gone totally unnoticed, but Carville's wife, Polly, posted about it on Facebook. Baran, who had never met her neighbors, saw the news of the proposal shared in her feed.

"I messaged her and I'm like, 'Hey, I live across the street from you guys. We've never met. I actually think I recognize your name. I think I know who your kids are because I used to substitute in the schools,'" Baran says.

A conversation started, and finally, Baran asked her neighbors if they wanted to meet. That meeting led to calling a neighborhood meeting: "Then next thing we know we have fifty people in my living room, and we went around and put a letter in every single mailbox on Nod Road, Nod Way, Woodford Hills, Hazen, Ridgebury. Fifty-six letters. And invited them for coffee, and I think the most important thing to say about that is: within ten minutes, we took a vote, having never met each other, that everyone was in agreement that we wanted to see no further development on the property. As opposed to allowing some, or trying to get them to reduce it. It was just unanimous."

The Save Nod Road group went from a few signs along the road to a full-fledged 501c3 nonprofit. On its website, one of the concerns listed about the possible new development was that it was "completely out of character on this scenic and rural road," which includes a beautiful view of Carville's Pickin' Patch, where local kids get their Halloween pumpkins in October, and of Tower Ridge Country Club, which comes complete with yet another golf course. All in all, golf courses take up a good amount of land in Avon, but this was about more than just losing a few holes: "We're pro responsible development," Baran tells me. "This isn't about stopping every development proposal that comes on the scene. It's more about looking at where they're proposing to build this stuff, and what are the motives behind it? And is there a need for it? There is no need for this. And the motive behind it is for—"

"Profit," Carville interjects.

But there was another problem the new homes would cause. Besides losing the nice views and the increase in traffic on Nod, there was the environmental impact to worry about, including whether the inland wetlands, wildlife, and Farmington River would suffer any damage. Avon is filled with creatures big and small, from woodpeckers to the state's largest population of bears roaming the forests. It has the kind of natural beauty developers keep wiping away to build more stuff. More stuff that seems unnecessary.

The fight for Nod Road became a big deal locally. I noticed some of my wife's childhood friends putting the nonprofit's logo on their

Instagram; the local news started to cover it; the Save Nod Road site, which was beautifully designed, included a "News and Media Blog" that was updated regularly as news trickled in. Locals were invested in keeping the condos away. Over eight hundred of them liked the Facebook page for the little local movement. There was a fundraiser at Metro Bis, which isn't located in Avon, but in nearby Simsbury, and the event featured a five-course menu that included salmon and a braised beef brisket, each plate with a wine pairing for $125 a person. There was even merchandise: buttons, large lawn signs, and, of course, T-shirts.

This was suburban activism. The people of Avon, a place where insurance industry executives and small business owners live a mostly peaceful existence, had to stand up and fight for their community. Sure, some of the activism was simply sticking signs in lawns or spending over a hundred bucks a head to eat a nice meal at a fundraiser, but it was a movement nonetheless. The idea of a bucolic existence was being threatened, and the people weren't having it.

The citizens of Avon got organized: you come for our way of life, and we'll fight back, the people of the Connecticut town were saying. They weren't exactly going to change the world, end war, cure cancer, or send shockwaves throughout the American political system, but the developer trying to build condos on the golf course did awaken something in the people of the quiet Connecticut town.

You often hear of famous fights to keep things the way they are, to restore and improve them instead of wiping them away.

Sometimes it's a matter of passing a bill like the Ancient Monuments Protection Act the U.K. passed in 1882, when the country's history was slowly being wiped away, or the founding of the National Trust for Historic Preservation. But in other cases, it's more public and there's a dose of celebrity involved. Like how in the seventies, Jacqueline Kennedy Onassis, then one of the most famous people in the world, brought her voice to the movement to keep and fix Grand Central Terminal instead of building a new, ugly structure where the turn-of-the-century Beaux-Arts beauty still stands.

But in the grand scheme of things, few fights to keep a place and a community intact have taken on the sort of mythos of Jane Jacobs's fight to save Greenwich Village from the likes of Robert Moses.

Jacobs occupies a place in the popular imagination as the angel to the devil Moses. He was the urban planner, a power broker whose life Robert Caro famously chronicled in one of the great American biographies. She was the scrappy activist and writer. Jacobs versus Moses and his urban renewal plans is one of the great rivalries of the twentieth century. When Moses wanted to rip up the West Village and put a highway through it, displacing numerous people and destroying the neighborhood, Jacobs and other activists rallied against it. They eventually helped save Washington Square Park and the surrounding area, and some see the city finally halting construction of the highway in 1962 as a moment when the massive amount of power Moses once had in New York started to slip.

You don't hear stories like that coming out of the suburbs. There isn't a Jane Jacobs of suburbia that I'm aware of, and I'd hardly go anywhere near comparing the Save Nod Road people to her. But the fight to keep the condos from going up on one of several golf courses in Avon led me to wonder what would happen if suburbanites started getting more proactive. What if the people of Avon and other places like it across the country started getting involved in local politics and attempted to better their way of life before it's threatened, helping to build and grow the community they live in?

Well, for one, they would probably need to get to know their neighbors better first. This is a chicken-and-egg sort of situation, I realize: Will they meet more people by being more involved, or will involvement lead people in the suburbs to get to know their neighbors a little better? A 2018 Pew study showed that about 28 percent of people living in the suburbs know all or most of their neighbors.[7] The amount isn't too far off from that of people who live in cities (24 percent), where moving from one place to another, the hustle and bustle, and not having much time are all common. It could be said, especially in a case like Avon, that the suburb is supposed to sit snugly between the city and the countryside, and that

people who live in the suburbs are looking for some of the conveniences of city life but the relaxed pace of the country. Yet people in the country, in the true small towns and rural areas, tend to know their neighbors 40 percent of the time. That's significant. It shows just how disconnected we've become when over half the population of America lives in the suburbs, and most of those people don't know their neighbors. How can anything get done if you don't know the people who share the living space around you? I'm not saying you need to be best friends with or even like them all that much, but the suburbs, by design, do make it exceedingly difficult to know who lives on your street or down on the next block.

One of the things you routinely hear from people who grew up in the suburbs in the middle of the last century is that they slept with their doors unlocked and everybody knew each other. While I tend to think history is easy to view through rose-colored lenses, I also believe there's something to that sentiment, and it speaks to how far apart we've grown over the last fifty or so years. Part of that is due to how dependent on cars Americans in the suburbs have become. Some studies show that the average American spends an hour a day commuting to and from work, and 91 percent of Americans use their personal vehicles to do that.[8] Add in the eleven hours a day Americans spend taking in various forms of media on their laptop screens, phones, and televisions,[9] all the little house chores one might have to do, the doctor appointments, the getting of groceries, and of course the hours in between at the office, and it doesn't seem like there's that much time to get to a neighbor's house. The physical sprawl of the suburbs and the mental sprawl of everyday life can make everything, especially getting people together, difficult.

But it pays off. Organizing, whether it's to fight a developer or to get people involved in local and national politics, is just as important in the suburbs as it is anywhere else, maybe even more so. As Rebecca Traister, in a 2017 article for the *Cut*, explored, women in "Georgia's affluent, suburban, predominantly white sixth district" were spending their time and energy—"in many cases, nearly *all* their time"—on stumping for the then-thirty-year-old Democrat Jon Ossoff, who was vying for a seat long held by the Republicans. The close race, Traister

noted, "can largely be attributed to the obsessive energies of the sixth district's women, an army of mostly white, suburban working mothers who had until now lived politically somnambulant lives." The women of the district, some lifelong Democrats, others who started getting active after the 2016 election of Donald Trump, articulated a new sense of purpose to Traister. One spoke about the isolation she felt working from home and taking care of her daughter, who has cerebral palsy and goes to a special-needs school, and that because of those things, she doesn't have much time to socialize with other parents at events like sports practices or PTA meetings. As a lifelong Democrat living in a red district, the woman said she felt "isolated" both socially as well as politically. But after 2016, she told Traister, "I'm feeling like I'm working toward something. After the anger and depression faded, the motivation kicked in."[10]

A year after Traister's article, in 2018, the Canadian magazine *Briarpatch* looked at the other side of the political coin, at the battle to win the votes of Chinese suburbanites outside Toronto. They examined how the left had spent years neglecting the growing Chinese community, how the right swept in by aligning with the Chinese Christian churches and bombarding the area with information through traditional and social media, and how the left was fighting to bring those voters back to their side. The issue shows how the right took the time to invest in these people who live in the suburbs, and how "sadly, the left has often been uninvested in the struggles of Chinese and other racialized working-class immigrants."[11]

The left's inability to court the suburban Chinese Canadian vote shows how important the suburbs have become politically, and it shows that it's not just in America and it's not just any one group of people. But since I'm an American, reading that article from our neighbors to the north got me thinking about my country's own 2016 election, the one that was a political awakening for so many people in Georgia's sixth district, the one where Democratic candidates lost 5 percent of the vote from just eight years earlier, down from 50 percent to 45. It shows just how important connecting with the people you want on

your side truly is. And in the suburbs, especially in states like Ohio, Florida, and Wisconsin, on which every election seems to hinge, getting to those voters is critical.

In 2018, of the sixty-nine suburban districts held by the Republicans, only thirty-two remained in the party's favor after the midterm election. While Jon Ossoff lost the 2017 special election for the suburban Georgia seat to Republican Karen Handel, he did get 48 percent of the vote, and the seat went blue the following year when Democrat Lucy McBath beat Handel by a few thousand votes. Engagement, especially in the suburbs, is critical. The most basic way to sum it up is if your side doesn't get to suburban voters, the other side will. Organizing, whether it's political or to ensure the neighborhood continues to grow and thrive, is imperative. It takes a village, as they say.

"I've never felt connected to any cause, or anything," says Save Nod Road cofounder Carville, whose family roots in Avon go way back. His father was born in the old log cabin not far from one of the high schools. "It's kinda like, 'All right, that's what they want to do, go ahead. They're gonna do it anyway.' That's been my thing. But this one, this is not appropriate development. That's really unappealing. That's why I've lashed out on it, personally. There's a reason there are no homes there. It's not the right place to build, otherwise they would have been built years and years ago."[12]

I found myself walking across the length of Blue Fox Run on a drizzly afternoon after I talked with the Save Nod Road people. It was the first time since my teenage years I had walked across a golf course. Back then, it was because my friends and I would use the mostly quiet course near our house for all sorts of activities that didn't include hitting a ball with a nine iron, activities that could only be classified as illicit. When we were kids, it felt to me like these big plots of seldom-used land were massive wastes of space.

I still feel that way today, especially when you consider the tax breaks and the environmental impact, the trees that could go where the putting green is, or the nature center that could sit on the same spot as the

clubhouse. I don't care for golf or the space it takes up, but I appreciate the stillness of a course. As the sun finally comes out from behind the clouds, I get why people like this one piece of land the way it is. I stand by one of the holes and look around, and a group of deer walk out of the forest a little ways away. They seem confused by all the open space but quickly adapt and begin to casually walk through the course before disappearing into another wooded area. It's a peaceful time, especially since the light rain has scared away any golfers. I appreciate this, I think. I'd like to have seen the wilds of the Farmington Valley before the course was built, but there's something nice about a suburban golf course, I will admit.

And while it's not Jane Jacobs taking on the most powerful man in New York City, and it probably isn't swinging any elections, the fight to keep a little part of an affluent suburb in Connecticut looking and feeling bucolic makes sense as I walk across the greens and catch a view of the distant mountains. I think of the daily complaints I hear about the new places going up in New York City, big glass condos right up the block from my apartment, and how they tend to sit vacant, either because rich people from other countries buy the units and never use them or because they're simply too expensive and there aren't enough millionaires to occupy them. Yet they keep going up. We keep building and building because some developer promises new homes will attract new residents and somehow make the neighborhood better. There's sort of an analogy there for everything that's wrong these days: we keep building instead of improving, creating instead of fixing. As a person who's lived in cities now for most of my life, the Save Nod Road struggle made me realize how much in common I actually have with people in the suburbs. It isn't about keeping people out or stopping developers from doing business. It's about retaining peace of mind, about holding people accountable and holding back the sprawl. People in the city I live in and cities all over routinely organize to try to stop the tide; suburbia would only benefit if more of its people did the same.

The day after I met with Baran and Carville, more than two hundred people showed up to the planning and zoning commission meeting on

the proposed zoning change. The meeting was moved to a larger venue—
the Avon Middle School cafeteria—but it wasn't enough: so many locals
wanted to comment that a second meeting was set up for later in the
summer. There was a July meeting, then a date for a vote was set.[13]

On September 10, 2019, the commission voted six to one to deny the
zone-change application. Suburban activism worked.

Go Back to the Suburbs

When I first told people I was working on this project, an attempt to better understand the suburbs and their impact on America and the world, the question I got most often was, "Would you ever move back?" I usually didn't answer, but I did find a way to talk about my favorite place in all of suburbia.

As the product of divorced parents who moved around a lot for the first twenty-five years of my life, it's difficult for me to definitively say there's one place I spent more of my childhood and picked up the life lessons that would guide me into adulthood. As a kid, I went from one house to another, Mom's, then Dad's. Every few years it felt like they lived in a new place. Then, in my late teens and twenties, I lived in the city, a place where you're lucky if you get two solid years out of an apartment, unless you own or have some lucky setup like rent stabilization. Still, if I had to pick a place to call home, I'd go with Skokie.

Once dubbed "The World's Largest Village," the thing I tend to hear from people who have never lived or even visited what I consider my hometown usually comes from librarians. They love the Skokie Public Library, and I totally get that: it's a great library. In 2008, it was the first public library in Illinois to be awarded the National Medal for Museum and Library Service. It's big, airy, and spacious, with sculptures all around.

Every single time I go back it's filled with people reading. I know that's what libraries are for, but the Skokie library truly feels like a popular place, and it makes me proud to be from there. It was my first library, and it will always be my favorite.

The other thing Skokie is famous—or maybe I should say infamous—for is when Illinois Nazis tried to hold a demonstration in the late seventies in the town that, at the time, had a large Jewish population as well as a large number of Holocaust survivors. There were worries that Nazis parading through the streets would end in violence. Ultimately the National Socialist Party of America held their demonstration in Chicago, and the world got the famous line, "I hate Illinois Nazis," from the 1980 film *The Blues Brothers.*

In many ways, Skokie really does feel like a village. From where I lived on Niles Avenue, you can walk basically everywhere. You have access to Chicago's CTA commuter system, the yellow line (known then as the Skokie Swift), which goes only from Skokie to one stop that connects you to the red and purple lines, and back. My school was nearby, as were the grocery and hardware stores, and of course, the library. Even now, when I go back, people still walk up and down the streets of Skokie, people from all over.

And that's the thing I loved most about growing up there. Besides the large number of Jews—some recently defected from the Soviet Union, some second- or third-generation Americans, others part of that sizeable population of Holocaust survivors—on my little street alone I can recall black neighbors and Greek neighbors. The family next door was from Bangladesh, the neighbors in my building spoke Spanish and Yiddish, and my best friend was a kid named Eugene whose family was originally from South Korea. I once heard somebody call Skokie "Little United Nations," and yeah, that actually sums it up well. That's why I'll always call it my hometown over all other places. Skokie is what I love about America and what I'd love to see more of. It's not perfect, but people there are out walking, talking to strangers, and going to the library, and its population comes from all over the world. I might not be a great person, but I'm certainly a better one because I spent some

really formative years of my life in a place where I could meet and interact with people from different backgrounds and get to know cultures other than my own. I'll always be thankful that Skokie raised me.

I drove through Skokie recently, and maybe it's because I have fond memories, but it doesn't feel all that different from the town I remember from 1986. It's still diverse, there's still a yeshiva not too far from a great Mexican restaurant that people from the city make the trip to try, and nearly 26 percent of the population responded that their background is Asian on the last census.[1] There are cute Chicago-style bungalows for sale all the time (something I know because in my weaker moments, I find myself checking real estate listings there), churches, mosques, and synagogues, and it takes less than twenty minutes to ride a bike to the Zen Buddhist Temple of Chicago. There's public transportation into the city, sidewalks to get you from one end of the town to the other, and, yes, the library. I'm obsessed with how good it is.

Some cities attempt to capture the sort of small-town look and feel of a Frank Capra film. Take a walk down Oakton Street, the heart of Skokie, and it's clear that at some point a decision was made not to knock things down and rebuild to look more modern. Instead, many of the buildings from the first half of the twentieth century remain, as do family-owned businesses and places to walk or sit. These buildings and businesses rest comfortably alongside big banks and the couple of chain fast food places that have tried to gain a footing, and I could see a modern-day George Bailey from *It's a Wonderful Life* buying a hammer from the Ace Hardware to help his elderly neighbor hang a painting or organizing a food drive at old St. Peter's Church with its All Are Welcome sign and its rainbow ichthus.

But the suburb of just under sixty-five thousand is a place where people live. Some are born there, some die there, and in the middle, they make it feel like an actual community, one that's welcomed people from all over the world for decades. Some places are built to look like they have history and character. Skokie just has them.

But would I ever go back and live there? Would I go back to Skokie or any other suburb? That's so hard to answer. Like I said, people ask

me, and I ponder the question sometimes, yet I never arrive at a yes or no answer.

In the winter of 2017, when I was still researching for this project, I hopped into a movie theater at the recently opened Dekalb Market Hall near the Manhattan Bridge. The market is one of many places in the last years of the 2010s built around New York City that I'd have no problem calling a mall. From Brookfield Place down by Ground Zero to Hudson Yards, the sprawling, $25 million development on the west side of Midtown presents itself as a city within the city, but it feels to me like a mall in the middle of a business park. I know from traveling the country from DC to San Francisco, these sorts of places seem to be popping up almost overnight—new developments disguised as "neighborhoods" that feel familiar to anybody who spent time in the suburbs but totally foreign and strange if you live in a city. They're cold, both in temperature and design. They're spotlessly clean and expensive. CityCenterDC, for example, which broke ground in 2011 and was completed in 2015, is a mixed-used development with residential space, two office buildings, and a luxury hotel. It also boasts Louis Vuitton and Hermès stores, and not much below that pricewise. It's free to the public to come in and walk around, but not everybody can afford everything, giving it that old suburban feeling that the place isn't for everybody.

Dekalb Market, on the other hand, has a Target and a Trader Joe's. There's a food court where you can get everything from a pastrami sandwich at an outpost of the famous Katz's Deli to stands where you can get dumplings, tacos, sushi, and just about anything else. And upstairs, there's an Alamo Drafthouse Cinema, where I found myself on that late-2017 evening to see Greta Gerwig's *Lady Bird*.

Christine "Lady Bird" McPherson (played by Saoirse Ronan) is a high school senior at a Catholic school in Gerwig's hometown of Sacramento. Lady Bird desperately wants to get out and go somewhere with "culture," and she generally looks down on her family, their struggles, and their surroundings. The film focuses on Lady Bird's relationships with her parents, her friends, and the people she'd like to be friends with.

But most of all, what the film accomplishes better than just about any movie I can think of is showing the complicated relationship so many of us have with suburbia. Lady Bird wants to get out. And she finally gets that opportunity, as her parents make yet another financial sacrifice to help her go to college in New York. Lady Bird seems content with her decision but quickly finds the city moves a lot faster than her suburban home, which she begins to miss.

In the film's last scene, Lady Bird leaves a voicemail for her mother. She asks, "Did you feel emotional the first time that you drove in Sacramento? I did, and I wanted to tell you, but we weren't really talking when it happened. All those bends I've known my whole life and stores and the whole thing," before telling her mother, whom she'd been fighting with before she left, that she loves her.[2]

I'd never seen or read anything that connected with my own thoughts and feelings about the suburbs in that way. I walked out of a movie theater in a Brooklyn mall that felt like it could live in a suburb anywhere in America. After months of reading about the design of the suburbs and race relations in suburbia, listening to hardcore records that came out of little suburban places scattered all across the map, reading John Cheever and Shirley Jackson stories, wondering if I could truly understand how I felt about the suburbs and all the things and people they've had a hand in shaping, something clicked.

"I wanted to make a love letter to Sacramento as seen through the eyes of someone who can't appreciate how beautiful it is until she's going away to someplace else," Gerwig told the Sacramento Bee around the release of the film. "That's very true of 17-year-olds. You don't realize how beautiful a place is until you step away."[3]

I was about the same age as Lady Bird when I finally left the suburbs. I was so young and buzzing with a new feeling every second, so distracted by the movements of the city that constantly tickled my synapses, that I didn't appreciate the beauty of where I came from. All I focused on was the bad of my past experiences.

Over time—especially the more time I spent away from suburbia—I evolved. Yet that scene in Lady Bird had me playing my own mental

montage of driving down streets near Lake Michigan, those calm, quiet moments that were all mine. I wondered if I could ever get that feeling back. As I started writing this book, I realized that, like Gerwig, I was writing a love letter to *my* suburbs, an open and honest one that was necessarily critical but that also focused on all the good and weird that came from these places. Maybe then I'd come closer to knowing whether I could ever go back.

Still, I have so many questions about the suburbs besides my own struggle with whether I'd ever settle down in one.

Like what if the Levitts never kept African American people from buying their homes? What if there were never any handshake deals keeping Jewish people from buying property in Midwest suburbs? What if people of Mexican, Greek, Chinese, or Italian descent hadn't been excluded from moving from the cities to the suburbs? It may not happen as much anymore, but it happened enough that Americans developed an idea of who did and did not live in the suburbs. Slowly but surely, some barriers went down—if you were white. People whose parents, grandparents, or even great-grandparents came from the shtetl or Sicily or a European country that doesn't even exist anymore had an easier time moving into suburbia as time wore on. We hear the term *white flight* and it's usually said with a hint of disdain, since the mass wave of mostly white people from all different backgrounds leaving cities like Gary, Indiana, or Oakland, California, coincides with the economic downfall of many of those places. It's not that people leaving the cities triggered the downfall of those places; it's that many of those people were given the opportunity to get out just in time. Black and Latino people weren't usually given the same chances. The idea that one family of color moving into a neighborhood could bring down property values was a real fear that spread throughout the suburbs. There are still zoning laws that restrict multifamily units, making it harder for more people to live in the suburbs for less. And there are still people who planners and residents alike consider undesirable; whether because of the color of their skin, religion, financial situation,

or something else, not everybody who wants to gets to share in the suburban dream.

I wonder what might've happened if more thought had gone into the planning of these places. I would walk to the grocery store and the playground and my school and the synagogue when I was a kid in Skokie the way I do today in New York. Today, drive anywhere outside it (I suggest this only because unless your destination is nearby Evanston or Chicago a few miles southeast, you'll probably need a car) and you get more of the suburbs as they've come to be known: hard to get around, poorly designed, and sprawling out of control. Skokie isn't perfect, but there's some sense of balance when I go through it.

Despite the city boom of the new century, people continue to march to suburbia. While places like Miami, Philadelphia, or Detroit may be more attractive to young people looking to find cheaper places to live, those places have also become more attractive to people who can afford to live just about anywhere. Gentrification has made many cities unaffordable. The middle class can't afford places like Manhattan or San Francisco, and people with dreams of making it in careers in the arts can't either; that's forcing people to look elsewhere. And millennials are looking to the suburbs, especially those that want to own their own home. In 2016, after over five years of the opposite, the suburbs once again started beating cities in terms of growth, according to census statistics.[4] And why not? All the good big cities are being populated by people with money; doctors, lawyers, people in tech or finance and other white-collar jobs are the ones that can afford places they may not have ventured into a decade ago. That, and the simple fact that not everybody wants to live in cities. Some people would like to live in a house on a street where there isn't much going on, where they can sit in their backyard in the summertime and have more space. That's something I think people who steer the cultural conversation from the coasts often lose sight of.

Today, over half of Americans claim they live in suburbia, and that number is still growing, but it seems like these places are also evolving. While the numbers still point to predominantly white populations,

that looks to be changing, and that's a good thing. Despite all our division, if there's anywhere to look for progress in America, it may be the suburbs. Personally speaking, I think that growing up around all kinds of different people in Skokie was one of the defining strokes of luck I've had in my life. I'm not afraid of other people and their cultures, and in America we're routinely taught to think and feel otherwise, that people who don't fit a certain set of stereotypes are either bad and evil or deserve to be mocked. But against all odds, the slow evolution of suburbia gives me hope that those things can change.

Just look to Morton Grove, about ten minutes by car from Skokie. For my father's parents, the village was their first attempt to move into the suburbs, into a ranch home I imagine looked like a glimpse into the luxurious future when it was built in the early sixties. Much like Skokie, Morton Grove had a diverse set of residents, from our Ukrainian friends across the street to their Greek neighbors and the many immigrant and first-generation Chinese people living around us. There was even a Brazilian family I never got to know, but who cooked some of the most delicious-smelling food I can recall.

When I was a kid, Morton Grove was where my grandpa lived, but more important, it was also where the Bennigan's across from the Toys "R" Us was. Thanks to the prospect of eating potato skins after getting new Transformers, I always looked forward to visiting Morton Grove. And while it has all the problems of any other modern suburb that really built itself up in the middle of the twentieth century, including roads that look like they'll crumble at any moment and unidentified wires hanging all over the place, there's something about Morton Grove I like.

It's diversity.

Since I say "diversity," I should point out that Morton Grove is still over 63 percent white. But people who marked Asian on the 2010 census form make up 28 percent of the village, and that number is growing, as it is across the country. The figures from that year also reveal that the bulk of the more than two hundred thousand residents who moved away from Chicago were black, while suburbs outside the city saw a rise in black residents.[5] The move had some calling it the "reverse

Great Migration": from the Midwestern cities that African Americans flocked to in the first half of the twentieth century to the suburbs.[6] Plainfield, Illinois, with its forest preserve that's perfect for bird watching and the DuPage River flowing through the center of the village, saw a 2,000 percent increase in African American residents. Other cities like Houston and Atlanta saw similar booms.

The trajectory in America has long been that you arrive here, spend time in the cities, and hope you can move sooner or later. The growing number of residents in suburbs like Morton Grove who came from or are a generation removed from places like Vietnam or China, or who live in suburbs that didn't allow their grandparents to move in a generation ago, shows that more people are now getting to live the American Dream of having a lawn to mow and a room for every member of their family to sleep comfortably in. It's another sign suburbia is diversifying. It isn't happening quickly, but when you consider how big a part the suburbs play in the story of modern-day America, it tells you something.

Cities have always been a melting pot. That's sort of one of the big draws. I go to a borough like Queens, for example, and I can be in a neighborhood made up of mostly Pakistani families for two blocks, then Bukharan Jews the next few blocks, until I'm in the largely Romanian section. I can get spices from any continent, talk soccer with people from the u.k., or get the best tamales from a lady who moved here a few months ago. You normally don't hear about that sort of diversity in the suburbs, but that has been changing. Dearborn, Michigan, for example, home to the Ford Motor Company, which sits about twenty-five minutes from the posh neighborhoods like Grosse Pointe and Royal Oak, has become home to one of the largest populations of Muslim immigrants in America. People trying to start over after the wars in Iraq and Syria have found a home there, and they have helped reshape the culture. The Houston suburbs, similarly, feel increasingly diverse, with populations of people from Latin America, India, and all over the Middle East finding a home and helping change the culture instead of letting the culture change them. That has long been one of the big issues with suburbia: that moving there changed people, forced them to shed

their heritage and identity to become just like everybody else. Spending time around Houston and Dearborn, I can't help but notice the vibrancy and different feel overall of them compared to other suburbs. These places feel like actual communities.

The term *ethnoburb* was coined by Dr. Wei Li in 1997 as a way to distinguish a suburb with a large number of people and businesses from a specific ethnicity—Dr. Li focused her paper on the Chinese population in the Los Angeles suburbs—from what we might call a "Chinatown" in a city. All through North America, ethnoburbs have been building steadily over time and will only continue to do so, a sign of change that should be welcomed; different cultures bring new ideas and energy. Since the suburbs make up so much of the American population, how they diversify in the future can act as a sort of barometer for where we're at and where we're going. For every immigrant population, from the Irish to the Germans, Jews, Italians, and Mexicans, as well as the African Americans who made the move from the South to the North during the Great Migration, the hope for many was to keep moving, to make it out of the cities and into a quieter, more peaceful place. Unfortunately, as we've seen, many of those people couldn't move in because of laws and ordinances designed to keep out anybody who was "other," be it because of the religion they practiced, the language they spoke, their sexual orientation, or their skin color. But the numbers point to those sorts of instances going the way of the dinosaur.

Just like Gerwig's Lady Bird, I know the cities are the cooler option, and that the places with working mass transit are better for the environment. People who want to go to the opera one night and see a punk show in a basement the next have a better chance in a place like San Francisco or Nashville. But I for one welcome more people moving to the suburbs. For so many it represents mobility, moving forward. It was something I saw in Skokie with my own family, half of which had come out of places ravaged by anti-Semitism or the hardships of the Soviet Union; their opportunities shrank and their lives were threatened. Skokie, Morton Grove, and the other suburbs my family moved to represented making it far away from those places, and not just surviving

but thriving. Sure, we had a neighbor who had lived on the street since the fifties and constantly referred to his Jewish, Chinese, and Hispanic neighbors as "you people." But he's gone, and that way of thinking in the suburbs will someday be the minority. I'm not saying racism will vanish overnight or maybe ever, but as the suburbs have become such a massive part of our lives in America, Canada, Europe, Australia, Asia, and across the world, my hope for the suburbs' legacy is that suburbia could give people the opportunity to get to know other people and their cultures, the way I've always felt lucky to do in Skokie. My hope is that these newer suburbanites won't lose their sense of community or heritage like the people who came before. I'd love to see the idea of the suburbs as a bland and boring place devoid of any culture go away. It's a big thing to hope for, I know, but I'm positive there's a chance, at least for some of the places. As I write this in 2019, things are strange, the news is almost always bad, and Americans' fear of "others," of people from different parts of the world or who practice different religions, is the highest it has been in my lifetime. Yet the places I saw on the borderlands of cities like Houston and Detroit give me hope.

Despite everything, I believe in the suburbs. I believe they can be welcoming places for everybody, places that are environmentally friendly, less car oriented, and designed (or redesigned) smarter. Places where the community is active in building where they live and plays a part in making it better.

I appreciate people like Ebenezer Howard and Frank Lloyd Wright, who wanted to build places and structures outside cities that benefited humanity and synced with the natural environment, because I believe design matters in the fostering of some sense of civic pride and our emotional well-being. At some point, however, we got lazy. The prefabricated everything culture, the sprawl that keeps growing and growing, it's just so much easier. To make the suburbs better, we need to decrease the ease.

I hope things that we've become so used to, from driving everywhere to the huge waste of land we use to grow these places to the manicured

green lawns that are a suburban hallmark, start to decrease, because they need to. I read about "anti-lawn" movements popping up across the country, people realizing that turf lawns are not only unappealing and bland but also bad for the environment. These people are adding more trees, letting natural grasses sprout, not using poisonous insecticides, and even using part of their yards to compost or grow food. Sure, there are often neighborhood codes and restrictions that hinder that sort of change from happening—the need to keep order and sameness in suburbia routinely holds these places back from growing and evolving—but we can learn from those mistakes. I'm hopeful that we can keep growing, that there are more movements within the suburbs to make these places better, more sustainable, and inviting.

There's no magic-bullet solution: we're not going to make places more bike friendly or add more accessible public transportation overnight; the turf lawns won't all disappear, native grasses growing in their places. Planning won't suddenly get better, and the suburbs won't up and become "cool" to people after decades of being viewed otherwise. But as I write this in 2019, there's no better time than the present to start reworking suburbia, moving these places closer to the original idea of humans living a more harmonious existence and further away from the sprawl of the post-Levittown era.

I spent two years researching this project, but I spent the first eighteen years of my life living in the suburbs. I went away, but as I started working on this, I found myself going back and learning more than any book or news article could teach me. I went to the places I've known and discovered ones I'd never been to or even heard of. I never came up with the answer to whether I could move back for good, because, ultimately, I've made my home in a city. Yes, I was drawn there because it's an urban area, and when I was younger it offered more of what I wanted from a place. But over time it became my home, the place where my community is. So theoretically, yes, I could live in the suburbs, but I probably won't. I'm from suburbia, but that's about it; I grew up and became an adult in the city, the one I live in today, the place where I've settled.

The sprawl has consumed so much of this country with its ugly houses, chain store upon chain store, forgotten shopping plazas, and endless stretches of road. But it wasn't supposed to be this way, and in that I see a chance, an opportunity. (Granted, the way it *was* supposed to be wasn't all that great either, but hear me out.)

I believe in so much of what the suburbs have given us, all the books and records and movies that were often created despite the conformity and vapidity. All that energy could be harnessed and used for bettering our culture even more. I truly think our borderlands, the places outside our cities, can be better, more open, and more practical. I think that golden dream of the Levittown-era suburb is long dead, but some of the ideas (not *all* the ideas, mind you) of the suburbs, of a more harmonious, community-oriented type of place, make perfect sense to me.

And they should make sense to the people who develop and live in the suburbs if those areas are to thrive.

"The overarching point is that the suburban municipalities haven't been as involved as they should be, since they believe the hype that millennials are going to live in the city forever," one real estate consultant told the website *Curbed* in 2016.[7] The belief for so much of the twenty-first century was that younger people wanted to leave the suburbs for the cities, because the better jobs and lives were there. That the city boom was going to keep happening and the suburbs would be an afterthought, a place where our parents stayed behind. But that just isn't the case. By 2017 you started seeing the headlines and numbers that told a different story: *Bloomberg* proclaimed, "Millennials Are Driving the Suburban Resurgence,"[8] and in 2019, suburbs like Ankeny City, Iowa, and Apex, North Carolina, were among some of the fastest-growing places in the United States.[9] The cities, their bright lights once such a beacon for so many younger people, had become too expensive and too crowded. But can the suburbs capitalize? The real estate consultant who talked to *Curbed* seemed skeptical.

"Suburbs should realize there's a risk of corporations giving up on the suburbs. There are a lot of examples of companies saying that they

can't attract the talent they need in the 'burbs. Suburbs shouldn't just be thinking about attracting millennials to pay property tax. They need them here now to make sure the next generation of workers stays there as well," he said.[10]

And I get that. One of the jokes I often tell to explain why I'm willing to pay way too much money to live in New York and deal with all its failures is that I'm unemployable anywhere else. Yes, I love where I live, but there's also a reality I and many other people whose jobs get filed under "creative" have to face: the suburbs are nowhere near where we need to be. I could try Westchester or a commuter suburb in Connecticut, but the prices wouldn't be much different than where I live in the city. Yet the cities are becoming unlivable pricewise for people from all different fields; suburbs across the country should take advantage of this. Creativity has been the greatest export the suburbs have had to offer; why not either nurture what you already have or import it? Make the suburbs more enticing for creative and skilled workers. Make these places more than just rows of houses. Make them actual communities, places where people grow, thrive, and want to stay.

I thought about how funny it was that, to celebrate the twentieth anniversary of leaving the suburbs, I started working on a project that had me trying to better understand what I left behind. So I went back. I did what people who lived in the city used to tell me and my friends we should do, because, to them, we didn't belong: go back to the suburbs. It was such an insult, I remember.

I kept going back and something dawned on me: it's not about whether *I'd* move back; rather, what would've kept me in the suburbs in the first place? What could've changed or been different that would've made me stick around the type of place where I grew up? There could've been different circumstances, sure. I will say that part of my reason for wanting to leave was because I had a pretty unhappy childhood, and that sense of displacement, moving from one place to another, didn't help. But there was always the feeling that the suburbs didn't want me, like I didn't belong. I couldn't quite put my finger on it,

but then I heard the Arcade Fire song "Sprawl II (Mountains Beyond Mountains)," and the opening lyrics summed it all up for me. Régine Chassagne sings about other people in the suburbs telling her to give up her creative dreams and just do her job that she doesn't like. About feeling adrift and without purpose in suburbia, but how she could see the city lights shining far away, calling to her.

I've been away from the suburbs for so long that sometimes I forget how I felt. I talked earlier about the existential outsiders in suburbia, and I was certainly one of those. But when I think back, I can think of all the things the suburbs didn't offer me. Sure, I had places like the library to go and hide in for hours, but nothing much else. When we got old enough to leave the couple of blocks near my house, my friends and I would bide our time, riding our bikes and hanging out in front of convenience stores or walking around the woods with no real destination. That was fun and innocent, but it was all we had. I'm glad we found it, but I wish the places we lived in offered more.

What I was rich in was space, lots of space and plenty of free time to roam around it. I had physical space, but I also had mental space. I could really experience things—movies and records, books, and people. I had time to let it all seep in and help build the person I am today. The suburbs made me, and it took me a long time to understand that. Suburbia helped form the person I would become, and the places where I lived and claimed to hate as a kid fostered me until it was time to go.

Some of that space is gone now. I've been back to those places, and I see they've filled with new houses and more stores. More additions to the sprawl.

I mourn for that space and wonder what the kids that live in the areas where I grew up have now.

The overall problem with the American suburbs has always been carelessness. Profit over people; keeping people out to keep up the property value; building up and out without much reason besides making

more money. The idea is that what you and your family have is enough. What else could you need? Everything, you're supposed to think, is fine as it is.

Almost every suburb in America has one thing in common: somebody built the place and moved on. These little subdivisions and towns were built, but they weren't completed. Developers built houses and stores, but they couldn't create community. And that's the piece I saw lacking in so many suburban places from coast to coast: community. You can call the place you live one, but a community is only as good as the people who work to make it stronger. Nothing is complete: we've built the suburbs out, and now it's time to grow them from within. It's time to look at the past to see what we've done wrong, apply it to the present, and learn for tomorrow. Because whether we like it or not, the future is still in suburbia. We just need to reclaim it.

So, would I move back to the suburbs?

The truth is that I don't think I ever really left; either that, or the suburbs have found me even after all these years of living in the city. The truth is that I see beauty and good even through all the ugliness and sprawl, the mess and unfairness that have made up the suburban story. The truth is that I believe there's good in these places despite it all.

I just hope we find it before it's too late.

Notes

Preface

1. I say this because six months before I began writing this book, the Pew Research Center moved the markers, and my 1980 birth date placed me in a category with people born in the sixties and seventies, so I feel very stuck in the middle. (Michael Dimock, "Defining Generations: Where Millennials End and Generation Z Begins," *FactTank,* Pew Research Center, January 17, 2019, http://www.pewresearch.org/fact-tank/2018/03/01/defining -generations-where-millennials-end-and-post-millennials-begin.)

2. Alexis C. Madrigal, "The Racist Housing Policy That Made Your Neighborhood," *Atlantic,* May 22, 2014, https://www.theatlantic.com /business/archive/2014/05/the-racist-housing-policy-that-made-your -neighborhood/371439.

3. Adam Weinstein, "Trayvon Shooter's 911 Calls: Potholes, Piles of Trash— and Black Men," *Mother Jones,* March 22, 2012, https://www.motherjones.com /politics/2012/03/trayvon-shooters-911-calls-potholes-piles-trash-black-men.

4. Kim Parker et al., "Demographic and Economic Trends in Urban, Suburban and Rural Communities," Pew Research Center, May 22, 2018, http://www.pewsocialtrends.org/2018/05/22/demographic-and-economic -trends-in-urban-suburban-and-rural-communities.

5. *Merriam-Webster's Collegiate Dictionary,* s.v. "suburb," accessed February 10, 2020, https://www.merriam-webster.com/dictionary/suburb.

6. William H. Frey, "City Growth Dips below Suburban Growth, Census Shows," *Avenue,* Brookings Institute, May 30, 2017, https://www.brookings .edu/blog/the-avenue/2017/05/30/city-growth-dips-below-suburban -growth-census-shows.

7. "Suburban America Is on a Steady Decline," reported by John Hendren, *Al Jazeera,* posted August 11, 2017, YouTube video, 2:26, https://www.youtube .com/watch?v=-kw_96YV7xk.

Chapter 1: We Were Promised Hoverboards

1. "1957 Monsanto House of the Future," Retronaut, posted November 23, 2014, YouTube video, 8:27, https://www.youtube.com/watch?v=sk 2YBA_oa1A.

2. *Diner* (1982), *Stand by Me* (1986), *Peggy Sue Got Married* (1986), *La Bamba* (1987), *Great Balls of Fire* (1989), and *Dead Poets Society* (1989), among others.

3. Studs Terkel, *The Great Divide: Second Thoughts on the American Dream* (New York: Pantheon Books, 1988), 68.

4. Kim Janssen, "Seven Years after the Great Recession, Some Chicago Suburbs May Never Recover, *Chicago Tribune,* March 26, 2016, https://www .chicagotribune.com/business/ct-suburban-housing-slump-0327-biz-20160324 -story.html.

5. Dave Bartlett, "Markham, IL," *Electronic Encyclopedia of Chicago,* accessed February 2, 2020, http://www.encyclopedia.chicagohistory.org/pages/789 .html.

6. Scott W. Allard, *Places in Need: The Changing Geography of Poverty* (New York: Russell Sage Foundation, 2017).

7. Scott W. Allard and Benjamin Roth, "Strained Suburbs: The Social Service Challenges of Rising Suburban Poverty," Brookings Institute, accessed February 11, 2020, https://www.brookings.edu/research/strained-suburbs-the -social-service-challenges-of-rising-suburban-poverty.

8. Allard, *Places in Need.*

9. Dan Glaister, "There Goes the Neighbourhood: Mortgage Crisis Sees Suburbs Slump," *Guardian,* April 28, 2008, https://www.theguardian.com /business/2008/apr/28/us.subprime.

10. "A Visit to Ringwood, Illinois," *McHenry Plaindealer,* August 3, 1967.

11. The one building is the Count's House, a Greek revival built before the Civil War that was once the home of Austria's Count Oskar Bopp von Oberstadt and is now a private residence, which had a giant trampoline in the front yard last time I drove past it.

12. Chris Freeman, "Johnsburg Wal-Mart Opens," *Northwest Herald,* October 25, 2011, www.nwherald.com/2011/10/25/johnsburg-wal-mart-opens /axz06sv/?page=2.

13. Brian Wolf, "McHenry Downtown Theater," Cinema Treasures, accessed February 6, 2020, http://cinematreasures.org/theaters/16019.

14. "Arcadia Luxury Homes for Sale—Phoenix, Arizona," Sotheby's International Realty, accessed March 20, 2020, https://www.phxre.com/arcadia -real-estate.

15. Kate Wagner, "50 States of McMansion Hell: Scottsdale, Arizona,"

McMansion Hell, January 26, 2017, https://www mcmansionhell.com/post /156408871451/50-states-of-mcmansion-hell-scottsdale-arizona.

16. Lewis Mumford, *The City in History: Its Origins, Its Transformations, and Its Prospects* (New York: Harcourt, 1961), 597.

17. Kristin Iversen, "Is Brooklyn Just Another Suburb? On the Reality of the Suburbanization of New York," *Brooklyn,* October 10, 2014, http://www .bkmag.com/2014/10/10/is-brooklyn-just-another-suburb-on-the-reality-of -the-suburbanization-of-new-york.

18. Martial, *The Twelve Books of Epigrams* (New York: American Anthropological Society, 1926).

Chapter 2: If You Build It, He Will Come

1. Scott Lapatine, "MTV Playlist August 1st, 1981," *Stereogum,* August 1, 2006, https://www.stereogum.com/2995/mtv_playlist_august_1st_1981/video.

2. "In Brief," *Chicago Tribune,* May 28, 2009, https://www.chicagotribune .com/news/ct-xpm-2009-05-28-0905270951-story.html.

3. Lori Rotenberk, "Major League Hopes Pinned on the Minors," *New York Times,* April 4, 2009, https://www.nytimes.com/2009/04/05/us/05zion.html? _r=1&scp=1&sq=major%20league%20hopes%20zion,%20il&st=cse.

4. Bob Susnjara, "Fielders Lawsuit: We Were Duped by Zion Officials, Developer," *Daily Herald,* updated November 26, 2011, https://www.dailyherald .com/article/20111126/news/711269935.

5. Dan Moran, "Game Over: Zion, Lake Country Fielders Drop Lawsuits with $55K Settlement," *Chicago Tribune,* May 12, 2015, https://www.chicago tribune.com/suburbs/lake-county-news-sun/news/ct-lns-zion-fielders -llawsuit-st-0513-20150512-story.html.

6. Mary McIntyre, "Zion Seeking Redevelopment Proposals for Fielders, Dunes Properties," *Chicago Tribune,* January 18, 2017, https://www.chicago tribune.com/suburbs/lake-county-news-sun/ct-lns-zion-development-st -0119-20170118-story.html.

7. "A Woman's Letter," *Bulletin,* National Library of Australia, August 27, 1903, https://nla.gov.au/nla.obj-659229080/view?sectionId=nla.obj-664172 503&partId=nla.obj-659238552#page/n16/mode/1up.

8. "Early History," Zion Historical Society, accessed February 6, 2020, http://www.zionhs.com/history.htm.

9. Alan Burdick, "Looking for Life on a Flat Earth," *New Yorker,* May 30, 2018, https://www.newyorker.com/science/elements/looking-for-life-on-a-flat -earth.

10. Tom Kneitel, "WCBD, the 'Flat Earth' Radio Station," *Popular*

Communications, June 1986, https://www.americanradiohistory.com/Archive -Popular-Communications/80s/Popular-Communications-1986-06.pdf.

11. Edwin G. Burrows and Mike Wallace, *Gotham: A History of New York City to 1898* (New York: Oxford University Press, 1998), 972.

12. "About the Country Club," Country Club (website), accessed February 7, 2020, https://www.tcclub.org/club/scripts/public/public.asp.

13. Margaret Beattie Bogue, *Around the Shores of Lake Michigan: A Guide to Historic Sites* (Madison: University of Wisconsin Press, 1985), 131.

14. Henry David Thoreau, *The Writings of Henry David Thoreau,* ed. Bradford Torrey (Boston: Houghton Mifflin 1906), 472.

15. Emily Dickinson, *The Poems of Emily Dickinson,* ed. R. W. Franklin (Cambridge, MA: Harvard University Press, 1999).

16. *The Morning Call,* September 1, 1887.

17. If you're lucky enough to walk the grounds, you'll find that as Haskell planned his utopia (a term the community itself uses on its website) along with famed architect of the day Alexander Jackson Davis—whose Gothic revival masterpieces include modern-day national landmarks such as Jay Gould's Lyndhurst in Tarrytown, New York, and the Wadsworth Atheneum in Hartford, Connecticut, the oldest continuously operating museum in the United States—God was in the details.

18. John Muir, "The Cruise of the Corwin," journal entry, June 2, 1881, posted on the Sierra Club website, accessed February 10, 2020, https://vault.sierra club.org/john_muir_exhibit/writings/cruise_of_the_corwin/chapter_4.aspx.

19. Antoinette Martin, "Ins and Outs of Castle Selling," *New York Times,* February 3, 2008, https://www.nytimes.com/2008/02/03/realestate/03njzo .html.

20. Antoinette Martin, "An Enclave Wonders If It Is Too Private," *New York Times,* July 10, 2005, https://www.nytimes.com/2005/07/10/realestate/an-enclave -wonders-if-it-is-too-private.html.

Chapter 3: Not Allowed

1. "QuickFacts, Highland Park City, Illinois," United States Census Bureau, accessed February 7, 2020, https://www.census.gov/quickfacts/fact /table/highlandparkcityillinois/PST045217#viewtop.

2. Rosemary R. Sobol, "Rapper Chief Keef Clocked at 110 mph on Edens," *Winnetka Talk,* May 29, 2013, https://www.chicagotribune.com/g00/suburbs /winnetka/chi-chief-keef-speeding-ticket-story.html?i10c.ua=1&i10c.enc Referrer=aHR0cHM6Ly93d3cuZ29vZ2xlLmNvbS8%3d&i10c.dv.

3. Karen Berkowitz, "Highland Park Mansion's Use of Airbnb Spurs Neigh- bor Lawsuit: 'We Have to Clean Up Empty Beer Cans,'" *Chicago Tribune,* July 10,

2018, https://www.chicagotribune.com/suburbs/highland-park/ct hpn suit -seeks-to-halt-short-term-mansion-stays-tl-0712-story.html.

4. "Crime Rate in Highland Park, Illinois (IL): Murders, Rapes, Robberies, Assaults, Burglaries, Thefts, Auto Thefts, Arson, Law Enforcement Employees, Police Officers, Crime Map," City-Data.com, accessed February 7, 2020, http://www.city-data.com/crime/crime-Highland-Park-Illinois.html.

5. "Highland Park, Illinois, Population: Census 2010 and 2000 Interactive Map, Demographics, Statistics, Quick Facts," Census Viewer, accessed February 7, 2020, http://censusviewer.com/city/IL/Highland+Park.

6. "Complaints about Problems at the Home of Chief Keef's Manager," *Chicago Tribune,* April 3, 2014, https://www.chicagotribune.com/suburbs /winnetka/chi-chief-keef-northfield-complaints-20140403-htmlstory.html.

7. Duaa Eldeib et al., "Chief Keef's Northfield Neighbors Upset by Shooting, Other Problems," *Winnetka Talk,* March 28, 2014, https://www.chicagotribune .com/suburbs/winnetka/ct-xpm-2014-03-28-ct-chief-keef-shooting-met -20140329-story.html.

8. AJ LaTrace, "Chief Keef Falls Behind $30K on Rent, Gets Evicted from Home," *Curbed Chicago,* June 10, 2014, https://chicago.curbed.com/2014/6/10 /10089452/chief-keef-falls-behind-30k-on-rent-gets-evicted-from-home.

9. Stephen Richard Higley, *Privilege, Power, and Place: The Geography of the American Upper Class* (Lanham: Rowman & Littlefield Publishers, 1995), 61.

10. James W. Loewen, "Avoiding History at the National Trust," History News Network, accessed February 7, 2020, https://historynewsnetwork.org/article /25520.

11. "Dinner in Dixie Style," *Chicago Daily Tribune,* September 3, 1898.

12. *The Forester,* Lake Forest College, 1984, https://archive.org/details/forester 1984lake/page/24.

13. "Regional Framework Plan," Lake County, Illinois, November 9, 2004, https://www.lakecountyil.gov/DocumentCenter/View/2502/Chapter-2 -Population-PDF.

14. Eric Zorn, "Lake Forest Newcomer Lists A-Team as Reference," *Chicago Tribune,* September 12, 1986, https://www.chicagotribune.com/news/ct-xpm -1986-09-12-8603080174-story.html.

15. George Papajohn and Steve Johnson, "Mr. T Chops Away at Lake Forest's Fiber," *Chicago Tribune,* May 22, 1987, https://www.chicagotribune .com/news/ct-xpm-1987-05-22-8702070954-story.html.

16. Dick Johnson, "Genteel Chicago Suburb Rages over Mr. T's Tree Massacre," *New York Times,* May 30, 1987.

17. He also built a white stockade fence and tried to build a large iron *T* on the property, but the city council rebuffed him.

18. Damon Young, "The Disturbing Truth That Makes *Get Out* Depressingly Plausible," *Slate,* March 10, 2017, https://slate.com/culture/2017/03/get-out -and-americas-many-missing-black-people.html.

19. Brandon Harris, "The Giant Leap Forward of Jordan Peele's 'Get Out,'" *New Yorker,* March 4, 2017, https://www.newyorker.com/culture/culture-desk /review-the-giant-leap-forward-of-jordan-peeles-get-out.

20. Nicolas B. Aziz, "I Went to High School in the Suburb from 'Get Out'—But I Got Out," *Huffington Post,* March 3, 2017, https://www.huffpost .com/entry/i-went-to-high-school-in-the-suburb-from-get-out-but_b_58 cdfca8e4b0e0d348b34451.

21. Paige Glotzer, "Building Suburban Power: The Business of Exclusionary Housing Markets, 1890–1960," Joint Center for History and Economics, Harvard University, https://sites.fas.harvard.edu/~histecon/visualizing/build ingsuburbanpower/index.html.

22. Daniel Jeffreys, "No Jews on Their Golf Courses," *New Statesman America,* August 23, 1999, https://www.newstatesman.com/node/149688.

23. Rakesh Satyal, interview with the author, July 9, 2019.

24. Rakesh Satyal, interview with the author, July 9, 2019.

25. Molly McArdle, "Hella Hella Serious, Dire Truth Telling with Poet Morgan Parker," *Brooklyn,* February 27, 2017, http://www.bkmag.com/2017/02 /27/morgan-parker-poetry-beyonce.

26. Rakesh Satyal, interview with the author, July 9, 2019.

Chapter 4: Life on Mars

1. Susan Kronberg, "Fort Lee Appears Urban, but It Feels Suburban," NJ.com, updated January 17, 2019, https://www.nj.com/towntours/2015/02 /fort_lee_appears_urban_but_it.html.

2. David Mikkelson, "Popcorn Subliminal Advertising," *Snopes,* updated May 3, 2011, https://www.snopes.com/fact-check/subliminal-advertising.

3. Thomas Payne, "The Crisis," *The American Crisis,* no. 1, December 23, 1776.

4. Anthony Bourdain, "Anthony Bourdain: My Family Values," interview by Britt Collins, *Guardian,* September 27, 2013, https://www.theguardian .com/lifeandstyle/2013/sep/27/anthony-bourdain-parts-unknown-family- values.

5. Anthony Bourdain, "John Cheever," *Lucky Peach,* no. 23, summer, 2017.

6. Samin Nosrat, "'I've Become a Rummager, a Magpie of Sorts': Samin Nosrat," interview by Dale Berning Sawa, *Guardian,* January 13, 2018, https:// www.theguardian.com/lifeandstyle/2018/jan/13/ive-become-a-rummager -a-magpie-of-sorts-samin-nosrat.

7. Ditta M. Oliker, "On Being the Outsider," *Psychology Today,* November 9,

2012, https://www.psychologytoday.com/intl/blog/the-long-reach-childhood/201211/being-the-outsider.

8. William Gibson, interview with the author, January 6, 2019.

9. William Gibson, "Surface Tension," *High Profiles,* October 4, 2010, https://highprofiles.info/interview/william-gibson.

10. Anthony Bourdain "By the Book," *New York Times,* November 22, 2017, https://www.nytimes.com/2017/11/22/books/review/anthony-bourdain-by-the-book.html.

11. Kim Gordon, *Girl in a Band* (New York: HarperCollins, 2015), 162.

12. William Gibson, interview with the author, January 6, 2019.

13. William Gibson, *Distrust That Particular Flavor* (New York: Berkley, 2012).

14. William Gibson, interview with the author, January 6, 2019.

15. William Gibson, "Surface Tension."

16. Rem Koolhaas, "Junkspace," in *October* 100 (Spring 2002), 175.

17. "Nation's Biggest Housebuilder," *Life,* August 23, 1948.

18. Colin Marshall, "Levittown, the Prototypical American Suburb—A History of Cities in 50 Buildings, Day 25," *Guardian,* April 28, 2015, https://www.theguardian.com/cities/2015/apr/28/levittown-america-prototypical-suburb-history-cities.

19. Emily Badger, "This Is What the Legacy of 'White Privilege' Looks Like in Bill O'Reilly's Hometown," *Washington Post,* October 17, 2014, https://www.washingtonpost.com/news/wonk/wp/2014/10/17/what-bill-oreilly-doesnt-get-about-the-racial-history-of-his-own-hometown.

20. Bruce Lambert, "At 50, Levittown Contends with Its Legacy of Bias," *New York Times,* December 28, 1997, https://www.nytimes.com/1997/12/28/nyregion/at-50-levittown-contends-with-its-legacy-of-bias.html.

21. Andres Duany, Elizabeth Plater-Zyberk, and Jeff Speck, *Suburban Nation: The Rise of Sprawl and the Decline of the American Dream* (New York: North Point Press, 2000), 31.

22. William L. Hamilton, "How Suburban Design Is Failing Teen-Agers," *New York Times,* May 6, 1999, https://www.nytimes.com/1999/05/06/garden/how-suburban-design-is-failing-teen-agers.html?pagewanted=all.

23. James Howard Kunstler, "The Ghastly Tragedy of the Suburbs," TED talk, February, 2004, https://www.ted.com/talks/james_howard_kunstler_the_ghastly_tragedy_of_the_suburbs.

24. Olivia Laing, *The Lonely City* (London: Picador, 2017), 3.

Chapter 5: Monsters, Mad Men, and the Mundane

1. "W.C.T.U. Protests 'Oases' on Trains; Two New Tavern Cars on New Haven Railroad Arouse Ire of Springfield Group," *New York Times,* May 14,

1953, https://www.nytimes.com/1953/05/14/archives/w-c-t-u-protests-oases
-on-trains-two-new-tavern-cars-on-new-haven.html.

2. Michael M. Grynbaum, "One for the Road? Bar Cars May Face a Last
Call," *New York Times,* April 20, 2010, https://www.nytimes.com/2010/04/21
/nyregion/21barcar.html.

3. "Boozy Commuter Train Retires Legendary Bar Cars," NBC News, updated
May 8, 2014, https://www.nbcnews.com/nightly-news/boozy-commuter-train
-retires-legendary-bar-cars-n100916.

4. John Cheever, *The Journals of John Cheever,* ed. Robert Gottlieb (New
York: Vintage, 1990), 4.

5. Susan Cheever, *Home Before Dark* (New York: Washington Square Park,
1984), 92.

6. John Cheever, "The Swimmer," *New Yorker,* July 11, 1964, https://www
.newyorker.com/magazine/1964/07/18/the-swimmer.

7. Blake Bailey, *Cheever: A Life* (New York: Vintage, 2009), 316.

8. John Cheever, *The Journals of John Cheever* (New York: Vintage, 1990),
187.

9. Lewis Mumford, *The City in History: Its Origins, Its Transformations, and
Its Prospects* (New York, Harcourt, 1961).

10. Jane Jacobs, "Disturber of the Peace: Jane Jacobs," interview by Eve
Auchincloss and Nancy Lynch, *Mademoiselle,* October 1962.

11. Erik Gunther and Claudine Zap, "Suburban Home with Sex Dungeon
Spanks Competition, Becomes Most Popular Home," Realtor.com, February 15,
2019, https://www.realtor.com/news/trends/sex-dungeon-suburban-home-most
-popular.

12. Neil MacFarquhar, "What's a Soccer Mom Anyway?" *New York Times,*
October 20, 1996, https://www.nytimes.com/1996/10/20/weekinreview/what
-s-a-soccer-mom-anyway.html.

13. Sallie James, "Fear, Anxiety Force Many to Retool Halloween Plans,"
South Florida Sun Sentinel, October 24, 2001.

14. Tamar Lewin, "Sikh Owner of Gas Station Is Fatally Shot in Rampage,"
New York Times, September 17, 2001, https://www.nytimes.com/2001/09/17
/us/sikh-owner-of-gas-station-is-fatally-shot-in-rampage.html.

15. Shirley Jackson, "The Lottery," *New Yorker,* June 26, 1948, https://www
.newyorker.com/magazine/1948/06/26/the-lottery.

16. Ruth Franklin, *A Rather Haunted Life* (New York: Liveright, 2016).

17. Quoted in Franklin, *A Rather Haunted Life.*

18. Shirley Jackson, *The Lottery and Other Stories* (New York: Farrar, Straus
and Giroux, 1948).

19. Franklin, *A Rather Haunted Life.*

20. Michael Ziser, "Speculative Infrastructures," *Boom* 3, no. 4 (Winter 2013), https://boomcalifornia.com/2014/01/30/speculative-infrastructures.

21. *The Twilight Zone*, "The Monsters Are Due on Maple Street," written by Rod Serling, season 1, episode 22, March 4, 1960.

22. *The Twilight Zone*, "The Monsters Are Due on Maple Street."

23. Olivia B. Waxman, "The U.S. Is Still Dealing with the Murder of Adam Walsh," *Time*, August 10, 2016, http://time.com/4437205/adam-walsh-murder.

24. Robert Reinhold, "Cat Mutilations Spread Fear of Cults in Suburb," *New York Times*, August 13, 1989, https://www.nytimes.com/1989/08/13/us/cat-mutilations-spread-fear-of-cults-in-suburb.htm.

25. "L. I. Children Get Poison 'Treat'; Accused Housewife Committed," *New York Times*, November 2, 1964.

26. Margaret Talbot, "The Lives They Lived: 01-07-01: Peggy McMartin Buckey, b. 1926; The Devil in the Nursery," *New York Times Magazine*, January 7, 2001, https://www.nytimes.com/2001/01/07/magazine/lives-they-lived-01-07-01-peggy-mcmartin-buckey-b-1926-devil-nursery.html.

27. "Members of Bloods Street Gang Found in Chicago Area," CBS Chicago, May 18, 2011, https://chicago.cbslocal.com/2011/05/18/members-of-bloods-street-gang-found-in-chicago.

28. Christopher Carbone, "MS-13 Terrorizing American Small Towns and Suburbs Ill-Equipped to Fight Back," *Fox News*, November 15, 2017, https://www.foxnews.com/us/ms-13-terrorizing-american-small-towns-and-suburbs-ill-equipped-to-fight-back.

29. Colin Dickey, *Ghostland* (New York: Penguin Random House, 2017).

30. Michael Kernan, "The Calamityville Horror," *Washington Post*, September 16, 1979.

31. Christine Hauser, "Maine Just Banned Native American Mascots. It's a Movement That's Inching Forward," *New York Times*, May 22, 2019, https://www.nytimes.com/2019/05/22/us/native-american-sports-logos.html.

32. Dickey, *Ghostland*.

Chapter 6: What's Reality, Anyway?

1. Becky Nicolaides and Andrew Wiese, "Suburbanization in the United States after 1945," *Oxford Research Encyclopedias*, April 2017, http://oxfordre.com/americanhistory/view/10.1093/acrefore/9780199329175.001.0001/acrefore-9780199329175-e-64.

2. Kate Wagner, "McMansions 101: What Makes a McMansion Bad Architecture," McMansion Hell, August 7, 2016, https://mcmansionhell.com/post/148605513816/mcmansions-101-what-makes-a-mcmansion-bad.

3. Virginia Savage McAlester, *A Field Guide to American Houses* (New York: Knopf, 1984).

4. Leigh Gallagher, *The End of the Suburbs: Where the American Dream Is Moving* (New York: Penguin, 2013).

5. Philip Langdon, "A Good Place to Live," *Atlantic Monthly* 261, no. 3 (March 1988): 39–60, https://www.theatlantic.com/past/docs/issues/96sep/kunstler/langdon.htm.

6. Leigh Gallagher, *The End of the Suburbs: Where the American Dream Is Moving* (New York: Penguin, 2013).

7. Ursula K. Le Guin, *The Ones Who Walk Away from Omelas* (Mankato, MN: Creative Education, 1993).

8. Shirley Jackson, "The Lottery," *New Yorker*, June 26, 1948, https://www.newyorker.com/magazine/1948/06/26/the-lottery.

9. Le Guin, *The Ones Who Walk Away from Omelas*.

10. "Seaside Real Estate," David Properties (website), accessed February 10, 2020, http://www.davisprop.com/seaside-fl-homes-for-sale.php.

11. Kelsey Campbell-Dollaghan, "Celebration, Florida: The Utopian Town That America Just Couldn't Trust," *Gizmodo*, April 20, 2013, https://gizmodo.com/celebration-florida-the-utopian-town-that-america-jus-1564479405.

12. Henry Pierson Curtis, "David Murillo, First Person Convicted of Murder in Celebration, Sentenced to Life in Prison," *Orlando Sentinel*, April 26, 2013, https://www.orlandosentinel.com/news/os-xpm-2013-04-26-os-celebration-killer-david-murillo-sentencing-20130426-story.html.

13. Walter Pacheco, "Standoff Ends in Disney Town of Celebration, Gunman Dead," *Orlando Sentinel*, December 3, 2010, https://www.orlandosentinel.com/news/os-xpm-2010-12-03-os-celebration-standoff-gunman-dead-20101203-story.html.

14. Audrey Wachs, "Celebration, Florida, Is Ruined by Mold and Shoddy Construction, Residents Say," *Architect's Newspaper*, November 21, 2016, https://archpaper.com/2016/11/celebration-fl-mold-shoddy-construction.

15. Jason Guerrasio, "The Mystery Behind Why a Beautiful Movie Theater in the Town Created by Disney World Has Been Closed for Almost a Decade," *Business Insider*, April 5, 2018, https://www.businessinsider.my/disney-world-mystery-of-movie-theater-in-celebration-florida-being-closed-2018-3.

16. Tom Leonard, "The Dark Heart of Disney's Dream Town: Celebration has Wife-Swapping, Suicide, Vandals . . . and Now Even a Brutal Murder," *Daily Mail*, December 9, 2010, https://www.dailymail.co.uk/news/article-1337026/Celebration-murder-suicide-wife-swapping-Disneys-dark-dream-town.html.

17. People v. Weaver, 90 Ill. App.3d 299 (1980), https://www.leagle.com /decision/198038990illapp3d2991347.

18. Ed Baumann and John O'Brien, "Murder, They Wrought," *Chicago Tribune*, August 25, 1991, https://www.chicagotribune.com/news/ct-xpm-1991-08-25 -9103030675-story.html.

19. People v. Weaver.

20. "Updates to the OED," *Oxford English Dictionary Online*, updated October 2019, https://public.oed.com/updates.

21. This quotation can also be found in David Lynch's *Lynch on Lynch*, ed. Chris Rodley (London: Faber and Faber, 2005).

22. Robert McCoppin, "Long Grove Tries to Bridge Past, Future," *Chicago Tribune*, October 2, 2017, http://digitaledition.chicagotribune.com/tribune /article_popover.aspx?guid=503a7446-8c89-463e-a92f-a4d2ce0572e5.

Chapter 7: Mousepacks

1. W. David Marx, *Ametora: How Japan Saved American Style* (New York: Basic Books, 2015).

2. P. E. Schneider, "300,000 French Students Can't Be Wrong; Jammed into Ancient Universities Built to Accommodate One-Tenth Their Number, Rebellious French Undergraduates Are Taking to the Streets to Demand a New Deal," *New York Times*, February 9, 1964, https://www.nytimes.com/1964/02/09 /archives/300000-french-students-cant-be-wrong-jammed-into-ancient.html.

3. Jon Savage, "Mods v Rockers: Two Tribes Go to War," BBC, October 21, 2014, http://www.bbc.com/culture/story/20140515-when-two-tribes-went -to-war.

4. Jack Batten, "The Invention of the Teenager," *Maclean's*, September 5, 1964, https://archive.macleans.ca/article/1964/9/5/the-invention-of-the-teenager #!&pid=12.

5. Gay Talese, "Battling Gangs Reported Waning; Police Note Summer Quiet—Civil Rights Role Cited," *New York Times*, July 31, 1964, https://www .nytimes.com/1964/07/31/archives/battling-gangs-reported-waning-police -note-summer-quietcivil-rights.html.

6. McCandlish Phillips, "The Talk of Darien; Self-Conscious Suburb; Darien Presents a Serene Exterior, Hiding a Conflict Over Its Morals," *New York Times*, November 2, 1964, https://www.nytimes.com/1964/11/02/archives/the-talk-of -darien-selfconscious-suburb-darien-presents-a-serene.html.

7. Quoted in Phillips, "The Talk of Darien."

8. Jay McInerney, "Chloë's Scene," *New Yorker*, November 7, 1997, https:// www.newyorker.com/magazine/1994/11/07/chloes-scene.

9. Amanda Fortini, "Going Home with Chloë Sevigny," *New York Times,* February 10, 2017, https://www.nytimes.com/2017/02/10/t-magazine/chloe -sevigny-home-connecticut.html.

10. Other people who spent formative years in the town include the musician Moby and the director Gus Van Sant.

11. Fortini, "Going Home."

12. Jessica Seigel, "Kids Bring City Gangs to Suburbs," *Chicago Tribune,* October 29, 1989, https://www.chicagotribune.com/news/ct-xpm-1989-10-29 -8901260561-story.html.

13. Seigel, "Kids Bring City Gangs to Suburbs."

14. Robert Blau, "Gang Wars Terrorizing Englewood," *Chicago Tribune,* October 6, 1989, https://www.chicagotribune.com/news/ct-xpm-1989-10-06 -8901190813-story.html.

15. Ronald Koziol, "Suburbs Act to Stem Growth in Gang Activity," *Chicago Tribune,* August 12, 1990,

16. John W. Fountain, "Suburbs Trying to Nip Gangs in the Bud," *Chicago Tribune,* March 1, 1991, https://www.chicagotribune.com/news/ct-xpm-1990 -08-12-9003070626-story.html.

17. *The Columbine Killers,* written and directed by Stephanie Kaim (Doc En Stock, 2007).

18. Jodi Wilgoren, "TERROR IN LITTLETON: THE GROUP; Society of Outcasts Began with a $99 Black Coat," *New York Times,* April 25, 1999, https:// www.nytimes.com/1999/04/25/us/terror-in-littleton-the-group-society-of -outcasts-began-with-a-99-black-coat.html.

19. Dave Cullen, "Inside the Columbine High Investigation," *Salon,* September 23, 1999, https://www.salon.com/test/1999/09/23/columbine_4.

20. Neil Strauss, "A Bogey Band to Scare Parents With," *New York Times,* May 17, 1997, https://www.nytimes.com/1997/05/17/arts/a-bogey-band-to -scare-parents-with.html.

21. "Do Suburbs Create Teen Rage?" CBS News, June 7, 1999, https://www .cbsnews.com/news/do-suburbs-create-teen-rage.

22. "Mousepacks: Kids on a Crime Spree," *San Francisco Examiner,* November 11, 1973.

23. "Brewer Island Deeds Filed; 35,000 to Live in Foster City," *San Mateo Times,* September 6, 1960.

24. Advertisement, *San Mateo Times,* January 23, 1965.

25. *San Mateo Times,* February 1967.

26. William O'Brien, "A Look at a New Town's Problems," *San Francisco Examiner,* July 25, 1960.

27. *San Mateo Times,* April 17, 1969.

28. R. L. Revenaugh, "Foster City Sale Negotiations Under Way," *San Francisco Examiner,* July 11, 1969.

29. Letter from Mary Cardle to the editor, *San Francisco Examiner,* November 18, 1963.

30. Renee Schiavone, "Foster City Is the 98th Safest City in America: Analysis," *Patch,* updated February 13, 2018, https://patch.com/california /fostercity/foster-city-98th-safest-city-america-analysis.

31. It remained in Foster City until moving to San Francisco in 2009 but still keeps an office there that employs around a thousand locals.

32. "QuickFacts, Foster City, California," United States Census Bureau, Accessed May 18, 2020 https://www.census.gov/quickfacts/fostercitycity california.

Chapter 8: In the Garage

1. Rachel Aroesti, "Lil Yachty: 'Older Hip-Hop People Don't Understand Evolution—or Don't Want It,'" *Guardian,* May 18, 2017, https://www.the guardian.com/music/2017/may/18/lil-yachty-im-like-the-outcast-of-hip-hop.

2. John Mendelsohn, "Long Player," *Rolling Stone,* March 18, 1971, https:// www.rollingstone.com/music/music-album-reviews/long-player-251036.

3. Suzi Quatro, *Unzipped* (London: Hachette, 2007).

4. *The Virgin Suicides,* adapted for screen and directed by Sofia Coppola (Paramount, 1999).

5. Megan Abbott, "*The Virgin Suicides,* 'They Hadn't Heard Us Calling,'" Criterion Collection, April 18, 2018, https://www.criterion.com/current/posts /5573-the-virgin-suicides-they-hadn-t-heard-us-calling.

6. Suzi Quatro, *Unzipped.*

7. Jon Caramanica, "The Rowdy World of Rap's New Underground," *New York Times,* June 22, 2017, https://www.nytimes.com/2017/06/22/arts/music /soundcloud-rap-lil-pump-smokepurrp-xxxtentacion.html.

8. The subgenre took its name from the streaming service most of the artists used to deliver their music to the public, which Caramanica noted in his article "has become the most vital and disruptive new movement in hip-hop thanks to rebellious music, volcanic energy and occasional acts of malevolence."

9. Steven Ross Johnson, "Strung Out in Suburbia: Opioid Drug Crisis Hits the Suburbs," *Modern Healthcare,* March 25, 2017, https://www.modern healthcare.com/article/20170325/MAGAZINE/303259990/strung-out-in -suburbia-opioid-drug-crisis-hits-the-suburbs.

10. Alina Simone, *Madonnaland: And Other Detours into Fame and Fandom* (Austin: University of Texas Press, 2016).

11. Khalil AlHajal, "Madonna's Favorite Part about Growing Up in Michigan: 'Oh, Nothing,'" *MLive,* updated April 3, 2019, https://www.mlive.com/news/detroit/2015/03/madonnas_favorite_part_about_g.html.

12. Dale Arnold, "Maintain Service, Railroad Ordered," *Detroit Free Press,* March 14, 1964.

13. Steve Miller, *Detroit Rock City: The Uncensored History of Rock 'n' Roll in America's Loudest City* (Boston: Da Capo Press, 2013).

14. Marc Fischer, Hardcore Architecture, https://hardcorearchitecture.tumblr.com.

15. Marc Fischer, "Mechanized Death," Hardcore Architecture, September 13, https://hardcorearchitecture.tumblr.com/post/150362049370/mechanized-death-the-address-given-for-their.

16. Marc Fischer, "Virulence," Hardcore Architecture, March 6, https://hardcorearchitecture.tumblr.com/post/140566310520/virulence-the-address-given-for-their-promise.

17. Marc Fischer, "Society's Trash," Hardcore Architecture, December 30, https://hardcorearchitecture.tumblr.com/post/136294531480/societys-trash-the-address-given-for-their.

18. Robert Palmer, "New Rock from the Suburbs," *New York Times,* September 23, 1984, https://www.nytimes.com/1984/09/23/arts/new-rock-from-the-suburbs.html?pagewanted=all.

19. Marc Fischer, "Pavement," Hardcore Architecture, October 19, https://hardcorearchitecture.tumblr.com/post/131535368505/pavement-the-address-given-for-their-slay-tracks.

20. The band was a pioneer of the merchandise game, selling everything from records and shirts with their logo to skateboard decks featuring their famous skull.

21. Jon DeRosa, "Stuck in Lodi," *Pitchfork,* March 7, 2005, https://pitchfork.com/features/article/5982-stuck-in-lodi.

Chapter 9: Mondo-Condo-Shopping-Mall-Hell

1. Jia Tolentino, "The Overwhelming Emotion of Hearing Toto's 'Africa' Remixed to Sound Like It's Playing in an Empty Mall," *New Yorker,* https://www.newyorker.com/culture/rabbit-holes/the-overwhelming-emotion-of-hearing-totos-africa-remixed-to-sound-like-its-playing-in-an-empty-mall.

2. Tolentino, "The Overwhelming Emotion."

3. Robert D. Putnam, *Bowling Along: The Collapse and Revival of American Community* (New York: Simon and Schuster, 2000).

4. Hussein Kesvani, "The Teens Who Listened to 'Mallwave' Are Nostalgic for an Experience They've Never Had," *MEL,* February 2019, https://mel

magazine.com/en-us/story/the-teens-who-listen-to-mallwave-are-nostalgic
-for-an-experience-theyve-never-had.

5. Jordyn Holman, "Millennials Tried to Kill the American Mall, but Gen Z Might Save It," *Bloomberg Businessweek,* April 25, 2019, https://www .bloomberg.com/news/articles/2019-04-25/are-u-s-malls-dead-not-if-gen -z-keeps-shopping-the-way-they-do?utm_medium=social&utm_campaign =socialflow-organic&utm_content=businessweek&utm_source=twitter &cmpid=socialflow-twitter-businessweek.

6. Holman, "Millennials Tried to Kill the American Mall."

7. Malcolm Gladwell, "The Terrazzo Jungle," *New Yorker,* March 15, 2004, https://www.newyorker.com/magazine/2004/03/15/the-terrazzo-jungle.

8. Katherine Brooks, "Eerie Photos of Abandoned Malls Reveal a Decaying Side of Our Consumer Culture," *HuffPost,* updated December 6, 2017, https:// www.huffpost.com/entry/seph-lawless_n_5213346.

9. Matt Stopera, "Completely Surreal Photos of America's Abandoned Malls," *BuzzFeed,* April 2, 2014, https://www.buzzfeed.com/mjs538/completely-surreal -photos-of-americas-abandoned-malls.

10. JoAnn Greco, "The Psychology of Ruin Porn," *CityLab,* January 6, 2012, https://www.citylab.com/design/2012/01/psychology-ruin-porn/886.

11. Sam Wetherell, "The Shopping Mall's Socialist Pre-History," *Jacobin,* April 8, 2014, https://www.jacobinmag.com/2014/04/the-last-shopping-mall.

12. Jay Cridlin, "Tiffany Talks about the Death of Malls, Her Rivalry with Debbie Gibson and More," *Tampa Bay Times,* March 14, 2018.

13. Tolentino, "The Overwhelming Emotion."

14. Chris Reed, "Are There Too Many Malls in Singapore?" *Singapore Business Review,* July 14, 2015, https://sbr.com.sg/commercial-property/commentary /are-there-too-many-malls-in-singapore.

15. Before that, it was Outlet Square, and before that, when it opened in 1968, it was Buford-Clairmont Mall.

16. I say "basically" because I believe that if I'd wanted, I probably could've had a permanent place to live. I recognize that I had that privilege. I can't be certain since it's all in the past, but I feel it's important to mention.

17. Sonia Saraiya, "Why Is Gen Z Obsessed with *The Office*?" *Vanity Fair,* April 26, 2019, https://www.vanityfair.com/hollywood/2019/04/billie-eilish -the-office-gen-z-netflix.

18. Harling Ross, "This Brand Is Making Me Want to Dress Normcore Again," *Man Repeller,* January 1, 2018, https://www.manrepeller.com/2018/01 /normcore-2018.html.

19. Zach Baron, "In Praise of Being Washed," *GQ,* July 2, 2018, https://www .gq.com/story/in-praise-of-being-washed.

Chapter 10: The Battle for the Soul of Nod Road

1. Leo Marx, *The Machine in the Garden: Technology and the Pastoral Ideal in America* (New York: Oxford University Press, 1964).

2. As of 2010, Avon is home to more than eighteen thousand people.

3. Michael Bamberger, "Where Are All the Black Golfers? Nearly Two Decades after Tiger Woods' Arrival, Golf Still Struggles to Attract Minorities," *Golf,* July 3, 2013, https://www.golf.com/tour-and-news/where-are-all-black -golfers-nearly-two-decades-after-tiger-woods-arrival-golf-still-st.

4. Florida, I should mention, literally has a village named Golf in Palm Beach County, which is basically a golf course that two hundred people live on.

5. Spencer Gardner, "How Golf Courses Rob Their Cities of Tax Revenue," *Strong Towns,* January 8, 2016, https://www.strongtowns.org/journal/2016 /1/7/golf-course-tax-revenue.

6. Robin Baran, interview with the author; "Introduction," in *Town of Avon: Plan of Conservation and Development,* accessed February 14, 2020, https:// www.avonct.gov/sites/avonct/files/file/file/pocd_chap_1-introduction.pdf.

7. Kim Parker et al., "How Urban, Suburban and Rural Residents Interact with Their Neighbors," Pew Research Center, May 22, 2018, https://www .pewsocialtrends.org/2018/05/22/how-urban-suburban-and-rural-residents -interact-with-their-neighbors.

8. "National Household Travel Survey Daily Travel Quick Facts," Bureau of Transportation Statistics, updated May 31, 2017, https://www.bts.gov /statistical-products/surveys/national-household-travel-survey-daily-travel -quick-facts.

9. Quentin Fottrell, "People Spend Most of Their Waking Hours Staring at Screens," August 4, 2018, https://www.marketwatch.com/story/people-are -spending-most-of-their-waking-hours-staring-at-screens-2018-08-01.

10. Rebecca Traister, "Can the New Activist Passion of Suburban White Women Change American Politics?" *Cut,* June 19, 2017, https://www.thecut .com/2017/06/jon-ossoff-karen-handel-georgia-race-white-suburban-women -activists.html.

11. Justin Kong, Edward Hon-Sing Wong, and Veronica Yeung, "Organizing the Suburbs," *Briarpatch,* October 29, 2018, https://briarpatchmagazine.com /articles/view/organizing-the-suburbs.

12. Christopher Carville, interview with the author.

13. Emily Brindley, "Avon Public Hearing on Controversial Nod Road Development Continued to July," *Hartford Courant,* June 25, 2019, https:// www.courant.com/community/avon/hc-news-avon-nod-road-golf-course -public-hearing-continued-20190626-zgaqifuj4ngbjbfnjl6gowhtmm-story .html.

Chapter 11: Go Back to the Suburbs

1. I should mention that the statistic constitutes people that are only Asian or a specific demographic and does not include self-reported biracial individuals.

2. *Ladybird,* written and directed by Greta Gerwig (IAC Films, 2017).

3. Debbie Arrington, "Greta Gerwig on filming 'Lady Bird' in Sacramento: The City Showed Its 'Most Beautiful, Charming Self,'" *Sacramento Bee,* November 3, 2017, https://www.sacbee.com/entertainment/movies-news-reviews/article182216891.html.

4. William H. Frey, "City Growth Dips below Suburban Growth, Census Shows," *Avenue,* Brookings Institute, May 30, 2017, https://www.brookings.edu/blog/the-avenue/2017/05/30/city-growth-dips-below-suburban-growth-census-shows.

5. William Mullen and Vikki Ortiz-Healy, "Chicago's Population Drops 200,000," *Chicago Tribune,* February, 15, 2011.

6. Jeremy Hobson, Marcelle Hutchins, and Chris Bentley, "Thousands of African-Americans Are Leaving Chicago Each Year. Why?" WBUR, "Here & Now" segment, February 28, 2019.

7. Patrick Sisson, "Millennials Look to the Suburbs, Not Cities, for First Homes," *Curbed,* June 21, 2016, https://www.curbed.com/2016/6/21/11956516/millennial-first-time-home-trends-suburbs.

8. Justin Fox, Conor Sen, and Noah Smith, "Millennials Are Driving the Suburban Resurgence," *Bloomberg,* August 25, 2017, https://www.bloomberg.com/opinion/articles/2017-08-25/millennials-are-driving-the-suburban-resurgence.

9. U.S. Census Bureau "Fastest-Growing Cities Primarily in the South and West," press release, May 23, 2019, https://www.census.gov/newsroom/press-releases/2019/subcounty-population-estimates.html.

10. Sisson, "Millennials Look to the Suburbs."

Acknowledgments

I am grateful to all the folks at Coffee House Press for their willingness to put out a book like this, specifically Chris Fischbach for his guidance; Carla Valadez, Lizzie Davis, and Annemarie Eayrs for their patience; Anitra Budd, Zoë Koenig, and Claire Fallon for the copyedits; Laurie Herrmann for the proofreading; and Daley Farr for dealing with my countless emails. Thank you to Harriet, Barry, Tessa, and Lacey Goldsher for letting me use their home to write a lot of this book. Thank you to Paul Lucas for being a great agent. Thanks to Michael Crowder for being a great friend to bounce ideas off of. Thanks to Maris Kreizman, Jami Attenberg, Jesse David Fox, Lincoln Michel, Alice Sola Kim, Josh Gondelman, Margaret Eby, Adam Chandler, Isaac Fitzgerald, Alexander Chee, Dan Saltzstein, Jaya Saxena, Matt Lubchansky, and all my other friends who encourage me as people and writers. Cal Morgan, thanks for being a champion of literature and encouraging me to push the idea for this book further early on. To Walker Loetscher, Mike Conklin, Scott Cohen, Steve Klinsky, and the rest of the InsideHook team, thanks for giving me a fun and engaging place to work. Thanks to William Callahan for being there for me early on when I first started thinking up this project. Thank you to booksellers and every indie bookstore, especially Books Are Magic, Word, Greenlight, The Strand, Unnameable Books, Community Bookstore, and all the other NYC places I haunt to find inspiration. As I write this, your doors are closed, but I hope they open soon. Thank you to all the librarians and archivists who helped me with research. Thanks to

places like R&D Foods, the to-go coffee counter at Gold Star, Hungry Ghost, and all other coffee shops that kept me fueled up during this time. Thanks to Spoons, Zoe, and Max for letting me know when it was time to get off the computer every night. Thanks to Emily for loving me.

Coffee House Press began as a small letterpress operation in 1972 and has grown into an internationally renowned nonprofit publisher of literary fiction, essay, poetry, and other work that doesn't fit neatly into genre categories.

Coffee House is both a publisher and an arts organization. Through our *Books in Action* program and publications, we've become interdisciplinary collaborators and incubators for new work and audience experiences. Our vision for the future is one where a publisher is a catalyst and connector.

LITERATURE
is not the same thing as
PUBLISHING

Funder Acknowledgments

Coffee House Press is an internationally renowned independent book publisher and arts nonprofit based in Minneapolis, MN; through its literary publications and *Books in Action* program, Coffee House acts as a catalyst and connector—between authors and readers, ideas and resources, creativity and community, inspiration and action.

Coffee House Press books are made possible through the generous support of grants and donations from corporations, state and federal grant programs, family foundations, and the many individuals who believe in the transformational power of literature. This activity is made possible by the voters of Minnesota through a Minnesota State Arts Board Operating Support grant, thanks to the legislative appropriation from the Arts and Cultural Heritage Fund. Coffee House also receives major operating support from the Amazon Literary Partnership, Jerome Foundation, McKnight Foundation, Target Foundation, and the National Endowment for the Arts (NEA). To find out more about how NEA grants impact individuals and communities, visit www.arts.gov.

Coffee House Press receives additional support from the Elmer L. & Eleanor J. Andersen Foundation; the David & Mary Anderson Family Foundation; Bookmobile; Dorsey & Whitney LLP; Foundation Technologies; Fredrikson & Byron, P.A.; the Fringe Foundation; Kenneth Koch Literary Estate; the Matching Grant Program Fund of the Minneapolis Foundation; Mr. Pancks' Fund in memory of Graham Kimpton; the Schwab Charitable Fund; Schwegman, Lundberg & Woessner, P.A.; the Silicon Valley Community Foundation; and the U.S. Bank Foundation.

The Publisher's Circle of Coffee House Press

Publisher's Circle members make significant contributions to Coffee House Press's annual giving campaign. Understanding that a strong financial base is necessary for the press to meet the challenges and opportunities that arise each year, this group plays a crucial part in the success of Coffee House's mission.

Recent Publisher's Circle members include many anonymous donors, Patricia A. Beithon, the E. Thomas Binger & Rebecca Rand Fund of the Minneapolis Foundation, Andrew Brantingham, Dave & Kelli Cloutier, Louise Copeland, Jane Dalrymple-Hollo & Stephen Parlato, Mary Ebert & Paul Stembler, Kaywin Feldman & Jim Lutz, Chris Fischbach & Katie Dublinski, Sally French, Jocelyn Hale & Glenn Miller, the Rehael Fund-Roger Hale/Nor Hall of the Minneapolis Foundation, Randy Hartten & Ron Lotz, Dylan Hicks & Nina Hale, William Hardacker, Randall Heath, Jeffrey Hom, Carl & Heidi Horsch, the Amy L. Hubbard & Geoffrey J. Kehoe Fund, Kenneth & Susan Kahn, Stephen & Isabel Keating, Julia Klein, the Kenneth Koch Literary Estate, Cinda Kornblum, Jennifer Kwon Dobbs & Stefan Liess, the Lambert Family Foundation, the Lenfestey Family Foundation, Joy Linsday Crow, Sarah Lutman & Rob Rudolph, the Carol & Aaron Mack Charitable Fund of the Minneapolis Foundation, George & Olga Mack, Joshua Mack & Ron Warren, Gillian McCain, Malcolm S. McDermid & Katie Windle, Mary & Malcolm McDermid, Sjur Midness & Briar Andresen, Daniel N. Smith III & Maureen Millea Smith, Peter Nelson & Jennifer Swenson, Enrique & Jennifer Olivarez, Alan Polsky, Robin Preble, Alexis Scott, Ruth Stricker Dayton, Jeffrey Sugerman & Sarah Schultz, Nan G. Swid, Kenneth Thorp in memory of Allan Kornblum & Rochelle Ratner, Patricia Tilton, Stu Wilson & Melissa Barker, Warren D. Woessner & Iris C. Freeman, and Margaret Wurtele.

For more information about the Publisher's Circle and other ways to support Coffee House Press books, authors, and activities, please visit www.coffeehousepress.org/pages/donate or contact us at info@coffeehousepress.org.

Jason Diamond is a writer and editor living in Brooklyn. His first book was *Searching for John Hughes*.

The Sprawl was designed by
Bookmobile Design & Digital Publisher Services.
Text is set in Adobe Garamond Pro.